Auguri Cordiali
pel 1900 V. Sella

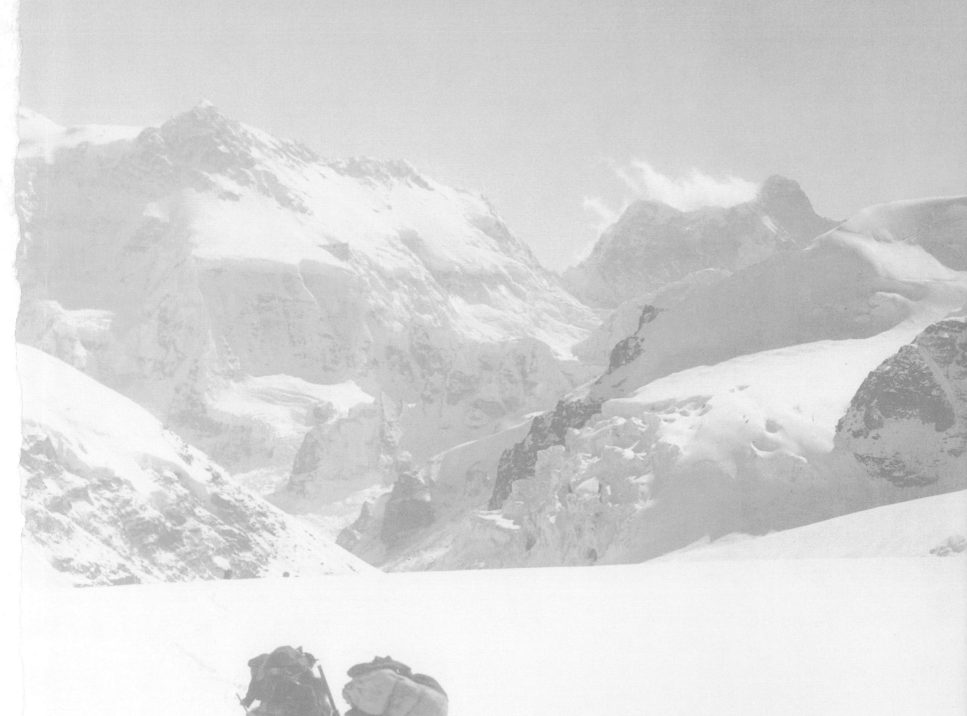
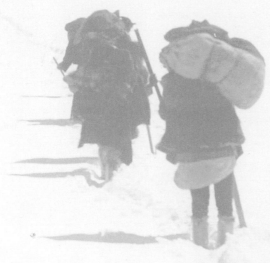

SUMMIT / VITTORIO SELLA

MOUNTAINEER AND PHOTOGRAPHER / THE YEARS 1879–1909

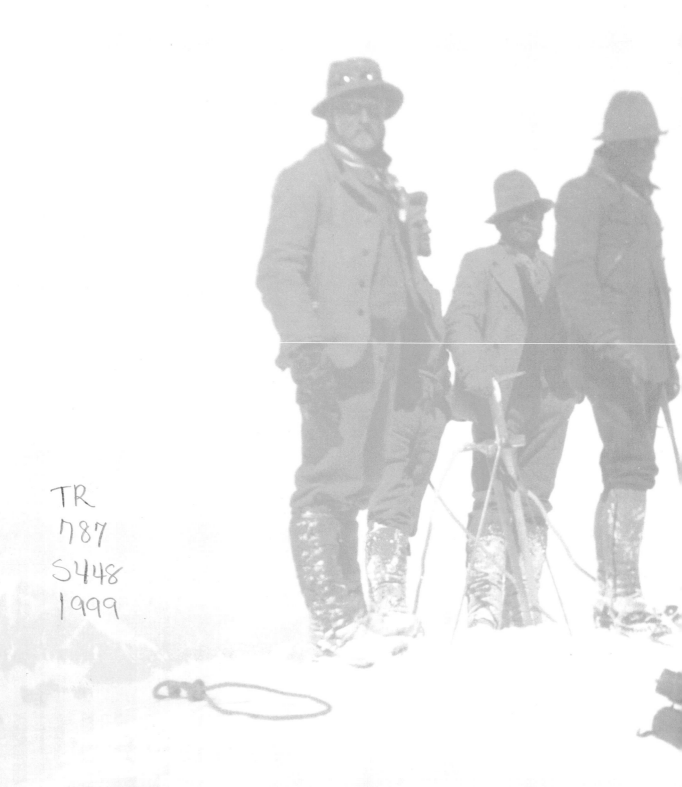

(ENDPAPERS) DESCENDING THE SEWARD GLACIER
ON THE RETURN FROM MOUNT SAINT ELIAS, ALASKA, 1897

(PREVIOUS) CROSSING JONSONG-LA WITH KANGCHENJUNGA
AND JANNU IN THE BACKGROUND, NEPAL, 1899

ANDREA PELLISSIER, LORENZO CROUX, GIUSEPPE PETIGAX, LUIGI AMEDEO DI SAVOIA
(DUKE OF ABRUZZI), FILIPPO DE FILIPPI, ERMINIO BOTTA, ANTONIO MAQUIGNAZ,
AND UMBERTO CAGNI AT SUMMIT OF MOUNT SAINT ELIAS, ALASKA, JULY 1897

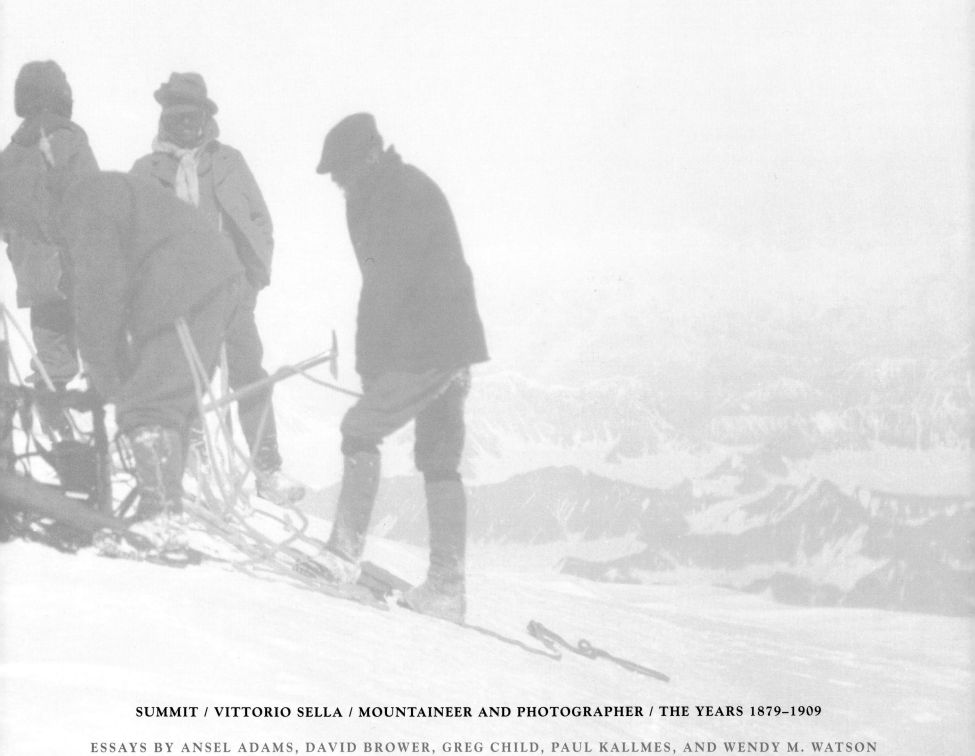

SUMMIT / VITTORIO SELLA / MOUNTAINEER AND PHOTOGRAPHER / THE YEARS 1879–1909

ESSAYS BY ANSEL ADAMS, DAVID BROWER, GREG CHILD, PAUL KALLMES, AND WENDY M. WATSON

IN ASSOCIATION WITH FONDAZIONE SELLA AND THE MOUNT HOLYOKE COLLEGE ART MUSEUM

APERTURE

TABLE OF CONTENTS

APERTURE GRATEFULLY ACKNOWLEDGES THE GENEROUS SUPPORT FOR SUMMIT FROM
JOANNE AND ARTHUR HALL, FAIRWEATHER FOUNDATION (FORMERLY HALL FAMILY FOUNDATION);
FURTHERMORE, THE PUBLICATION PROGRAM OF THE J.M. KAPLAN FUND; J.T. AND LINDÉ RAVIZÉ
AND THE INSTITUTE OF MOUNTAIN PHOTOGRAPHY; AND RHETT TURNER.

BY DAVID BROWER

They called it the squirrel cage, a random assortment of albums and journals in the old Sierra Club headquarters in San Francisco's Mills Tower. I was working for the Club part-time in 1939, poking around in the cage, when I decided to have a look inside a small trunk. The trunk had been a gift from Mrs. Frederick Morley, in memory of her husband, who lost his life in 1921 while climbing on the Cockscomb, near Yosemite's Tuolomne Meadows. A mountaineer myself, I was overwhelmed by what I found in the trunk: exhibit-sized photographs by Vittorio Sella. These were some of the most magnificent mountains I had ever seen or hoped to see.

I did not know it yet, but I was about to explore some of Sella's mountains myself in Italy, where the 10th Mountain Division and I would end World War II at the northern end of Lago di Garda, in May 1945, nearly a century after Sella's birth. Emerging without a scratch from the war, I returned to my Sierra Club haunts and became editor of the *Sierra Club Bulletin*. Having learned about Sella in the squirrel cage, and having admired the mountain photography of Ansel Adams (whom I had met in the High Sierra in 1934 when I knew who he was but neither of us knew who I was), I found it impossible not to display Sella's work in a Sierra Club exhibit. With Ansel's help and introduction, I also featured Sella's photographs in a sixteen-page spread in the 1946 *Sierra Club Bulletin*. The spread opened with the unbearably exquisite Sella presentation of Siniolchun, in Sikkim. No mountain should be permitted to be that beautiful. The spread closed with a photograph of the Mustagh Tower. No mountain has a right to be that terrifying.

In May 1995, almost sixty years after opening Mrs. Morley's trunk, I found myself at a film festival in Telluride, Colorado, where Paul Kallmes invited me to his exhibit of photographs by Sella and Brad Washburn. I had known Brad for decades, but knew Sella only by way of the trunk. Paul wanted to see an American book on Sella published, knew about the Adams essay I had run in the *Sierra Club Bulletin*, and wondered if I could be of any help. Within a short span of time, my wife Anne and I found ourselves at the Sella family estate, marvelling at Sella's ingenious solar enlarger. In Biella, fueled by an occasional grappa, and fully immersed in what Sella had achieved, I finally got the big picture.

So it was with Paul's help, and the ineluctable urging of his friends and fellow Institute of Mountain Photography directors, J. T. and Lindé Ravizé, that I learned the value of visiting one's own collection every fifty years or so. I will try to develop that habit. It was very rewarding to complete the circle and see this book come to life.

In Biella I became convinced that Sella would have agreed with Li Po—who preceded him by twelve centuries— "We never grow tired of each other, the mountain and I."

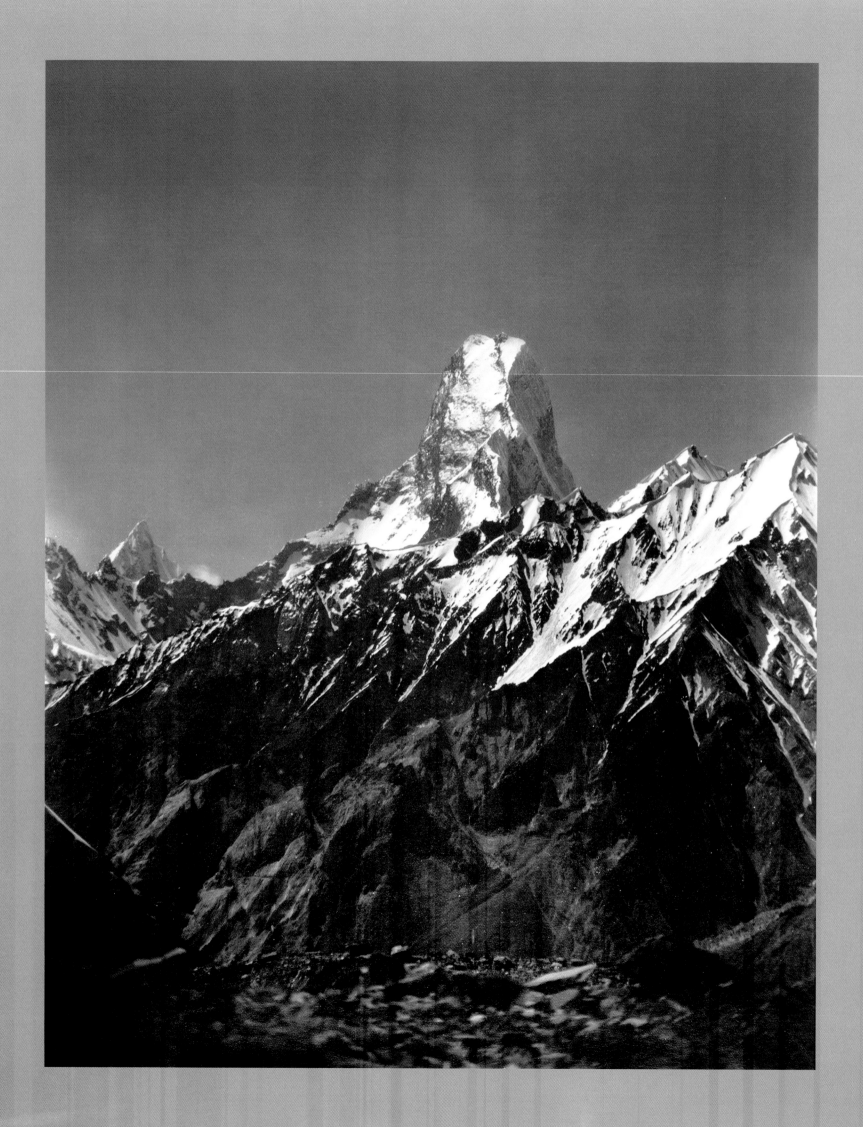

VITTORIO SELLA

BY ANSEL ADAMS

The memory of Vittorio Sella is closely embraced by the moods of the world's great mountains, many of which are known to us chiefly through the beautiful imagery of his lens. Mighty K2, shrouded in the gray plumes of the monsoon, the thundering avalanches of Mount Saint Elias, remote Ruwenzori glittering over the hot plains of Africa, and the noble crag of Ushba towering above the ancient Caucasian lands—these are revealed in all their sheer majesty in Sella's masterful photographs. His was a rich and productive life, and one of the happiest as well. Few have looked upon an equal wealth of the world's splendors, fewer still have enjoyed the opportunity to interpret and express them; and the period of his life encompasses the golden age of mountaineering and exploration. Sella was born in 1859 in Biella, in northern Italy, and died there in 1943. Apart from his photographic accomplishments in the Alps, he was photographer on many important

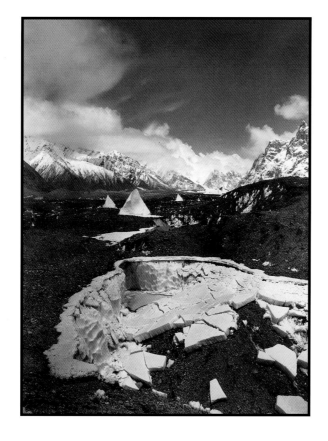

expeditions—to the Caucasus in 1889, 1890, and 1896, to the Saint Elias range in 1897, to the Himalayas and Sikkim in 1899, to the Ruwenzori, in Africa, in 1906, and to the Karakoram and Western Himalayas in 1909. He was a member of an old and honored Italian family; to quote Freshfield in his preface to *The Exploration of the Caucasus*, "The nephew of Quintino Sella, the Italian statesman, on the pedestal of whose statue his native town, Biella, has recorded in bronze tablets the two facts, that he added Rome to Italy and that he founded the Italian Alpine Club, Vittorio Sella has inherited his uncle's love of the mountains and the thoroughness he displayed in whatever he undertook."

The average "expeditionary" photography tends toward dullness and the mere factual recording of the scene, but with Sella's sensitive insight and response the magnificence of mountains is clarified and distilled into a high order of expression. For, to a very definite degree, the work of Sella contains the qualities of greatness. We will respond, if not to every pho-

(ABOVE) SERACS ON THE BALTORO GLACIER, KARAKORAM, 1909
(LEFT) TELEPHOTO OF MUSTAGH TOWER, KARAKORAM, 1909

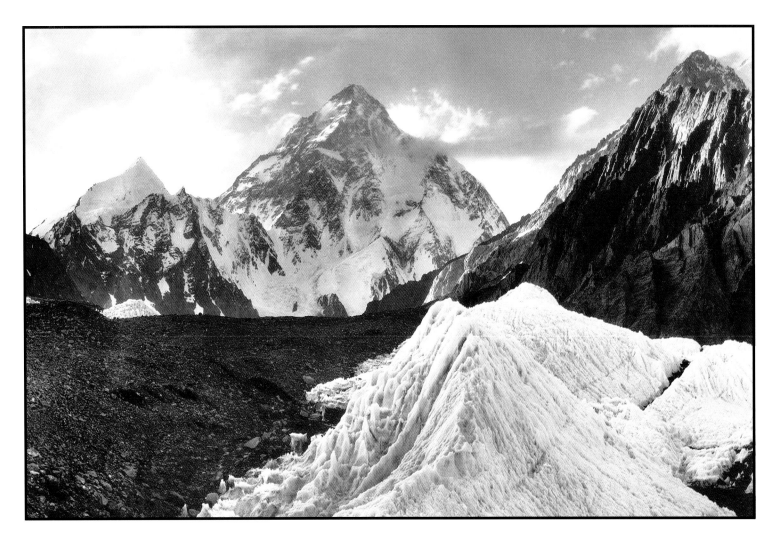

tograph, to his work as a whole, with appreciation of the tremendous grandeur of the mountain scene and his sensitive integrations of majesty and mood.

It is to the lasting splendor of photography that we have had, in every decade since the time of Hill and Daguerre, great exponents leading in both the creative and functional aspects of the art. No matter how far photography has been led by the Philistines and the Pictorialists from the clean fields of the honest concept and the direct statement, these beacons of expressive and applied photography have maintained a steady and progressive course. Perhaps the most important photography has been that which was directly related to nature, expressed in such clean factual images as those of O'Sullivan, P. H. Emerson, and Atget, and in the poignantly poetic equivalents of Stieglitz, Strand, and Weston. With our many critical evaluations we attempt to segregate and classify and explain, and yet no one had defined the sharp cleavage

supposed to exist between the purely fictional and the purely expressive in art. In truth, there is no such separation, only a fluid emphasis on one or the other. A photograph of the Canyon de Chelly by O'Sullivan, or of the Golden Throne by Sella, or of Death Valley by Edward Weston, are as concise, factual, and miraculously detailed as could be desired, yet all contain that magical and spiritual potential of vision which transcends analysis.

Knowing the physical pressures of time and energy attendant on ambitious mountain expeditions, we are amazed by the mood of calmness and perfection pervading all of Sella's photographs. The exquisitely right moment of exposure, the awareness of the orientation of camera and sun best to reveal the intricacies of the forms of ice and stone, the unmannered viewpoint—these qualities reveal the reverent and intelligent artist. In Sella's photographs there is no faked grandeur; rather there is understatement, caution, and truth-

ful purpose. The considered compactness of Sella's compositions is typical of good photography; there is no loose sentimentality or emphasis on obvious pictorial patterns. His compositions may appear severe to many, but this severity is actually the effect of accuracy and truth of mood. The icy plume of K2 and the vast thrusting form of the Mustagh Tower are revealed with emphasis on their glorious height and scale, Siniolchun glitters with an almost blinding intensity, and the expanse of the great glacier valleys suggests the sheer continental bulk of the Himalayas. In the Caucasus, in the high Alps, at Ruwenzori, and at Mount Saint Elias, one feels that Sella has captured the mood and spirit of each region, commanding the qualities of substance, air, and light to perfection.

Referring to the work of the earlier photographers—O'Sullivan in the Southwest, for example—we note a certain stylization of the values of images made with "ordinary" or color-blind plates (sensitive to blue and violet light only). White skies and very deep values representing foliage were typical of these images. Sella's photography was accomplished with orthochromatic plates which are sensitive to all colors of light except those of the red regions of the spectrum. Skies were rendered light gray, and foliage medium gray; atmospheric space was well recorded, and as there was little red in the general subject matter, "panchromatic" materials would have offered slight advantage. Color filters were undoubtedly used to reduce the values of the sky and to bring snow and clouds into vigorous relief. The contemporary photographer will do well to study Sella's craft. He is prone to overdo the panchromatic effect, typified by skies appearing too deep in tone, thereby depreciating the illusion of light, and the loss of atmospheric effects through the use of too-powerful filters. Many of our modern mountain photographers are definitely two-dimensional; planes are blended through elimination of

atmospheric values, near and far shadows are rendered in similar tone, and the general aspect is lunar and does not convey the illusion of light and air. Even in Sella's most austere and icy images, one feels space and air intervening, and one is both geometrically and spatially oriented with the subject.

The vastness of the subjects and the purity of Sella's interpretations move the spectator to a definitely religious awe. The step from the purely factual to the inspired interpretation is extremely tenuous; it is impossible to describe in other terms

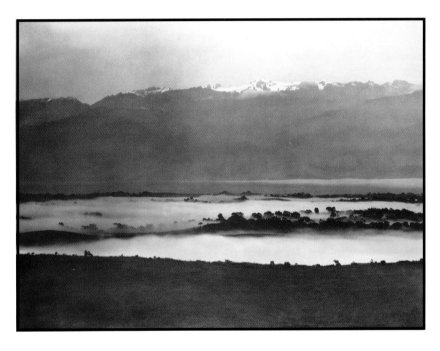

than actual experience of the images what this difference is. It may be traced to an intensity of seeing and a consistent interpretative intention. Photography such as Sella's supports the concept that intuition is the basic creative factor rather than a self-conscious awareness of modes and manners. As in all competent work the excellence of the mechanics is taken for granted; we are not dominated by an impression of technical facility, and none of the photographs have the quality of the tour de force so obvious in much contemporary photography.

Sella has brought to us not only the facts and forms of far-off splendors of the world, but the essence of experience which finds a spiritual response in the inner recesses of our mind and heart.

TELEPHOTO OF RUWENZORI RANGE FROM A DISTANCE, UGANDA, 1906

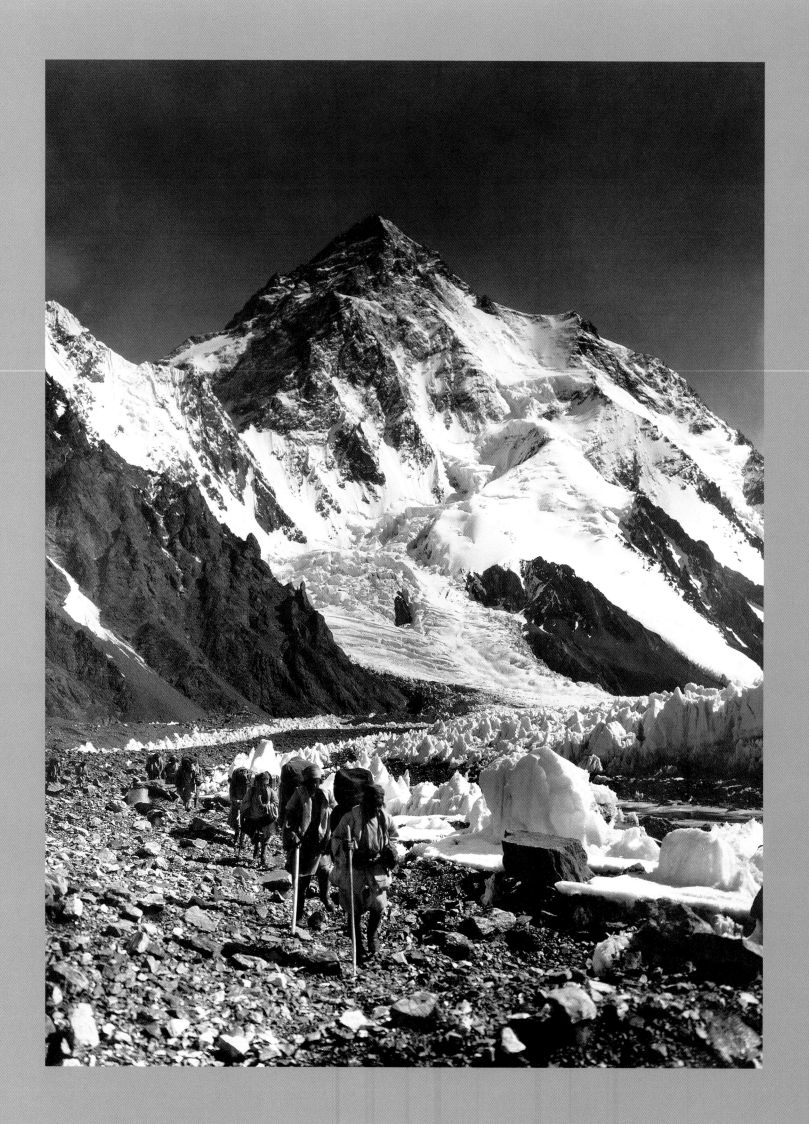

BY GREG CHILD

I well recall my first encounter with a Vittorio Sella photograph. It was 1982; I was an ambitious twenty-four-year-old mountaineer, and I had one Himalayan climbing expedition to India under my belt. The expedition was not long over, and already I longed to return to the strange, clear light of the high mountains of Asia. Sitting in my apartment at that time, in Berkeley, California, I found solace in a pile of borrowed mountaineering books. While perusing them, I came across a sweeping panoramic image of one of the most rugged stretches of land on the planet: the Baltoro Glacier of the Karakoram Range in the Western Himalayas.

The image, *Panorama of the Baltoro Glacier,* 1909 (see pages 107–110), showed a triumvirate of enormous mountains looming above a braid of winding, eerily striated glaciers. The leftmost peak was K2, which I knew to be the second tallest peak on earth, at 28,250 feet above sea level. Beside it stood the triple-crowned, 26,400-foot hulk of Broad Peak. Next in line, piercing the cold, cloudless sky, stood a freakishly symmetrical, truncated pyramid called Gasherbrum IV, twenty-six thousand feet tall.

The name of the photographer—Vittorio Sella—was unfamiliar to me, and the panorama he had pieced together was even stranger, unlike any natural scene I had ever laid eyes on. I was riveted.

Perhaps I found Sella's image so striking because human beings cannot view the world panorama-style. Simply stated, Sella had crammed more information into his image than the eye normally sees, and the effect was startling. Meandering through the feet of his mountains were rivers of bone-white, sun-sculpted ice ribboned with streaks of dark rock; Karakoram, in an archaic Tibetan dialect, means "black rock." Here, Sella's camera had captured a sense of movement—the relentless ancient ritual of ice, the thirty-five-mile-long Baltoro Glacier, chiseling away the mountain flanks and conveying the rubble at a speed of a few feet per year.

Sella had caught these mountains on a crystal clear day in 1909: K2 stood sphinx-like, arrogant, indifferent to the climbers who would, in time, vie for its summit. Gasherbrum IV, on the other hand, offered a more serene outlook, yet its compact deltaform dimensions, as I would discover when I climbed it in 1986, were no more welcoming to an alpinist than the steep angles of K2. And there stood Broad Peak, a vast empire of a mountain; Manhattan could fit onto its upper snowfields. For reasons I still don't fathom, it was this mountain that held my eye and ignited in me a furious desire to climb it. Maybe Broad Peak's sprawling form was simply closer to Sella's lens, and therefore it was easier to track a logical route up its western flank—which was in fact the path taken by Hermann Buhl, Kurt Diemberger, Marcus Schmuck and

Fritz Winterstellar, the Austrian mountaineers who made the first ascent in 1957, the year of my birth.

Sella's portrait of Broad Peak is a climber's photograph. Indeed, the Austrians used this panorama, as well as other Sella portraits of the mountain, like roadmaps to plot their way up its 10,500-foot west face. Sharply defined are the cliffs upon cliffs, the snowy *couloirs* and ramparts that lead up to acres of undulating snow and, finally, the three black caps of rock that make up its triple summit, the tallest being the southern, or rightmost.

Sella's photographs became maps for me too. I arrived at Broad Peak in 1983. It was the first of six trips I would make to the Baltoro Glacier and its snaking tributaries. By then I was acquainted with Vittorio Sella's legendary trove of photographs, and I had seen his images of the Karakoram mountains and the Balti villagers who inhabit the Braldu River Valley, the portal to the Baltoro. When I got there, I detected few visible changes in the villages of Chongo, Chakpo, and Askole since Sella's visit in 1909. The people still wore ragged clothes of homespun wool, and they planted wheat using hand tools and plows pulled by *zums*, a lumbering breed of animal that is half-cow, half-yak. The Balti eyed us with suspicion as our expedition marched through their villages; women veiled themselves and fled at the sight of us.

When Sella joined the Baltoro expedition of the explorer Luigi Amedeo di Savoia, the Duke of Abruzzi, he was already fifty-years-old and was credited with the first winter traverse of the Matterhorn, in 1882. Sella had previously accompanied the Duke on climbing expeditions to Alaska and to Africa. A wealthy and meticulous expeditioner, the Duke had ordered his favorite brass bed carried into base camp for the ascent of Mount Saint Elias in Alaska in 1897. On the Baltoro expedition, however, the Duke wisely left the bed in Italy, supplying his team instead with an ingenious system of modular sleeping bags made from camel's hair, eiderdown, goatskin, and waterproof canvas. The Duke's mission was to climb higher than anyone had before, and to this end he was the first to reach 19,685 feet on the south ridge of K2. Then he set the altitude record for the era on Bride Peak (now called Chogolisa) by climbing with his guides to 24,600 feet—just five-hundred feet shy of the top. These climbs were stunning feats for their time, and, on K2, the Duke's team laid the groundwork for the first successful ascent: the Italian expedition that finally made it to the summit in 1954.

Sella's mission, however, necessarily involved his camera; his ascents were a means of positioning himself to capture the sublimely austere landscape on film. I found the Baltoro most greatly changed, since his visit, at the rivers. Where Sella's team members can be seen fording the Indus River, at Shigar, on a *zhak*, a raft made of inflated goat bellies, our expedition drove across a bridge of steel girders. Closer to the mountains, the swaying bridges of twined willow branches that spanned the raging Braldu and Panmah Rivers in Sella's day had been replaced by taut steel cables. Yet the modern means of crossing those turbid rapids—a manually operated wooden car that hung beneath a squeaky pulley—seemed to me no less risky than the spans of vines.

At Chongo, I found the cemetery that Sella photographed, a somber cluster of graves marked with low-slung, sun-bleached wooden borders. At Skardu, Shigar, and Askole, I crossed polo fields where Sella had photographed equestrian tournaments. Villagers told me that these days most polo fields are dormant, as only wealthy folk can afford the cost of feeding a horse; a sensible man, they said, saves his rupees to buy a jeep, which can carry paying tourists.

When the mountains came into view, Sella photographed them on their own terms. Rather than shoot them from a valley, which can foreshorten or distort the picture, he would climb opposing ridges, however high, in an effort to present the subject face-on. In order to position himself

to take the photographs that make up *Panorama of the Baltoro Glacier*, Sella had his porters lug his heavy Ross & Co. camera and supply of film to 17,330 feet. From there, he artfully captured the perfect chaos of the Baltoro, sprawled before him at a mean elevation of 16,000 feet—a minefield of shifting rock and ice that is raked by avalanches from mountain flanks, and fractured with crevasses.

Looking through Sella's Karakoram images today is a nostalgic experience for me, in which scenes from six seasons spent on the Baltoro come alive. Once again I see the slender minarets of Lobsang Spire, Trango Tower, and the elusive Hainablak—granite spear points on which my friends and I dangled and felt the wrath of Karakoram winds and whims. I walk past Masherbrum and Mustagh Tower to the icy intersection of Concordia where, by day, I stared in homage at the mighty triumvirate and, by night, I huddled under a tarpaulin with Balti porters, shivering and singing away the darkness. Again I stand before K2's south face, studying the paths of my three separate attempts. (I finally found a way up in 1990, by the north ridge in China.) I ski below the massive and ever-avalanching ice cliffs of the east face of K2 to arrive at Windy Gap, on the Sino-Pakistan border, where I saw K2 shining blue-white and bitter-cold. I trace the line of our first ascent on Gasherbrum IV's northwest ridge, where my two partners and I spent an unplanned night sleeping in a snow burrow at twenty-six thousand feet, risking everything for the summit. Sella's regal photographs evoke these personal adventures for me in a way that my own collection of 35 mm slides never will. I owe him a debt of gratitude for furnishing the blueprints for my mountain dreams.

But mountains are made of ice and rock, not paper and emulsions of gelatin-silver. When I ventured onto Broad Peak for the first time, in 1983, I cringed at the finger-blanching

cold and the thin air that assailed my lungs. My partner was Peter Thexton, an English doctor and as gentle a Renaissance man as ever lived. Eighteen vertical feet from the summit, I collapsed onto the ridge. Pete and I had climbed Broad Peak too quickly, and now we were paying the price: acute mountain sickness laid me flat with a brief ataxic stroke. Pete stood me up, and we beat a retreat—so near to the summit, yet so far. Minutes later, Pete's pace slowed as well. He told me his lungs were failing; high altitude pulmonary edema was filling them with fluid. Descent to thicker air was the only cure, so we struggled down. Just before sunset, I became

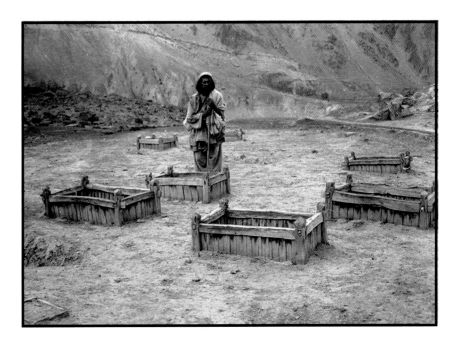

lucid enough to pull out the camera I had tucked into my climbing suit. I snapped off a frame. It shows Pete walking along a ridge in the sky, at twenty-six thousand feet. K2 hovers in the near distance. Pete seems about to step over the void of miles onto its slopes.

That photo was the last one of Pete ever taken. He died from his malady at sunrise in a tent at twenty-five thousand feet. Ever since, I have kept a ragged copy of Sella's *Panorama of the Baltoro Glacier* pinned to the wall of my office above my desk. Like all great photographs, it holds many memories locked within it.

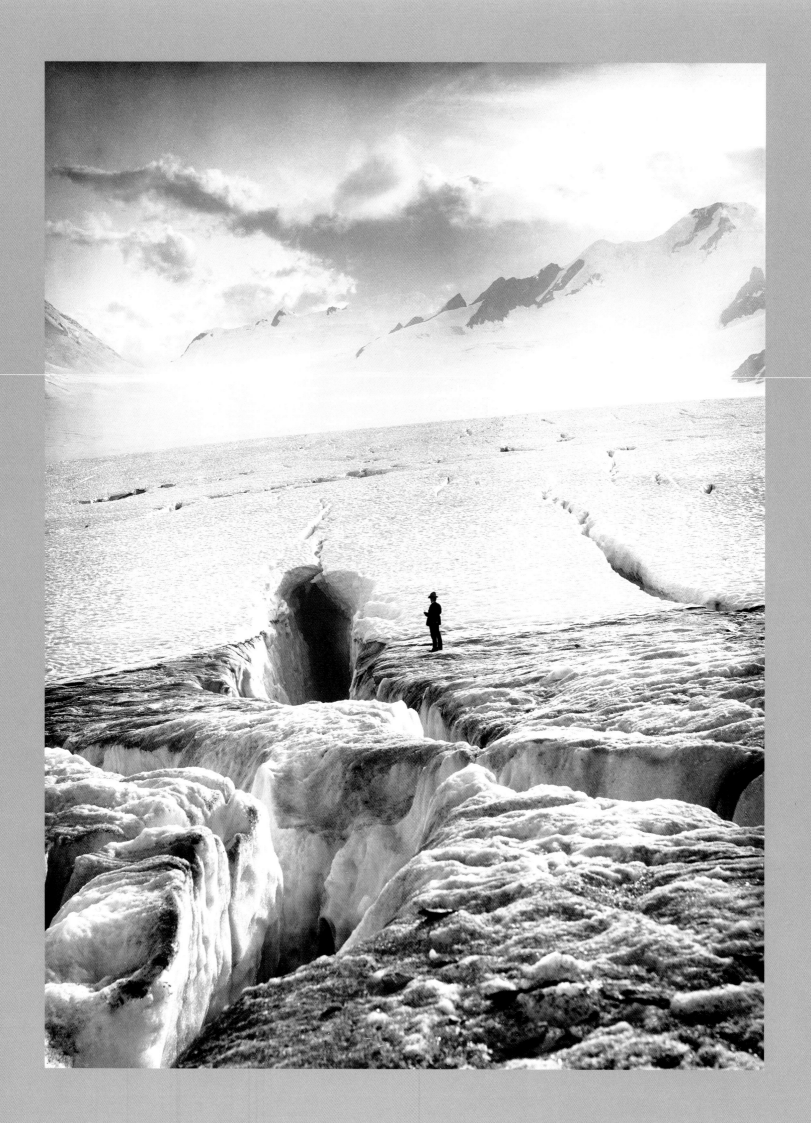

CHAPTER 1

THE ALPS, 1879–1895

I beg you to undertake immediately the camera for plates 30x40 cm

described in my letter; I beg you to make it in the best mahogany, with every care possible,

as I will serve myself of it for taking views in the high Alps. . . . Here we have

splendid weather, and I burn with impatience to start photographic excursions.

(Letter from Vittorio Sella to the Dallmeyer Camera Co., 1882)

In the summer of 1879, a young man from the Piedmont region of Italy set off for the summit of nearby Monte Mars, accompanied by a laborer from his family's textile mills. Carrying a large borrowed camera, glass plates for use as negatives, buckets and jars of developing solution, and a tent in which to work, Vittorio Sella would spend the better part of two weeks, including six nights on the summit, in pursuit of a thorough portrayal of the surrounding mountains. When he finally descended from Monte Mars, Sella had embarked on a career that had no predecessors, and even today has few, if any, equals.

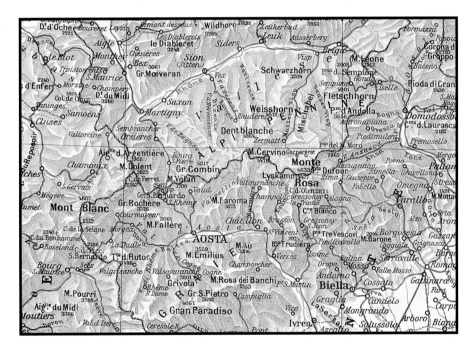

Vittorio Sella's lineage had prepared him well to pursue the newly emergent art of mountain photography. His father, Giuseppe Venanzio Sella, had written the first Italian treatise on photography in 1856. Translated into several languages, this book enjoyed a fair measure of success and instilled in Vittorio an early appreciation for photography. His visual portrayals were also enhanced by the education he had received in painting as a youth and complemented by a natural aptitude for technical matters.

Mountaineering also ran in Vittorio's family. His uncle Quintino was an accomplished climber, as well as a key player in the turbulent political events that brought about Italy's independence in the mid-nineteenth century. In an effort to strengthen his country's national identity, Quintino united the best mountaineers in the nation and formed the Italian Alpine Club in 1863. The official association of this large group of formidably talented individuals was described as an important progression for the newfound state: *In that generous spring-time of ideals it seemed to men of high attainments that the love and exploration of mountains, the struggle with rocks and ice, might be made a mighty instrument of progress. It seemed to them good that youths should mount the summits of the Alps to cry out joyfully to the peoples over the border that all Italy, or nearly all,*

belonged to the Italians. And the Alpine Club sprang from the mighty brain of Quintino Sella, like Minerva from the head of Jupiter, armed at all points ("*The Pioneers,*" Matterhorn Centenary, *1965*).

Italian mountaineers are still among the world's most accomplished practitioners of the sport, and the national standard of excellence can be attributed in part to the pioneering advancements made by Quintino and Vittorio Sella.

Vittorio's success on Monte Mars in 1879 gave him the impetus to create more complete renderings of the mountains in his vicinity. These early photographs showed him to

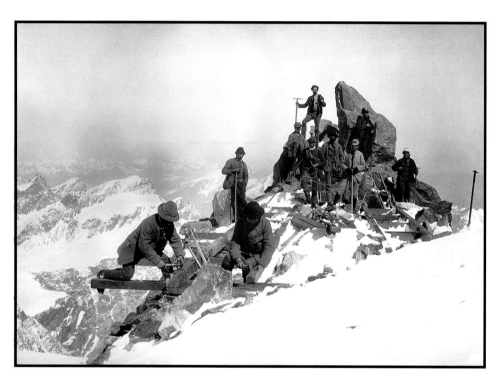

be exceptionally astute in technical matters. Even so, they did not yet possess the arresting power of his later works, like his magnificent portrait of Siniolchun, photographed from the Sikkim side of Kangchenjunga (see page 75), or his panorama of the Baltoro Glacier of K2 in the Western Himalayas (see pages 107–110). Vittorio's transformation into an artist of great talent and commitment didn't take place until a few years later, during the winter and summer of 1882 when he climbed the Matterhorn, the great 14,690-foot peak that straddles the border between Italy and Switzerland.

The Matterhorn has exerted a profound influence on generations of mountaineers. Yet in 1882, not a single climber had managed to reach its summit during the winter months—though many had tried. The ascent of a peak in winter is an especially noteworthy accomplishment because mountains can become quite hostile with little warning once the cold sets in, vastly increasing the challenge to climbers. The cold can be ferocious, ice and snow cover everything, and basic survival commands every bit of one's strength, skill, and intellect.

In February 1882, Sella, like many before him, attempted and failed to climb the Matterhorn. After just one month of recovery and planning at home, however, Sella tried again. On March 18, he and his guides managed not only to make the first winter ascent of the peak from the Italian side, but they traversed down into Switzerland as well. The achievement was widely heralded. The Alpine Club in London, a group not generally known for gratuitous bestowal of praise, said "this expedition is beyond doubt the most remarkable that has ever been made during the winter season, and on behalf of the Alpine Club, we most warmly congratulate Signor Sella on his magnificent feat" ("The Pioneers," *Matterhorn Centenary*, 1965).

Not content with this accomplishment on "Cervino," as Italians call the Matterhorn, Sella and his companions climbed it yet again, on July 29, 1882—this time with Vittorio's camera and thirteen glass plates. Sella created a twelve-frame, 360-degree panorama that met with universal acclaim. The thirteenth plate shows Vittorio and his brother Erminio perched on the summit, jauntily dressed in pinstripe pants and fedoras, the embodiment of confident youth. Of the photographs, Vittorio wrote in his journal, "Venerable Uncle

CONSTRUCTION OF THE CAPANNA REGINA MARGHERITA ON THE PUNTA GNIFETTI, MONTE ROSA, SEPTEMBER 15, 1892

Quintino was delighted with the results." Indeed the day was an important one for the Sella family. That same afternoon, one of Sella's brothers, Gaudenzio, and three cousins, Alessandro, Alfonso, and Corradino, also made the first ascent of the last unclimbed four-thousand-meter peak in the Alps.

This marked the end of the golden age of mountaineering in Europe—the thirty-year span in which all the major European peaks were climbed, and in which mountaineering became well-established as a sport. Vittorio's panorama also marked the beginning of his own golden age of Alpine photography. Sella spent part of every year from 1879 to 1895 photographing the entire span of the Alps. He covered even the highest, most inaccessible regions with a remarkable thoroughness and vitality, and his accomplishments during this time have set the standard for mountaineering photography for more than a century.

Sella's ambition of creating a portfolio of the high Alpine reaches was a daunting task. Vittorio's Dallmeyer camera alone weighed nearly forty pounds, and the glass plates weighed nearly two pounds each. In those sixteen years, he exposed about one thousand plates, roughly twelve hundred square feet of glass. Increased challenges, however, only seemed to spur Sella on to greater heights. One of the last photos of him in the mountains shows him as an elderly man of seventy-six, sitting on a ledge on the Matterhorn and scowling—because his guide had sprained his ankle and kept him from making the summit. His diaries suggest that sometimes he even preferred climbing in winter, rather than summer. He wrote: *The great cold cleanses the air and the liveliness of the colors and the whole splendor of the panoramas which men have before their eyes . . .*

you will find very few comforts: but you will return with greater feelings for, and greater knowledge of, the inhabitants of the Alpine villages (Ronald Clark, The Splendid Hills, 1948).

On future expeditions, to more remote and hostile ranges, Sella would rely on the endurance, strength, and skill he developed in the Alps. He had devoted fifteen years to the region, which allowed him to develop his trademark compositions of people, mountains, and the relationship between them: his small, calm, occasionally gesturing figures placed in the foreground of monolithic summits, or set amid gaping crevasses.

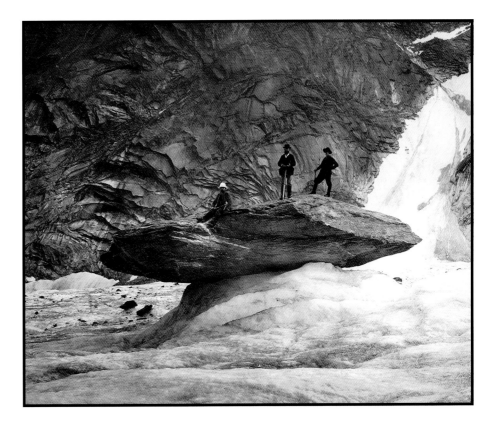

In Sella's day, the upper reaches of mountains were often seen at best as sterile wastelands, and at worst as the haunts of demons. Sella, more than any other photographer, must be credited with drawing the mountains out from under an age-old shadow of superstition. Sella saw the high mountains as pristine environments that invited the cautious and respectful visitor and paid a rewarding dividend to those who took the time to explore them properly.

GAUDENZIO SELLA, ALESSANDRO SELLA, AND JOSEPH MAQUIGNAZ
ON THE FINSTERAAR GLACIER, JULY 23, 1886

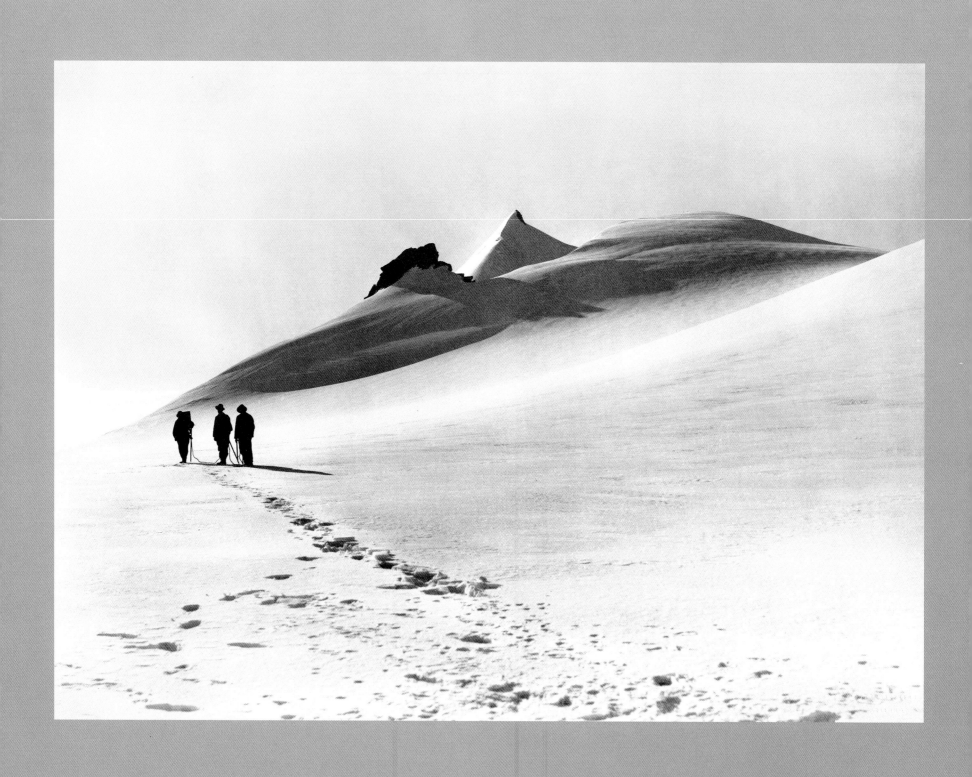

THE ALLALINHORN AS SEEN FROM
THE ALPHUBELJOCH, AUGUST 3, 1887

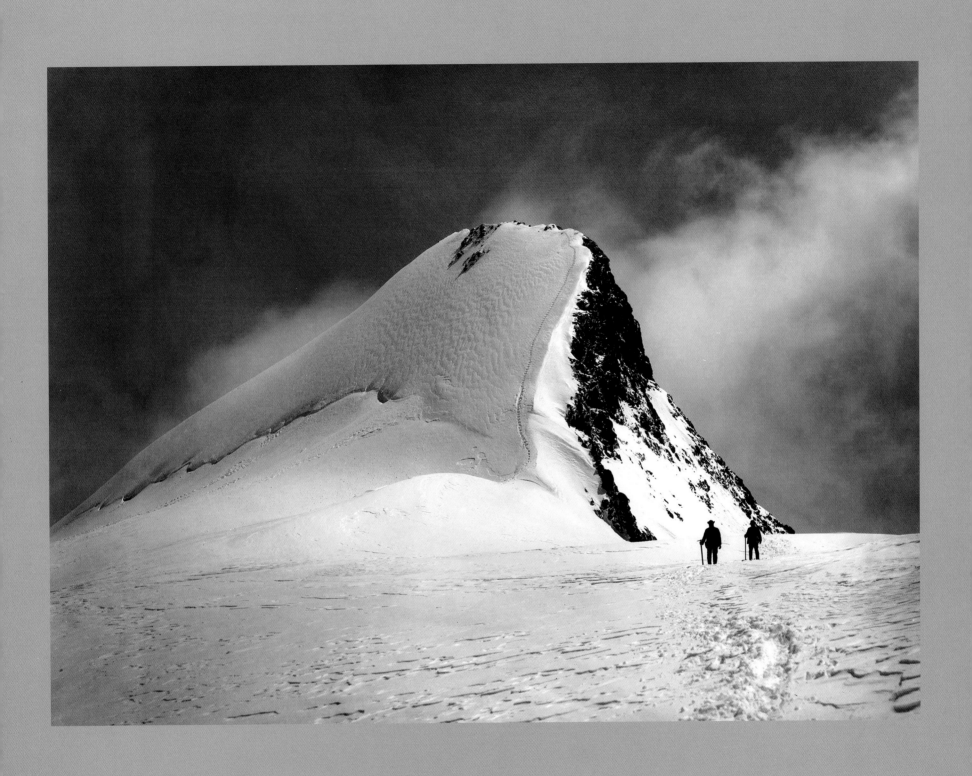

HIGHEST PEAK OF THE ROUIES AS SEEN
19 *FROM THE CHARDON GLACIER, AUGUST 3, 1888*

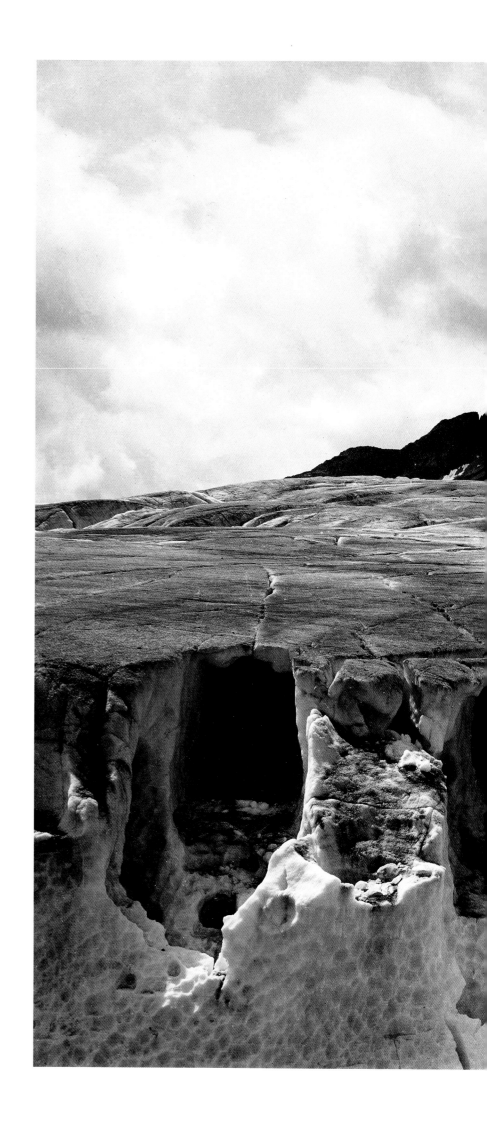

ICE CAVES ABOVE THE MRJELEN GLACIAL
20 *LAKE ON THE ALETSCH GLACIER, JULY 22, 1884*

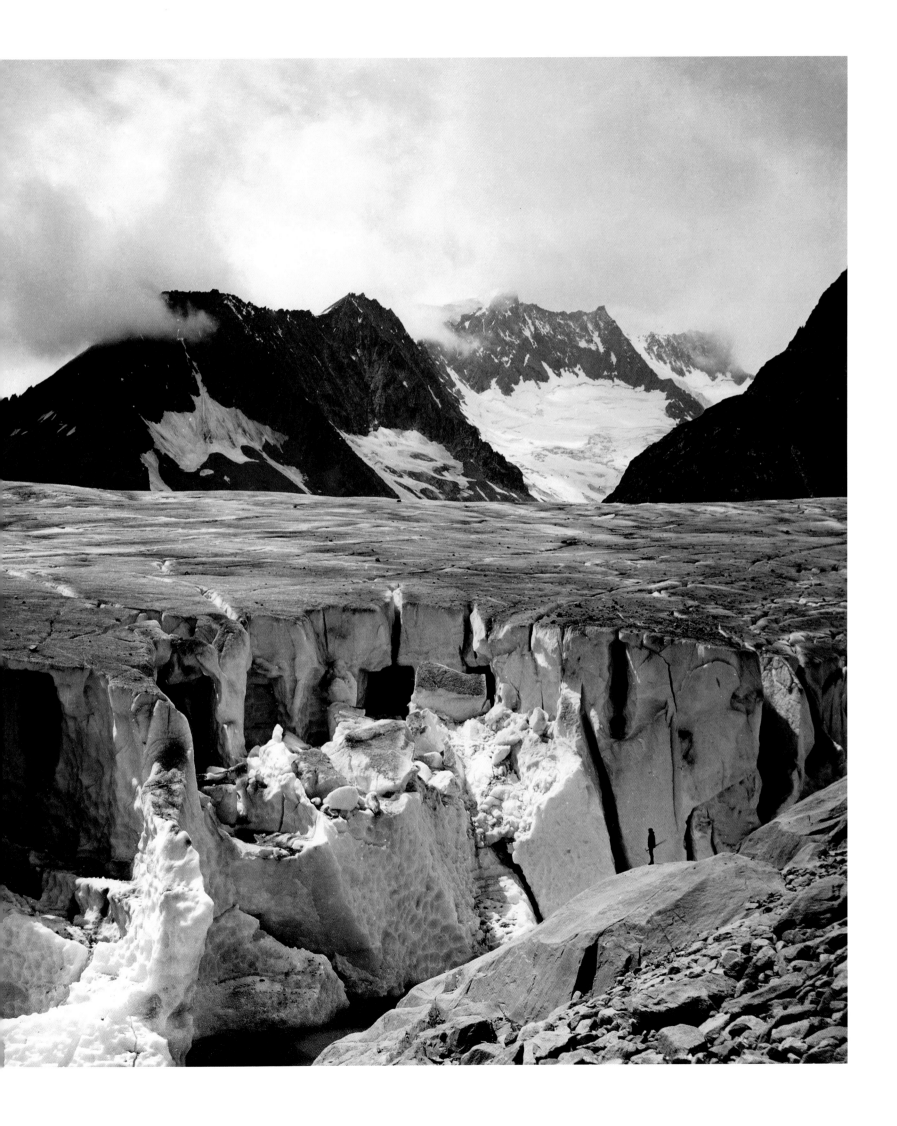

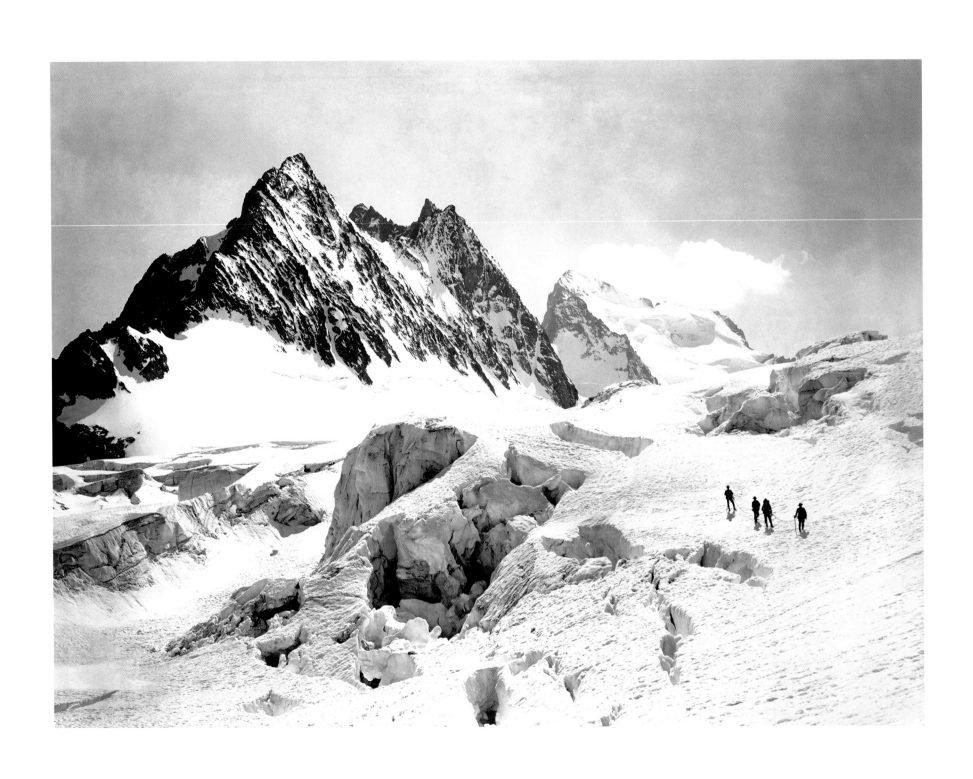

CREVASSES AND SERACS ON THE GLACIER BLANC, GRAND SAGNE AND ECRINS, AUGUST 13, 1888

(OPPOSITE) CLIMBERS DESCENDING THE HOFFMAN ROUTE, GROSS GLOCKNER, 1893

(NEXT, LEFT) A CREVASSE ON THE GABELHORN GLACIER, AUGUST 1, 1887

(NEXT, RIGHT) ALESSANDRO SELLA, JOSEPH MAQUIGNAZ, AND GAUDENZIO SELLA

ON THE WETTERHORN, JULY 19, 1886

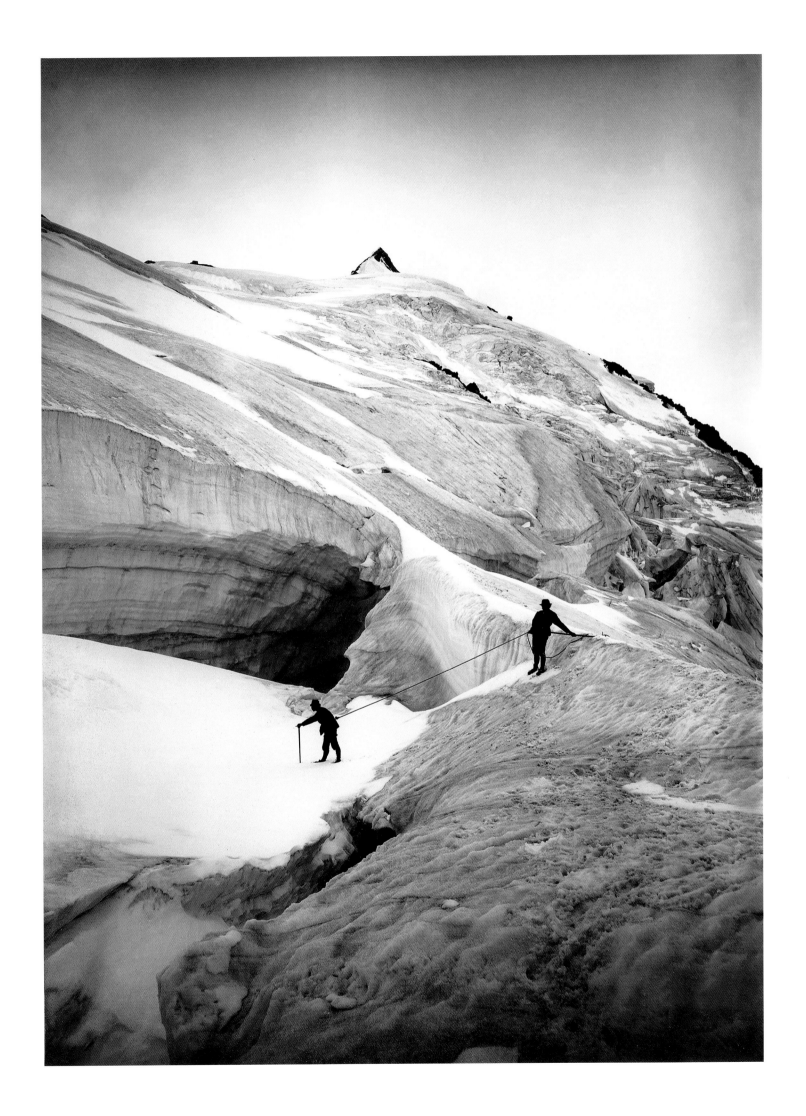

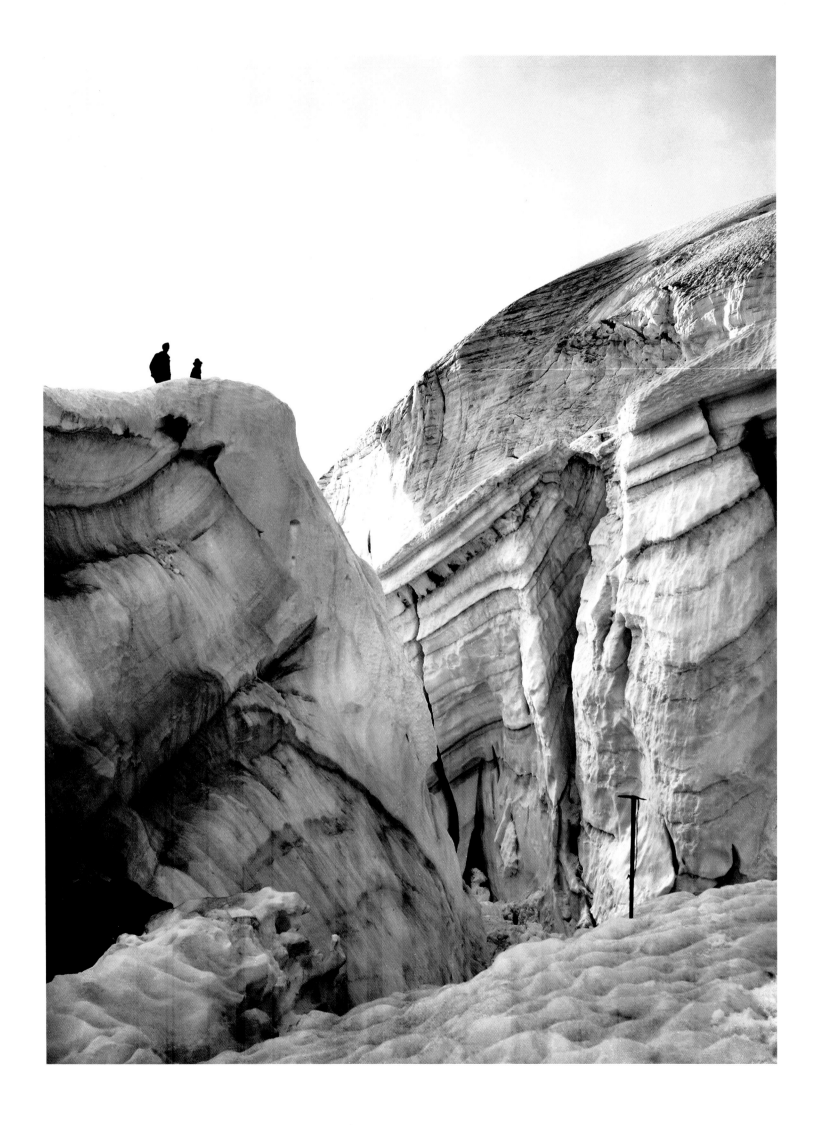

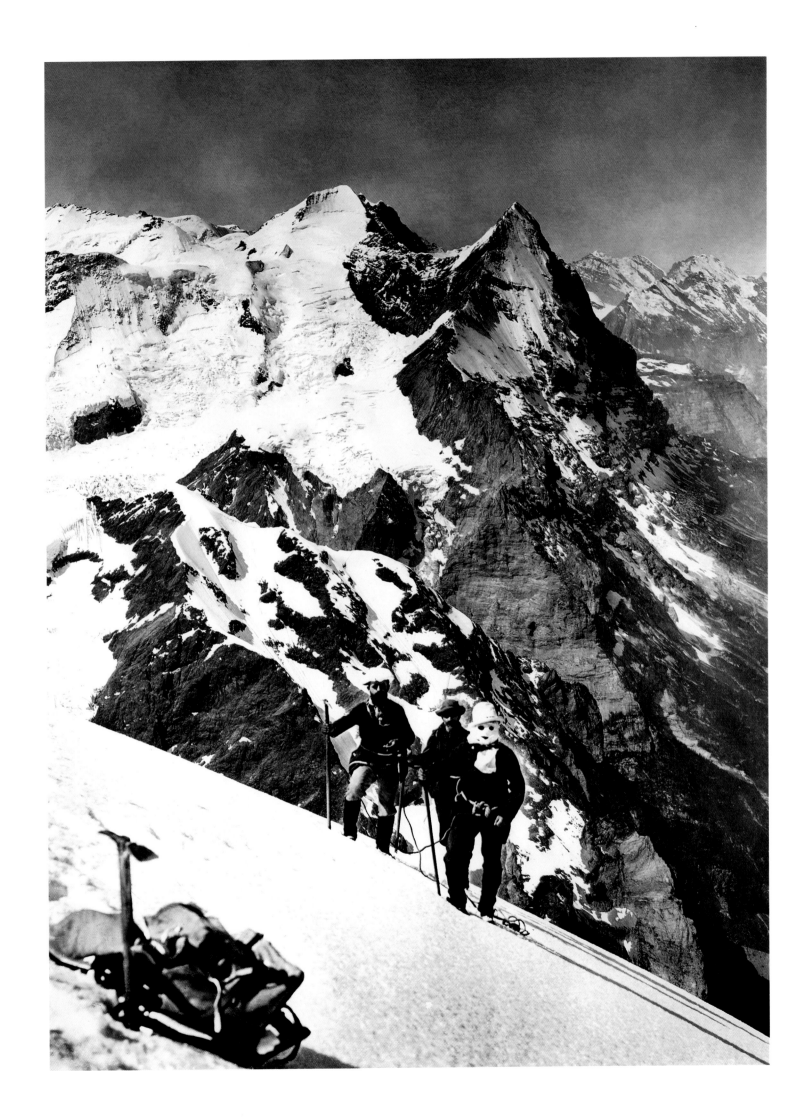

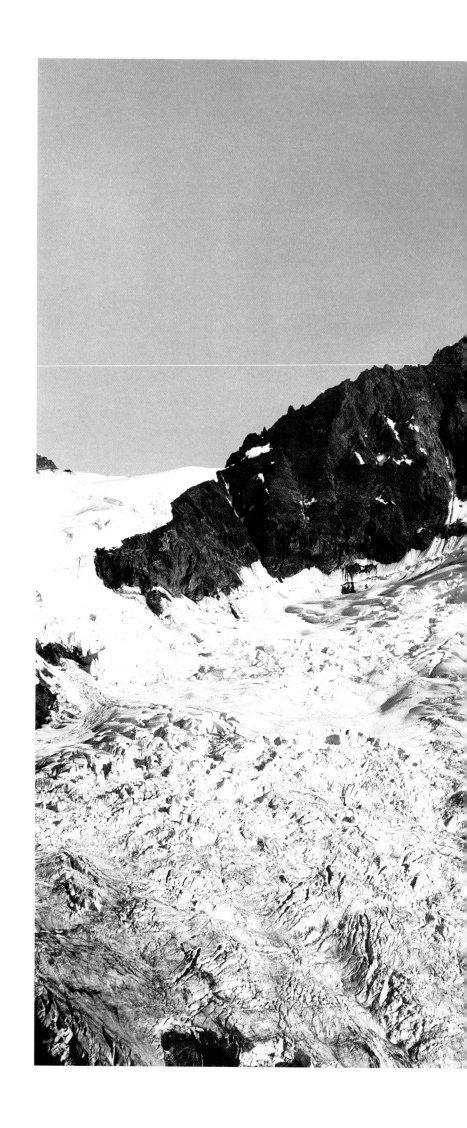

THE WEISSHORN AS SEEN FROM
THE METTELHORN, JULY 31, 1887

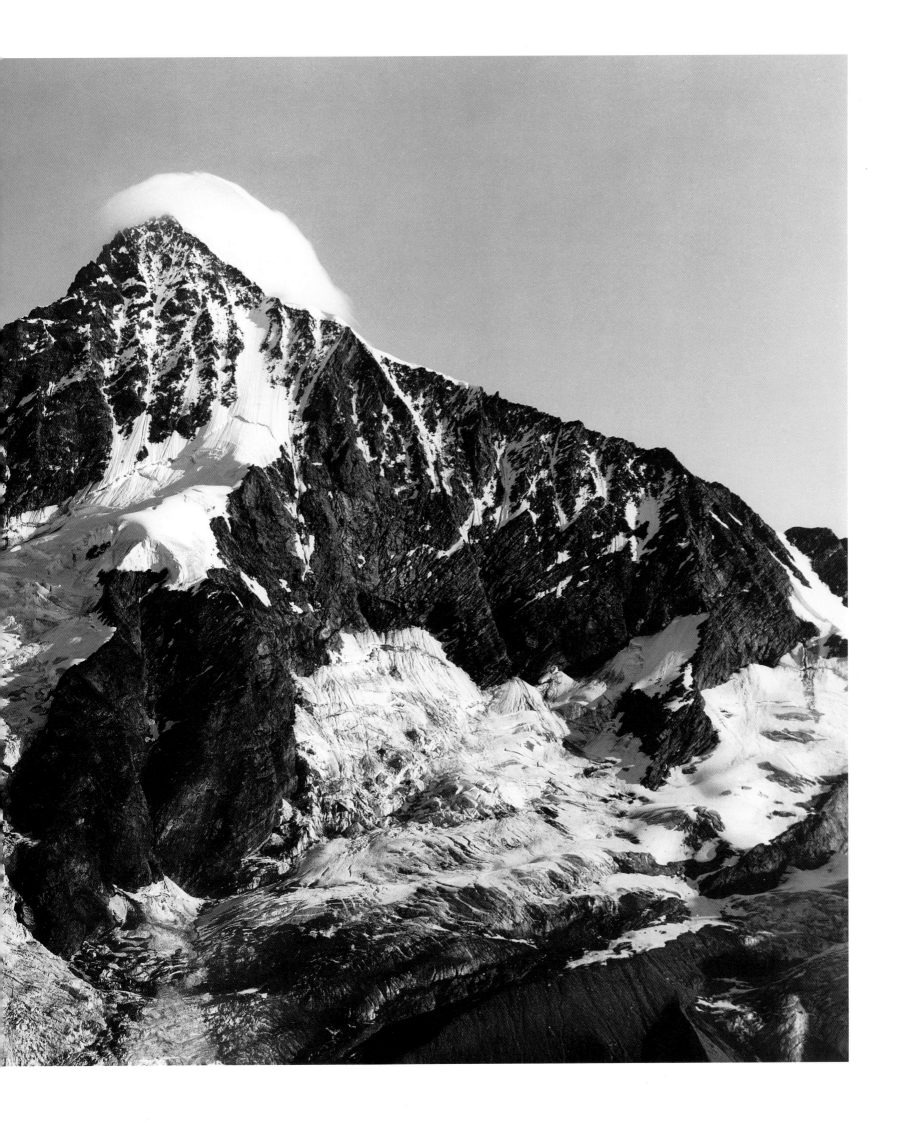

HIGHEST PEAK OF THE CIMON DELLA PALA,
DOLOMITES, AUGUST 26, 1891

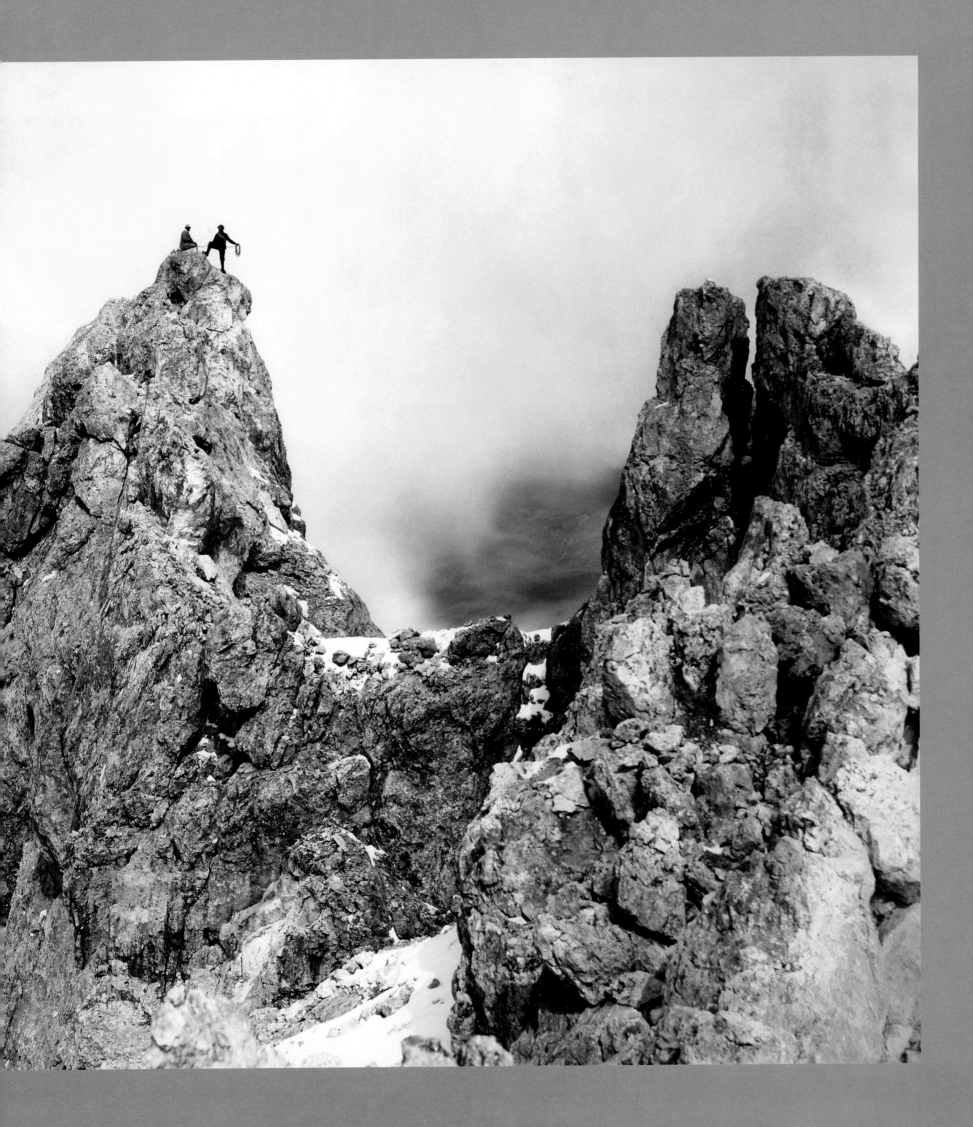

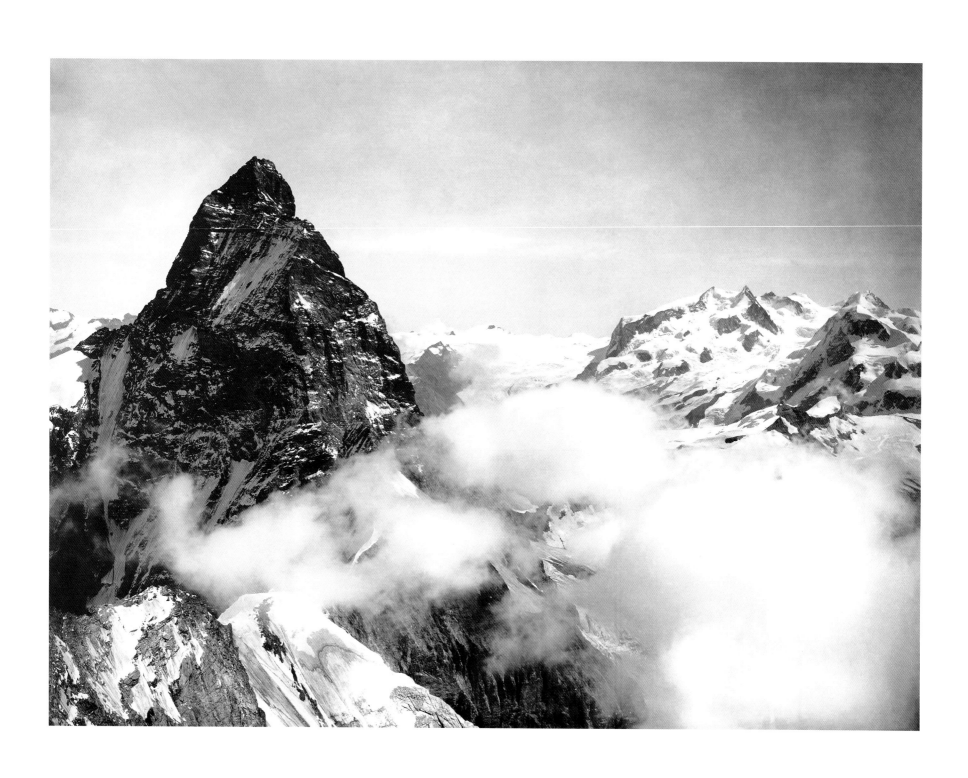

THE MATTERHORN AND MONTE ROSA AS SEEN FROM
30 *THE GRANDES MURAILLES PASS, SEPTEMBER 18, 1887*

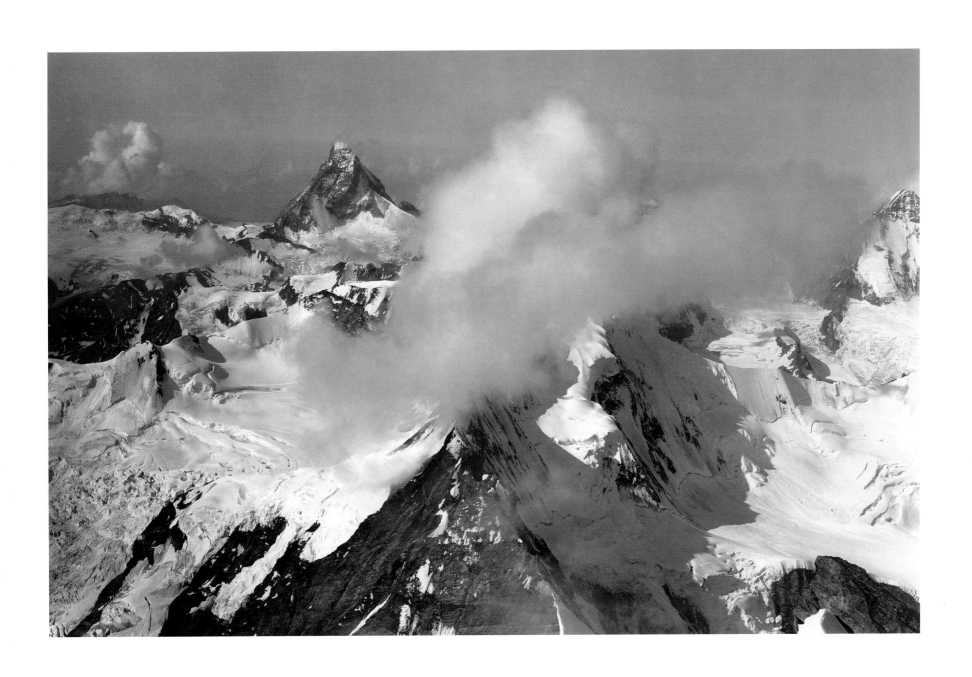

NORTH FACE OF THE MATTERHORN
31 *AS SEEN FROM THE WEISSHORN, JULY 30, 1887*

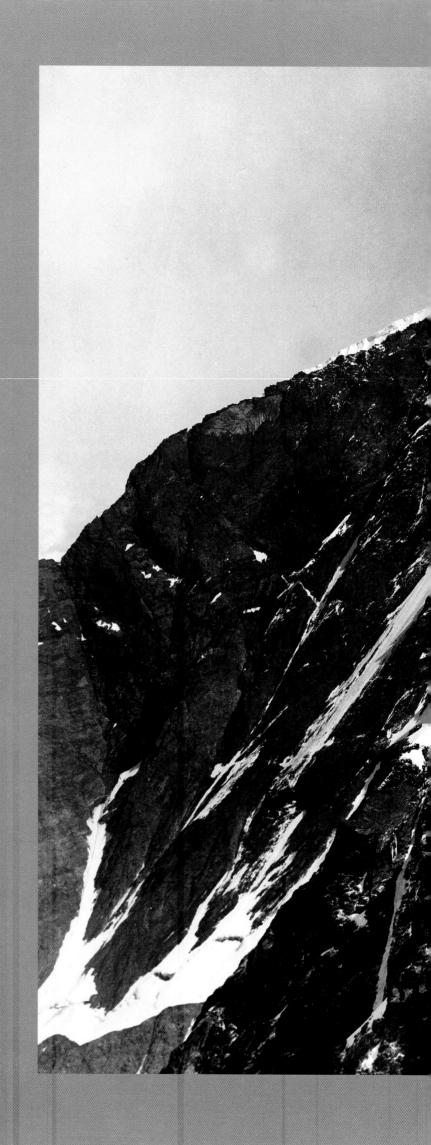

THE MISCHABELHORNER AS SEEN FROM THE
32 NORTH PEAK OF THE ALPHUBEL, AUGUST 3, 1887

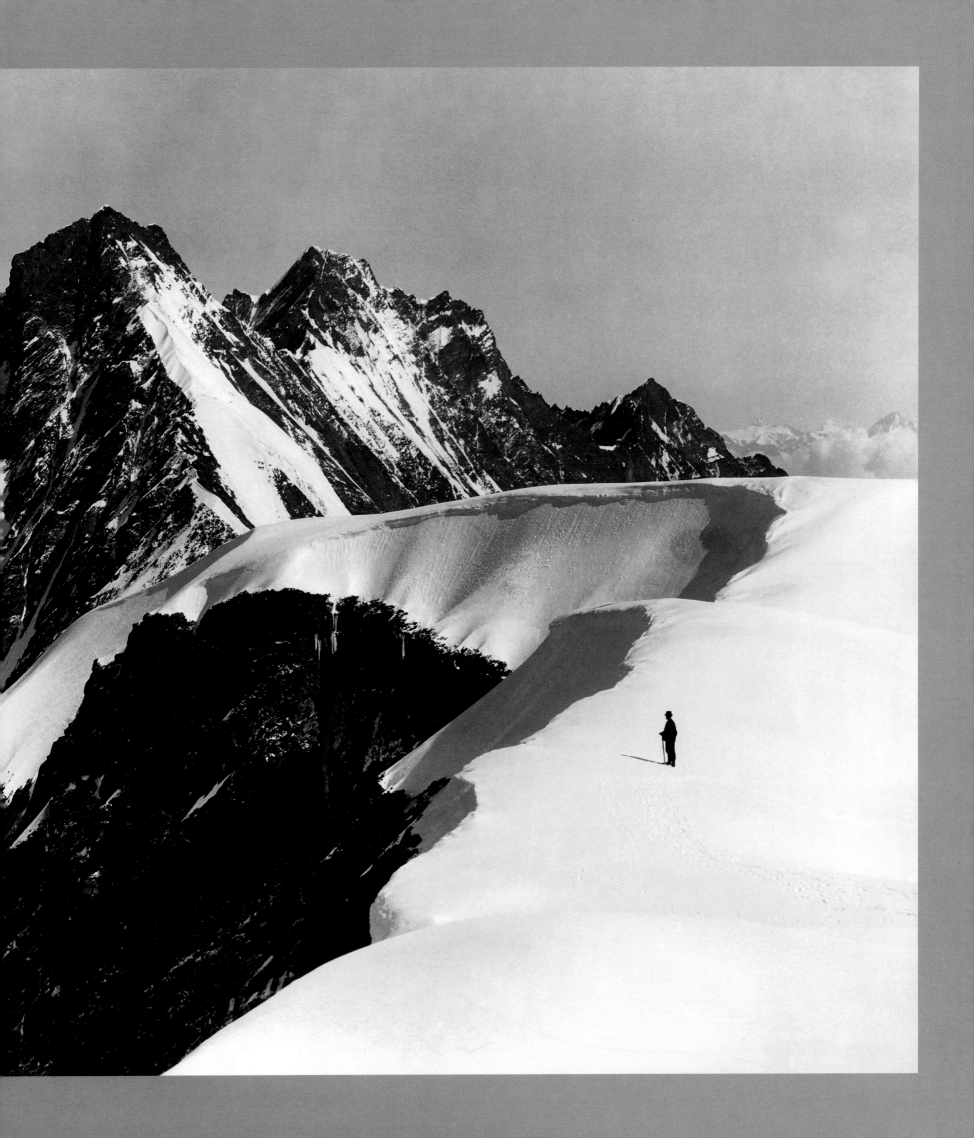

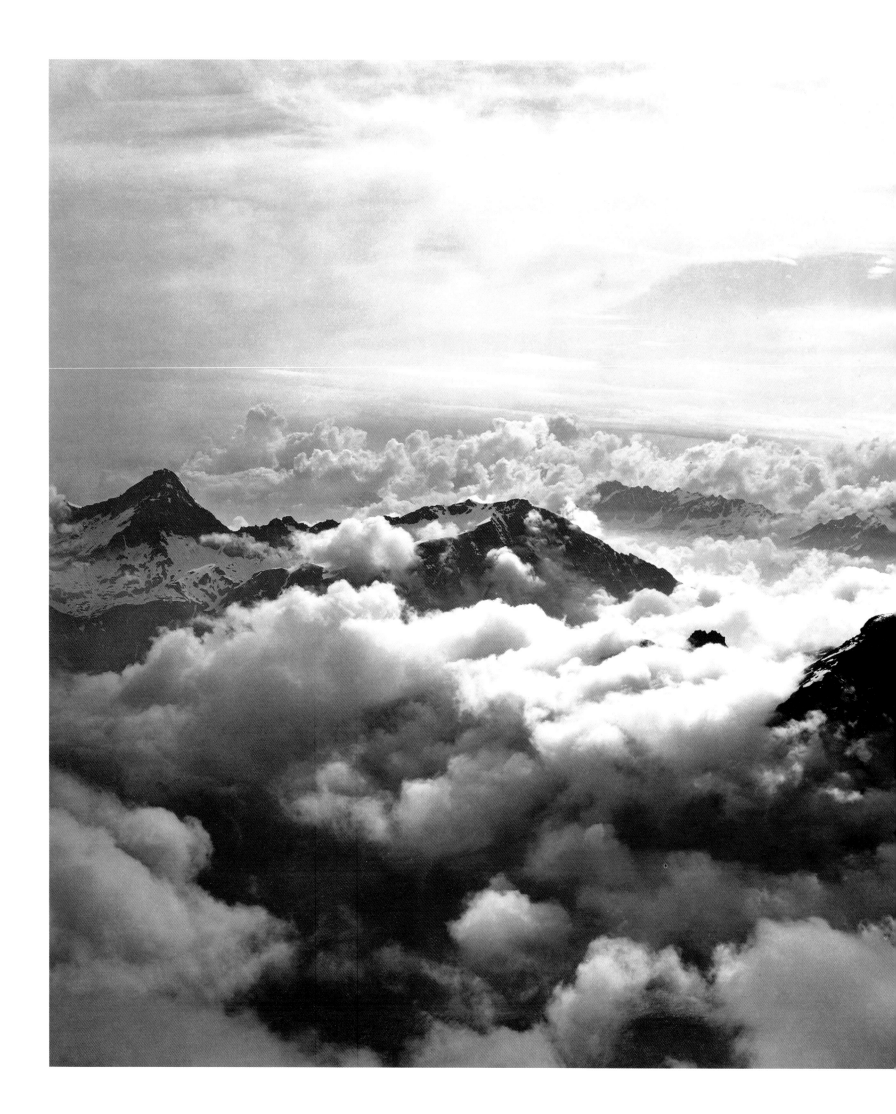

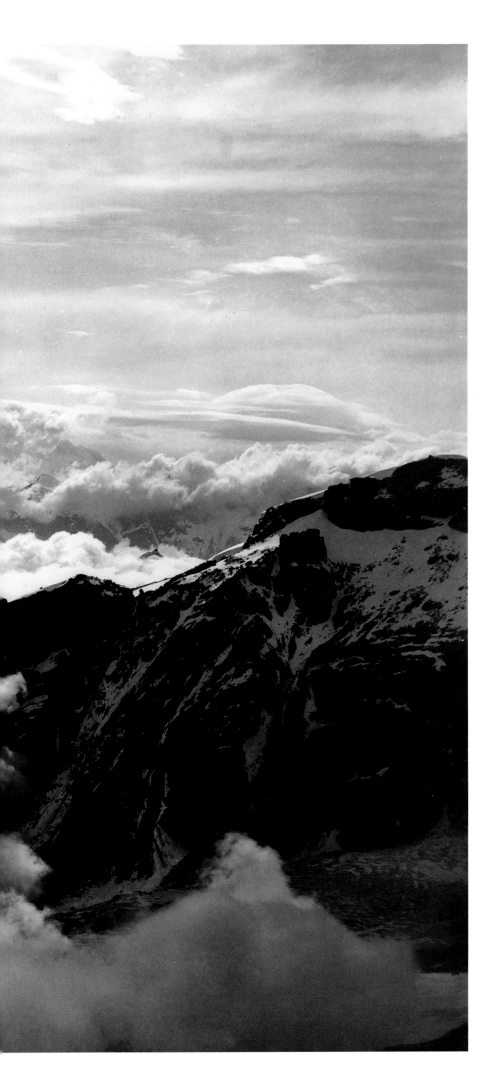

STORM OVER THE ALPS AS SEEN FROM THE
QUINTINO SELLA HUT, MONTE ROSA GROUP, JULY 15, 1888

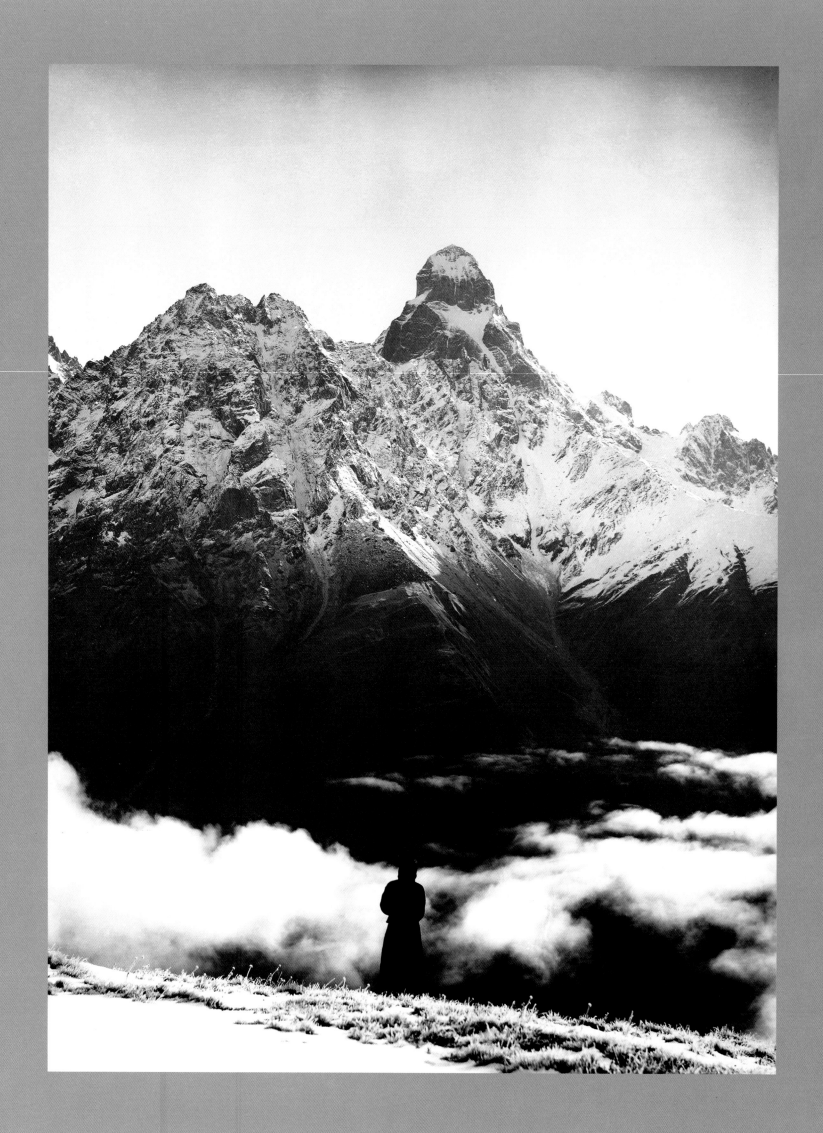

CHAPTER 2

THE CAUCASUS OF RUSSIA, 1889, 1890, 1896

The wish . . . to reproduce faithfully the atmosphere of the panorama even more

accurately than it can be seen by the eye or retained by the mind, delights the photographer.

It is not only that the hand trembles with cold. . . . One feels that one will not reach such a height again,

and that it is still less certain that the mountains will ever again be so ready for the camera.

I do not know if in such moments the climber or the photographer is more satisfied.

(Sella's thoughts on top of Elbrus, from Ronald Clark, The Splendid Hills, *1948)*

In 1993, a team of Italian climbers made a pair of remarkable discoveries during a visit to the Caucasus. They found on display in the homes of the indigenous mountain people there photographs that Vittorio Sella had given to locals in 1890 and 1896. They also found that Sella's name was still mentioned during banquet toasts. His visits had become a part of the local people's oral history, and the memory of him was remarkably vivid—as though he had visited yesterday.

Sella ran three expeditions to the Caucasus of Russia: in 1889, 1890, and 1896. Although, when compared to some of Sella's later destinations, the Caucasus is relatively close to Italy, it was still a fairly exotic destination at the time, and the mountains were relatively unknown. In 1868, Douglas Freshfield, Sella's future traveling companion, had made the first major exploratory trip and claimed numerous summits. When Sella visited twenty years later, however, many peaks remained inviolate—always a major attraction for an ambitious mountaineer. In addition, Sella was eager to create the first reliable visual record of the landscape, to be used for cartographic purposes.

Sella set out for the Caucasus in the fall of 1889 along with his brother Erminio, the guides Daniele Maquignaz and Giovanni Gilardi, and the porters Secondino Bianchetti and Giuseppe Gamba. The trip was an enormous success: the

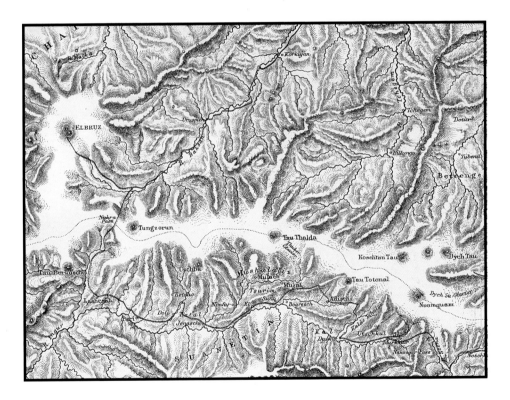

group of climbers claimed the summits of Ullu-aus-Bashi (15,390 feet), Kogutai-Bashi (12,540 feet), and Leila-Gora (13,400 feet). They also made the fifth ascent of the highest peak in Europe, Mount Elbrus (18,480 feet).

The team reached the top of Elbrus before dawn, but Sella still could not get all the views he had desired. Because

37 USHBA AT SUNRISE, SEPTEMBER 29, 1890

glass-plate negatives weighed so much, he had brought only 120 with him, a shockingly small quantity for a first visit to a major range. Upon his return to Biella, however, he improved upon his work by inserting climbers into his photograph of Elbrus's summit—the first of several times he would alter an image in the darkroom in order to add a human dimension to the work and dramatize the scale of the mountains. For example, in a two-frame panorama of the Baltoro Glacier (see pages 120–121), he drew human figures into the picture

dwellers—people who created enduring societies in harsh environments—and all such groups, regardless of ethnic background, will be exceptionally hearty, resourceful, and worthy of documentation.

Because Sella was equipped with so few glass plates, he particularly liked photographing villagers during their feasts (see page 130). Not only did these occasions allow Sella to include many people within a single frame, but they featured some of the more unique aspects of village life. Sella wrote in his diary: *August 7: In the vil-*

with a grease pencil. The wealth of outstanding images he managed to produce on this first trip to the Caucasus is all the more extraordinary given that he had so few chances to get the pictures right.

During Sella's 1889 expedition to the Caucasus, he devoted significant effort to visiting the numerous villages scattered along the flanks of the mountains and documenting the local people. In the Caucasus, Sella encountered people both vastly different from, and remarkably similar to, the inhabitants of his familiar Alpine villages. Caucasian culture was a coalescence of the various multitudes who had overrun this junction of Europe and Asia. Their languages, styles of dress, architectures, and religious customs and traditions were laden with European, Slavic, Arabic, and Byzantine elements. From Sella's point of view, this contrasted with the comparative uniformity of Italian and Swiss villagers. Like them, however, the Caucasian villagers were mountain

lage they observe a feast day. They are holding a ceremony to mourn the death of a fellow native. Everyone is grieving in the lower part of the village, where at the appointed hour, an elaborate repast will be offered to the multitude by friends and relatives of the deceased. The victuals are comprised of barley bread and vodka, also made with barley. I am going to make a record of the event with my camera. The village priest, they tell me, will officiate the funeral. In the interior of a house there is a courtyard where the village inhabitants are assembled, seated in a long row, and men distribute the following: first the bread, then a drink, which is hot and dirty, and finally, the freshly prepared vodka, again served warm. The people only begin to eat when the vodka comes, the arrival of which incites immense excitement.

Despite Sella's commitment to recording daily life in the Caucasus, his diaries sometimes betray an ambivalence toward these people whose customs differed so vastly from his own. He wrote: *August 22: The weather is constantly cloudy.*

We remain in Zinaga. The natives are peculiar and noisy. In the afternoon, they dance close to our shelter. Fat women, rather beautiful, but dirty. The dance is more or less like that of the Bezinghi natives, even though these people are Christians (if in name only, for they have neither a priest, nor a church; even in the cemetery, I failed to see even one single cross).

The success of the 1889 trip took him back to the Caucasus in 1890. The porters Bianchetti and Gamba came along, as did the guide Fabiano Croux. The group spent nearly four months on both the north and south sides of the range, making four more first ascents, and a second ascent of Burdjula, at 14,300 feet. On this latter peak, Sella had great hopes: *I connected such importance to the photographic views [which might be taken] from the peak of the Burdjula that I felt the healthy power of the sun coursing in the blood in my veins, tensing my muscles, giving me strength as if I . . . should take on my shoulders the weight of this great new world I could see beyond the crest, shimmering through an ocean of rosy light.*

The weather, however, turned bad, a mist moved in, and Sella came away with nothing to show for his work. He wrote, "We remained for a long while on the summit, despondent and in bad humor, with all obscured by the thick fog hugging the still snow." His patience, however, paid off, with his 1890 photograph of Ushba at sunrise (see page 36), an image that strongly demonstrates Sella's aesthetic approach to the mountains. The calmness that pervades the entire scene and Sella's articulation of scale simply and elegantly convey his understanding of the relationship between mountains and the humans who aspire to reach their highest peaks.

The majesty of Sella's work in the Caucasus on the 1890 trip is articulated by Douglas Freshfield: *Almost all [Sella's pictures] are fine examples of the photographic art, as well as of high topographic interest. . . . Those who have never seen a great mountain view may look on this presentment and form some accurate idea of the reality; those who have said there is nothing to be seen or learnt on the great peaks may look on it—and repent* ("Caucasian Photographs," Royal Geographic Society, *1890*).

Sella traveled to the Caucasus for a third time in 1896. He, his assistant, and his friend Emilio Gallo made three more

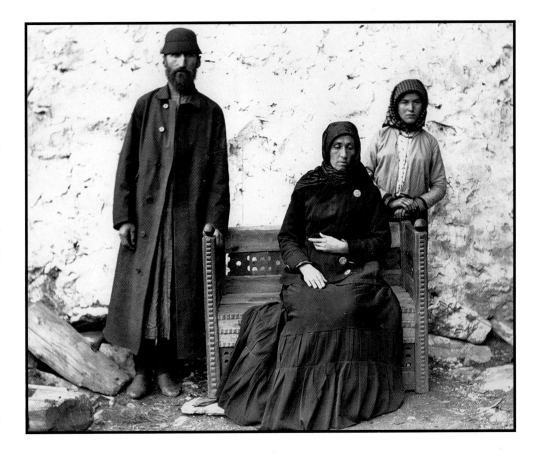

first ascents, and Sella himself created his most affecting portraits of villagers. By then, he must have been a familiar face in the high mountain villages of Mestia and Mulach, Stir-Digor and Sgid, Karaulta and Kussi, and his work shows an intimacy and familiarity with his subject that few photographers attain. In fact he had made more of an impression than he could have foreseen, evidenced by the display of his pictures in private homes more than a century later.

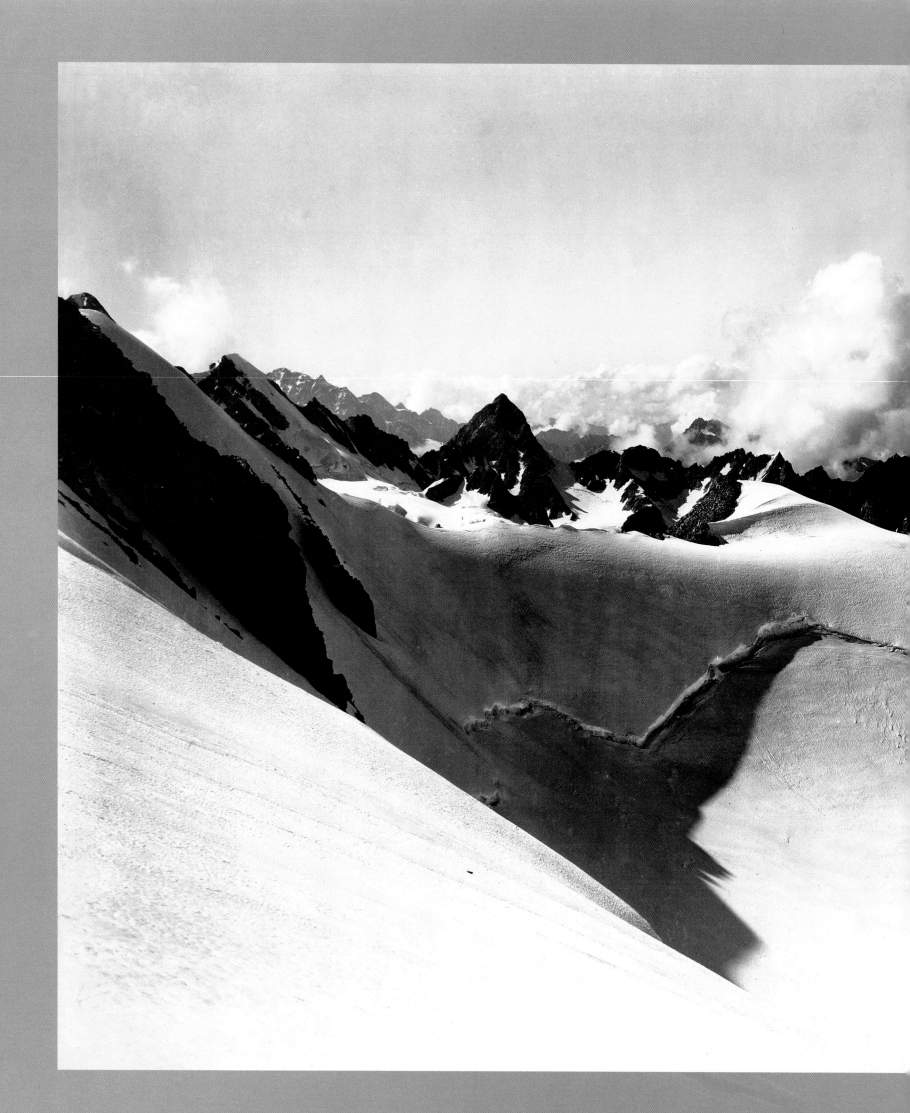

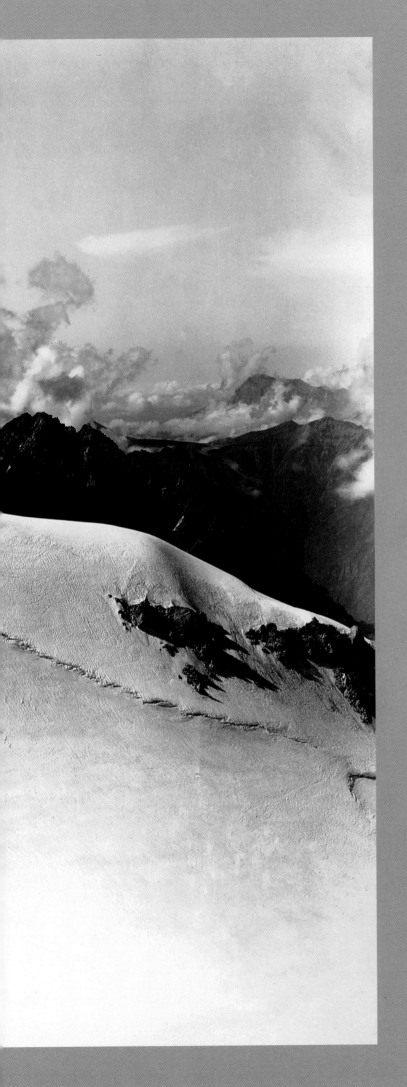

NORTH CREST OF THE SUGAN, 1896

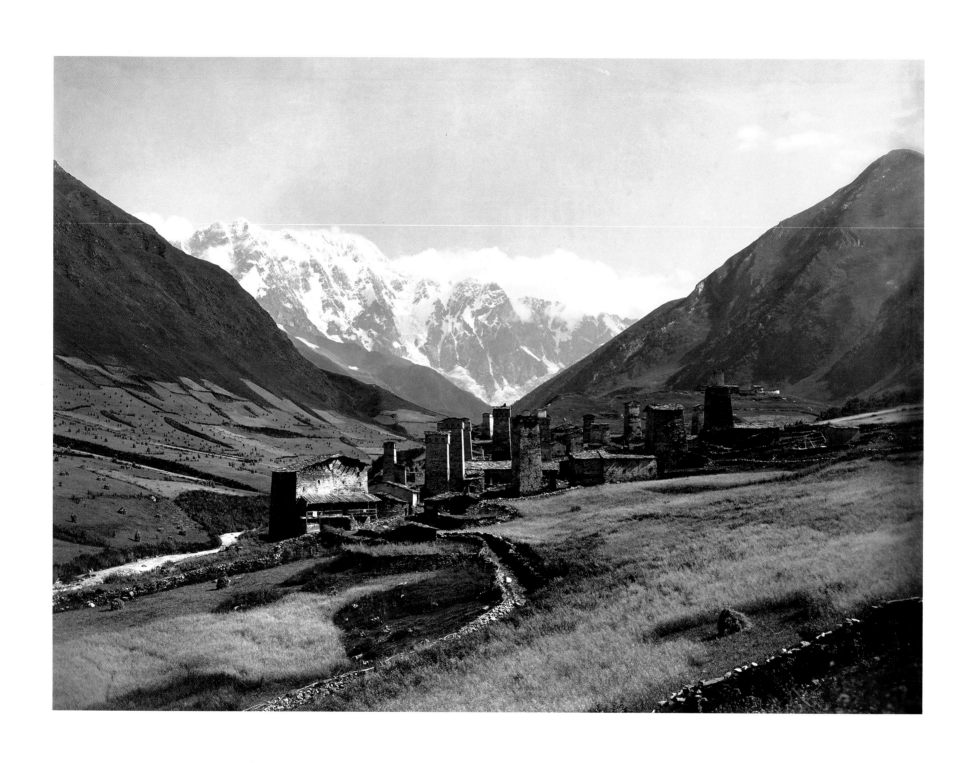

MOUNT SHKARA AND THE VILLAGE OF GIBIANI, 1890

42 (OPPOSITE) DADISH-KILIAN CASTLE AT KILIAN, MAZERI, 1890

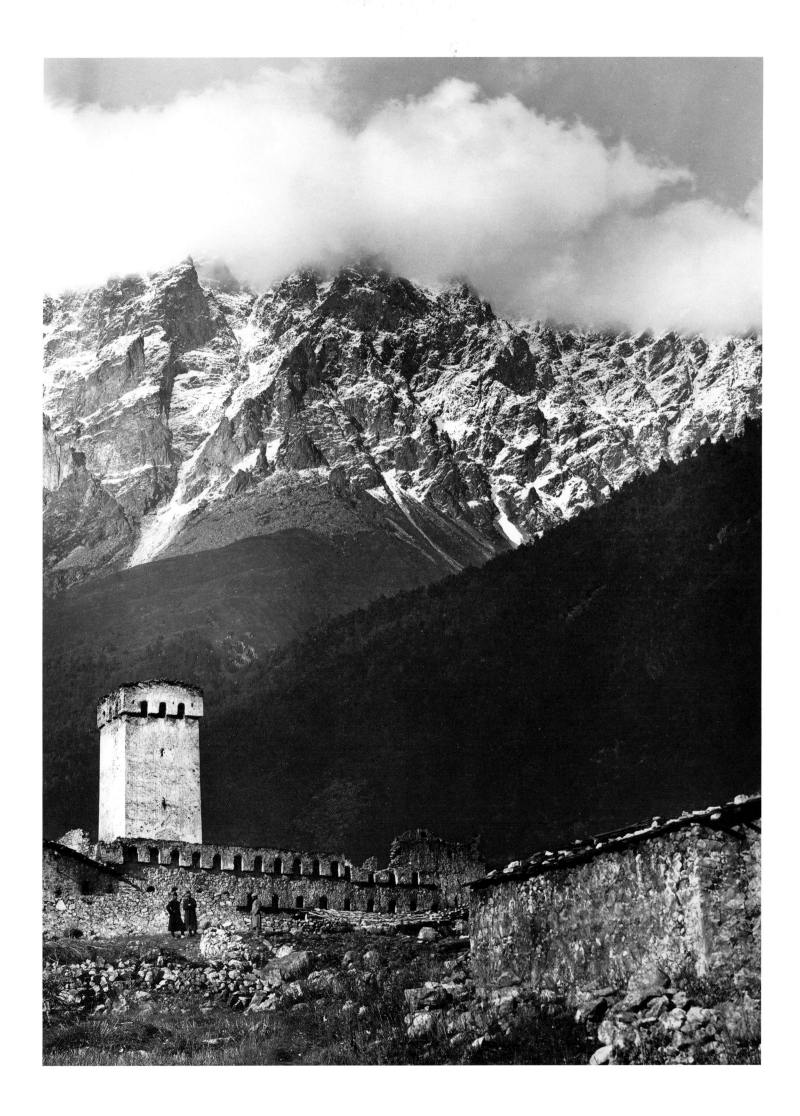

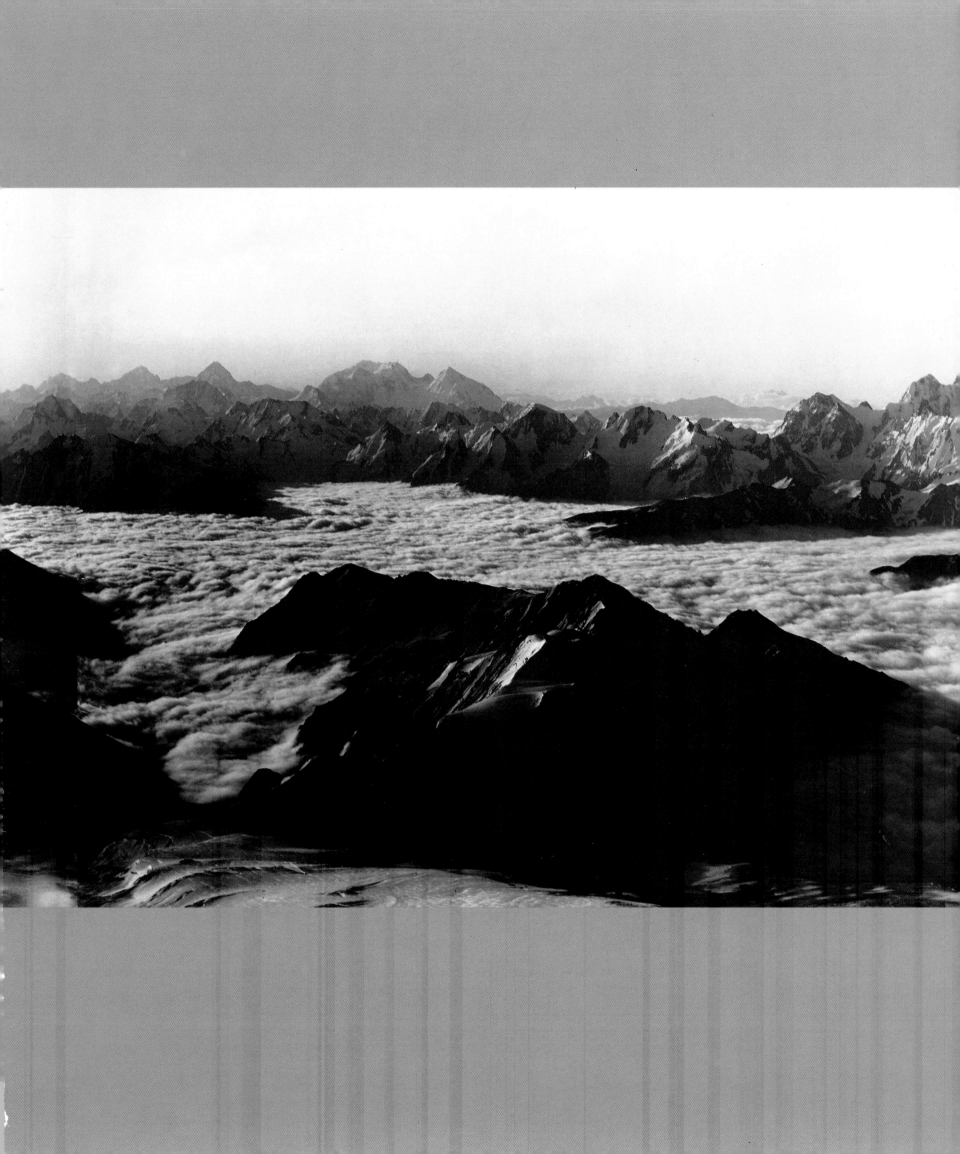

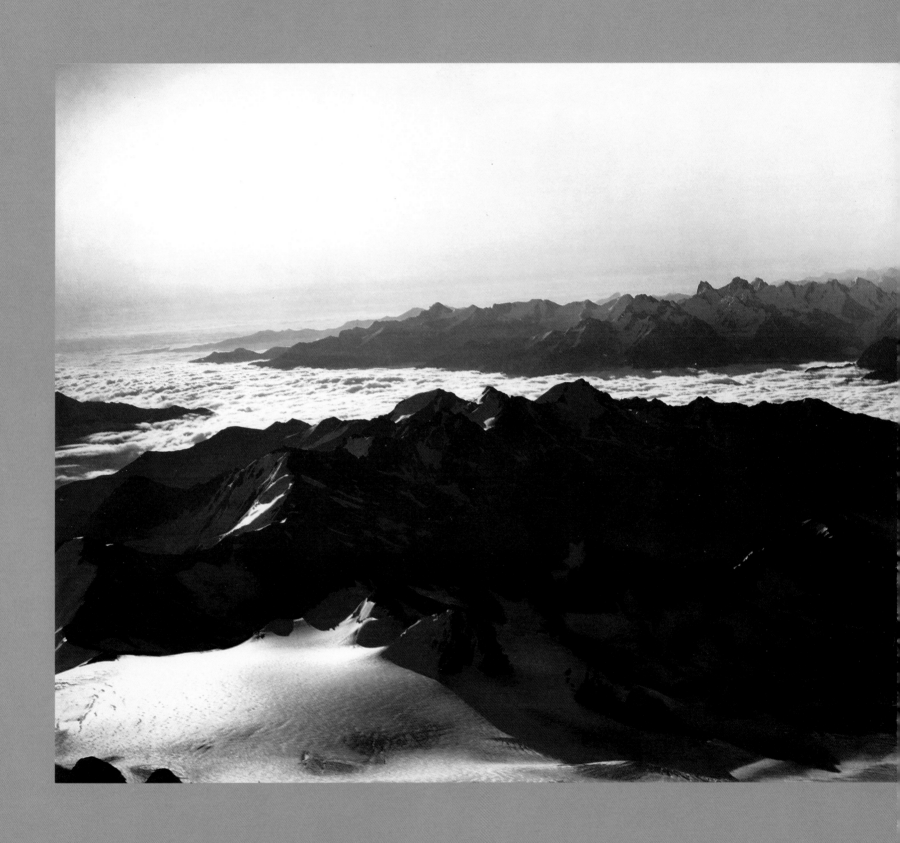

45 *PANORAMA FROM THE EASTERN SUMMIT OF ELBRUS, AUGUST 19, 1889*

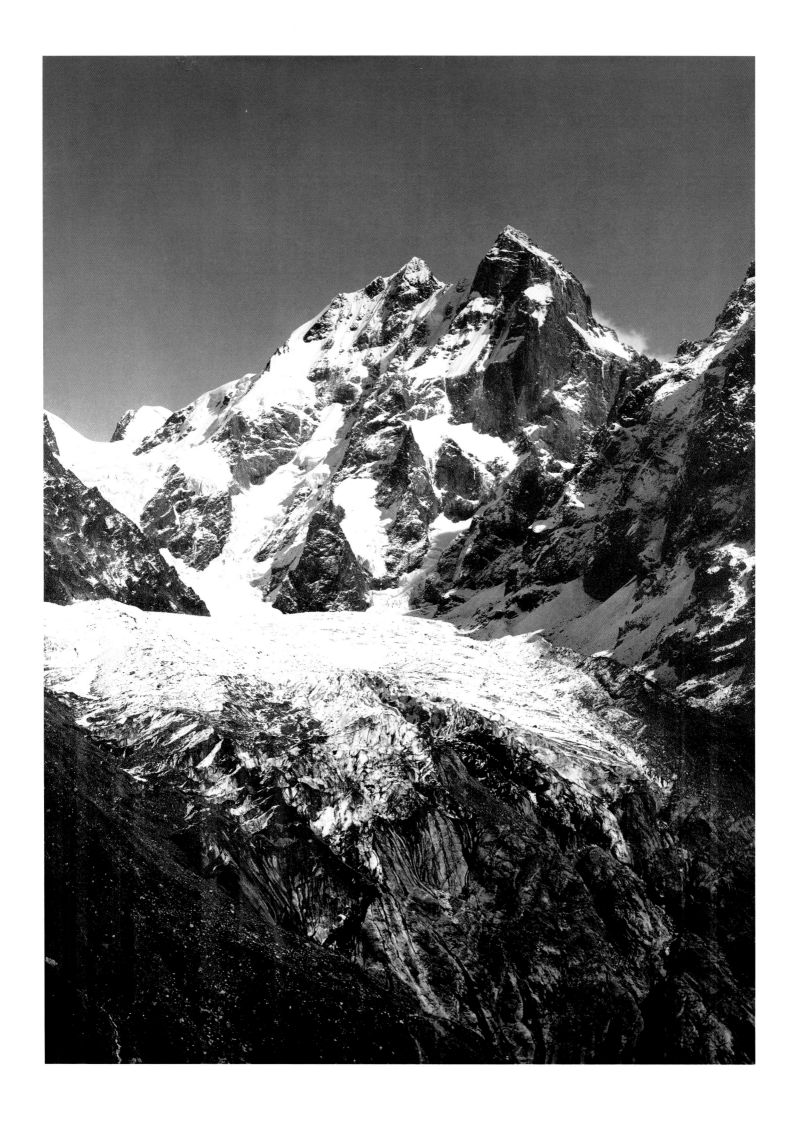

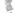

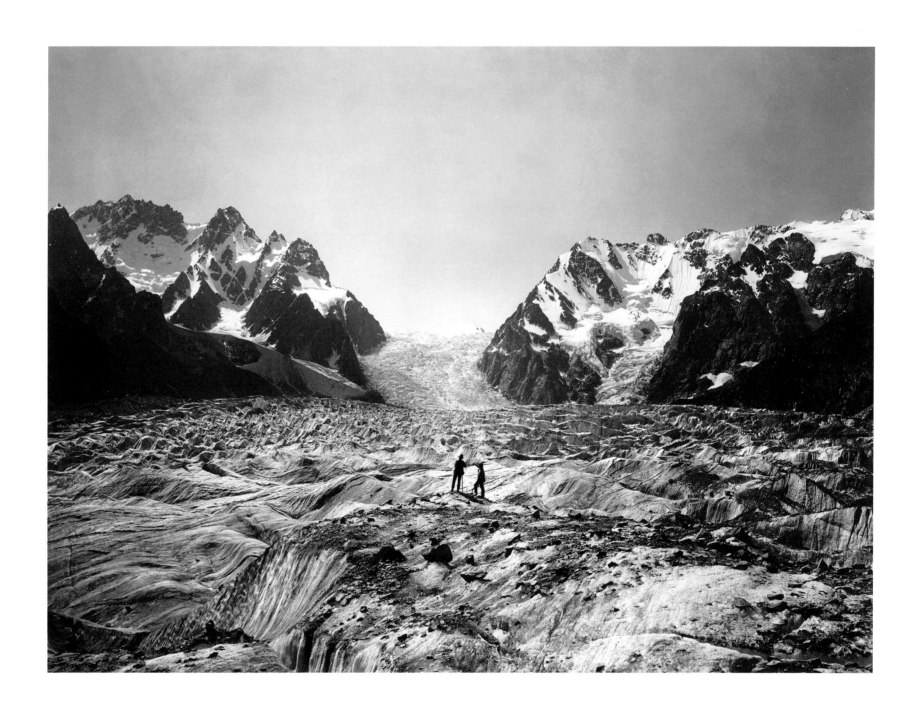

(OPPOSITE) USHBA FROM THE WEST, SEPTEMBER 1890

49 TWO MEN ON THE KARAGOM GLACIER, 1890

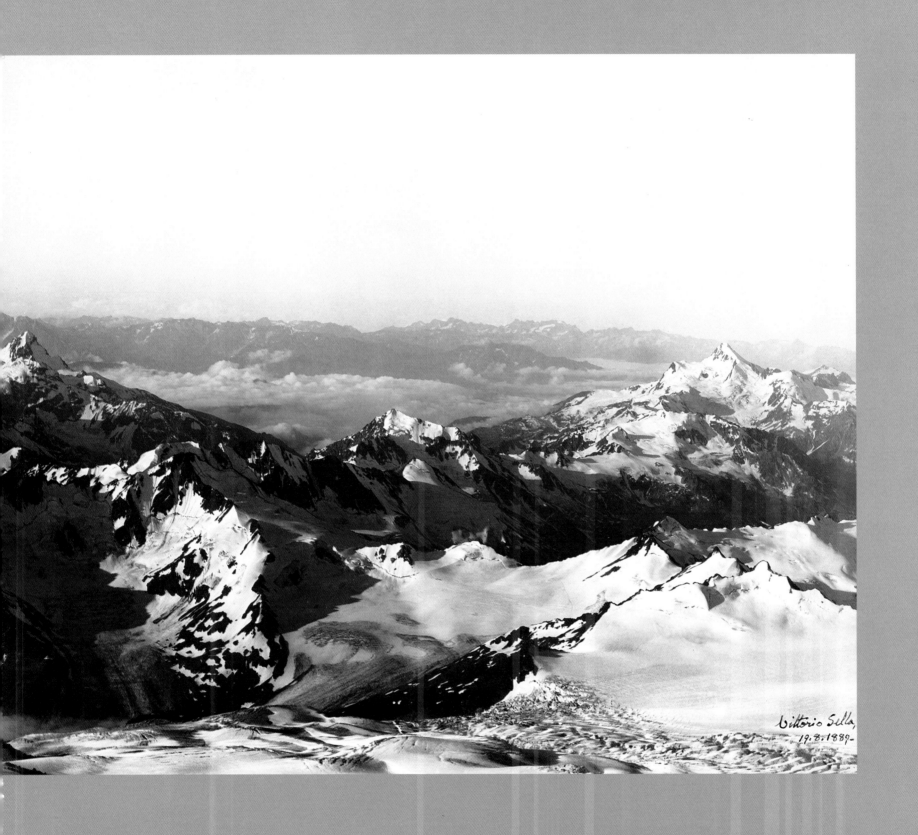

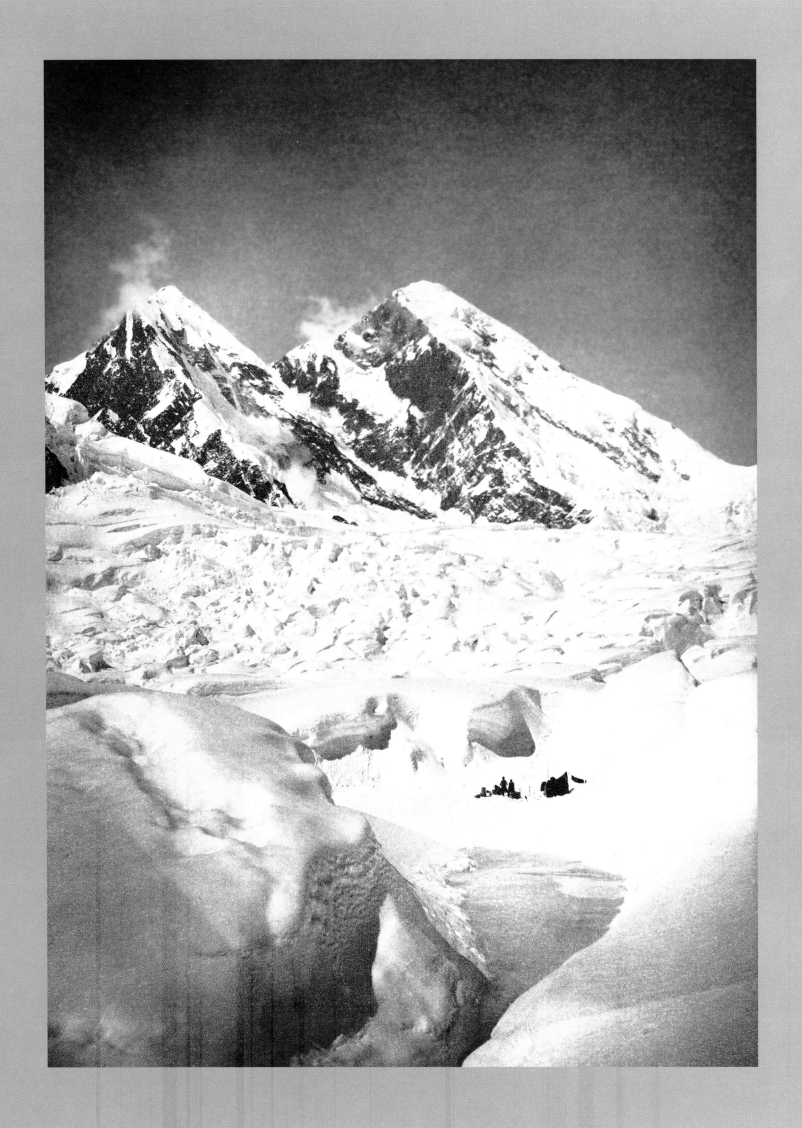

MOUNT SAINT ELIAS, ALASKA, 1897

The first great mountaineering expedition to Alaska, and one of the most brilliant in its history, was executed

by the [nephew] of the King of Italy, Prince Luigi Amedeo di Savoia, Duke of the Abruzzi. . . . With four crack

Alpine guides, ten porters, and five fellow climbers, including the world-famous mountain photographer Vittorio

Sella, Abruzzi traveled in grand style. For the comfort of the gentlemen climbers, five iron bedsteads were carried

to an altitude of 10,000 feet—and on the night before the climb, the duke slept cozily in his royal bed

at 12,000-foot Russell Col even though the party was to arise at midnight for its attack on the summit.

(David Roberts and Bradford Washburn, Mount McKinley: The Conquest of Denali, *1991*)

Although it may not be a common trip, the journey from Genoa, Italy, to Yakutat, Alaska, is a simple one, thanks to modern travel technologies. A couple of flights, perhaps a ferry ride up the Inside Passage for variety, and soon the small coastal town pulls into view. A century ago, however, it was a considerably longer trip, one that Luigi Amedeo di Savoia, the Duke of Abruzzi, embarked upon with the intention of climbing Mount Saint Elias. At the time, this expedition set an entirely new standard for audacity and effort.

One element of Yakutat, however, has not changed since the Duke's group steamed into port a century ago. Above the town still towers the largest coastal mountain on earth, the crystalline pyramid of Mount Saint Elias. Named somewhat inauspiciously for the patron saint of drought and earthquakes, this remarkable peak rises from the ocean to a summit of slightly more than eighteen thousand feet, in fewer than a dozen miles. The visual transition from ocean to a Himalayan-scale massif remains as impressive as it was a century ago.

From Yakutat, the contemporary Saint Elias climber would likely head to the airport for the flight to the base of

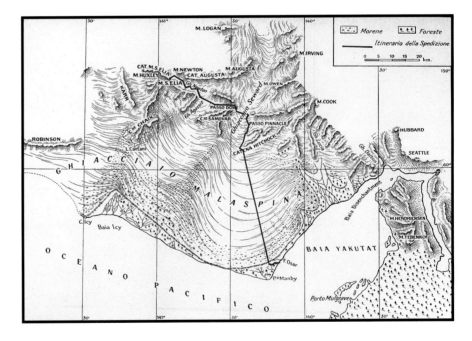

the mountain. The Duke's team, however, enjoyed no such option. They debarked on the shores of Icy Bay and began packing the requisite supplies for their trek. Never one to go without his customary comforts, the Duke had outfitted the

trip royally. Their sleds carried the essentials of an earlier time, along with a duke's preferences: iron bedsteads, canvas tents, woolen clothes, and steel barrels for food storage. Setting out with these four sleds, which weighed more than 750 pounds each, the group traversed the tortuous Malaspina Glacier, making their way through a completely unfamiliar terrain and climate. As the climbers pushed through neck-deep snowdrifts, on undulating ground, they learned that

MOUNT SAINT ELIAS AND CAMP ON THE
SECOND ICEFALL OF THE NEWTON GLACIER, ALASKA, 1897

southeast Alaska, draped with complex glaciers and tremendous snowfalls, is like few other places on earth. They found equally perilous circumstances on the peak, as the danger of avalanches was high.

Environmental obstacles aside, the unwieldy climbing gear at the turn of the century heightened the difficulty of the expedition. Their clothing of wool, silk, and leather was permeated by the omnipresent moisture—and a wet climber is an unhappy climber. For Sella, the camera technology of 1897 presented an additional barrier. He carried both his ten- and twenty-five-pound cameras all the way to the foot of the Malaspina, with the glass plates for both. Ironically, after all that work, he took only one picture with the heavier device, then decided to leave it behind to simplify his job as much as possible.

Alaska gave Sella an excellent opportunity to exercise the patience for which he was known. Constant storms meant long waits for the right light. The Duke, on the other hand, was not known for excess reserves of patience, and his constant urging further hampered Sella's attempts to photograph the landscape. Sella possessed an admirable ability, however, to focus on a challenge. Neither an impatient Duke nor uncooperative weather would derail his efforts to capture the extraordinary ice- and snowscape that is southeast Alaska.

He almost succeeded. The Saint Elias region has some of the wettest conditions anywhere. Sella had never en-

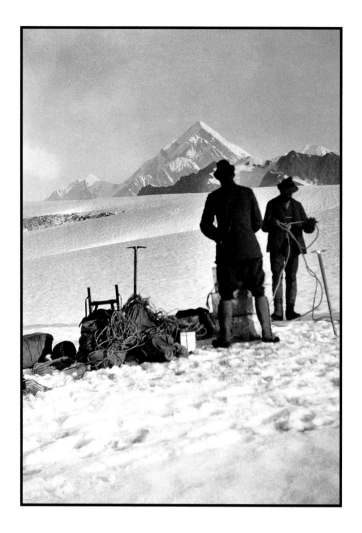

countered anything like it. Consequently, he made the only major blunder of his career on this trip. After exposing the glass plates, he stored them in a tent, in protective dividers. Unknown to him, condensation from his breath had settled on the plates and disturbed the emulsions, damaging many and altogether ruining some. He didn't discover his error—a realization that must have been one of the worst moments of his career—until he was back in Italy. Sella never forgave himself completely for this oversight, however impossible it might have been to anticipate.

Crossing the Malaspina Glacier and then entering the upper plateau of the Newton Glacier, the group followed the most obvious line up to the peak, eventually reaching Russell Col, the low point on a ridge between Saint Elias and Newton Peak. The summit, which they hoped to reach in a day, was about six thousand feet above them.

The group set off for the top in the midnight glow of July 31, 1897. Their schedule was ambitious, but their only option was to reach the summit and return in a single day, since it would have been virtually impossible to return to the beach in order to restock. They had grown tired of hauling iron bedsteads, but, once they had dropped their heavy loads, they felt liberated—ready to set off strong and light. Filippo de Filippi, the diarist of the expedition, provides the following account of this most fulfilling day: *Almost all of us are suffering more or less from the rarefaction of the air, some being at-*

THE DUKE OF ABRUZZI AND THE GUIDE GIUSEPPE PETIGAX
PREPARING FOR A RECONNAISSANCE OF THE MALASPINA GLACIER
WITH MOUNT SAINT ELIAS IN THE BACKGROUND, 1897

tacked by headache, others by serious difficulty of breathing and general exhaustion. . . . HRH, Sella, and two of the guides are the only persons showing no sign of distress. Our legs seem heavy as lead. Every step requires a distinct effort of the will, and we get on by dint of certain devices familiar to all who have made ascents when tired out—leaning both hands on the knees, or planting the axe in the snow ahead and dragging the body up by it, while at every step we pause for breath. Still we manage to climb somehow; we are spurred on by excitement, and our nerves are strung to the highest pitch.

Suddenly we saw the leading guides, [Giuseppe] Petigax and [Angelo] Maquignaz, move aside to make way for the Prince. They were within a few paces of the top. HRH stepped forward, and was the first to plant his foot on the summit. We hastened breathlessly to join in his triumphant hurrah!

It was the 31st of July, a quarter to twelve. A few minutes later, HRH hoisted our little tricolor flag on an ice-axe, and we nine gathered around him to join in his hearty shout for Italy and the king. Then we all pressed the hand of the Prince, who had so skillfully led the expedition, and had maintained our courage and strength to the last by the force of his inspiring example (Filippo de Filippi, The Ascent of Mount Saint Elias, 1900).

This style of mountaineering has gone the way of most monarchies. Today we have more highly detailed maps, high-tech gear, and satellite location systems; yet for all our technical accoutrements, we often seem to lack the audacity and daring that inspired these early practitioners. As we relentlessly uncover the last secrets of the most obscure mountain ranges on earth, we must acknowledge our debt to these explorers who laid crucial groundwork for future generations.

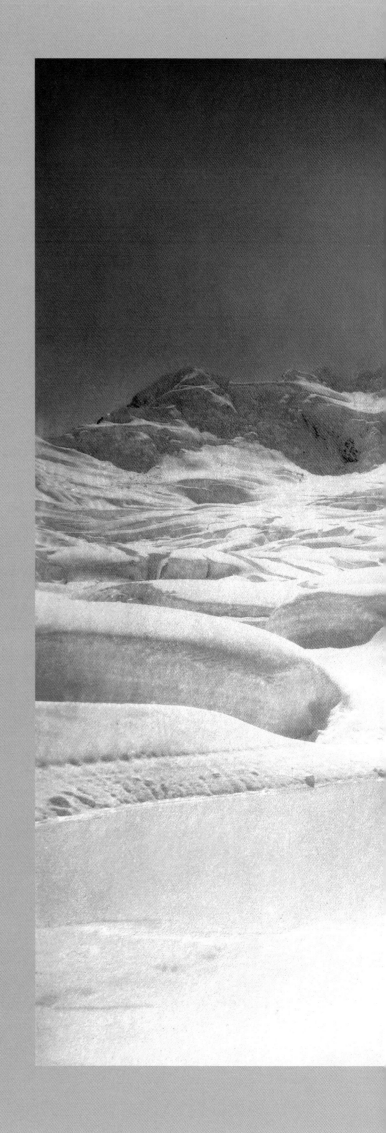

LAKE AMONG THE SERACS OF THE NEWTON GLACIER, 1897

(NEXT, LEFT) MOUNT SAINT ELIAS AS SEEN
FROM THE SECOND ICEFALL OF THE NEWTON GLACIER, 1897

(NEXT, RIGHT) CLIMBING TO THE RUSSELL COL
54 ON MOUNT SAINT ELIAS, JULY 30, 1897

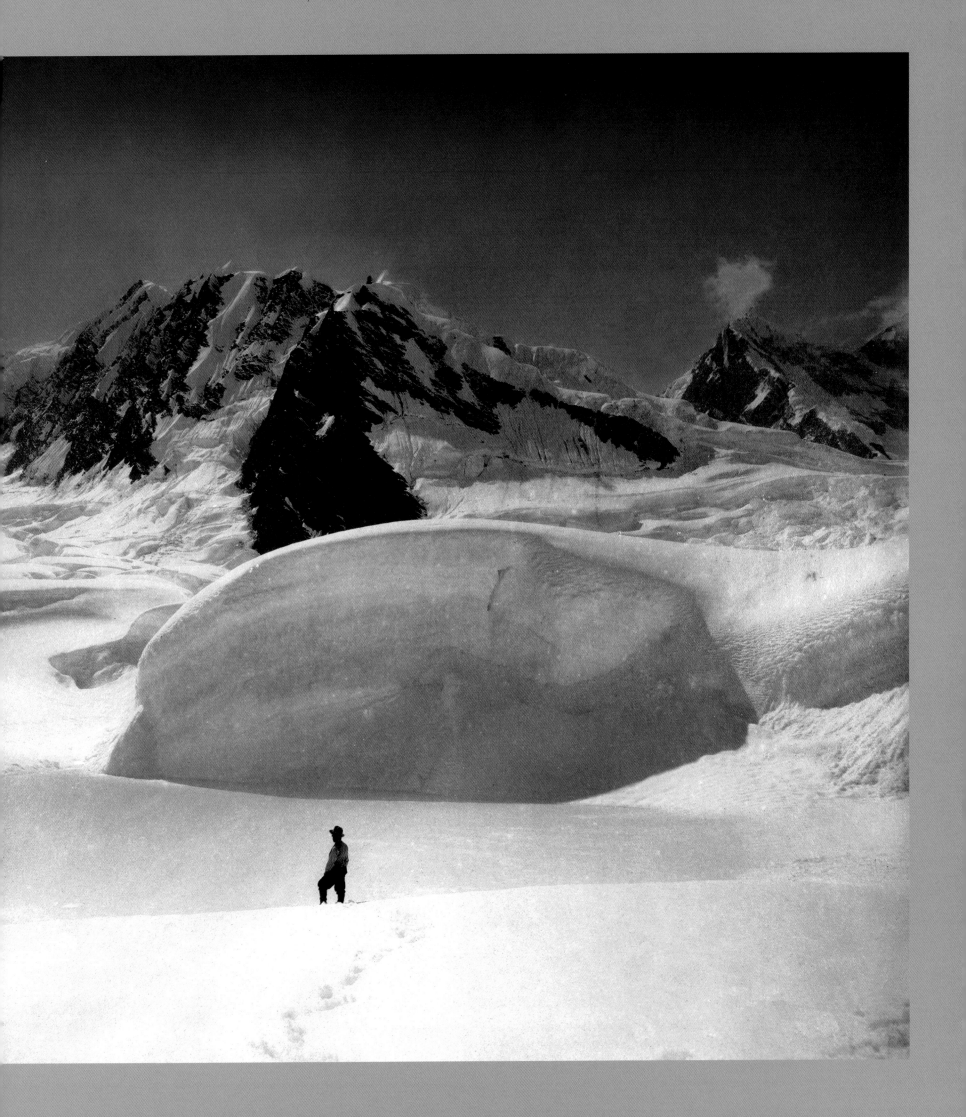

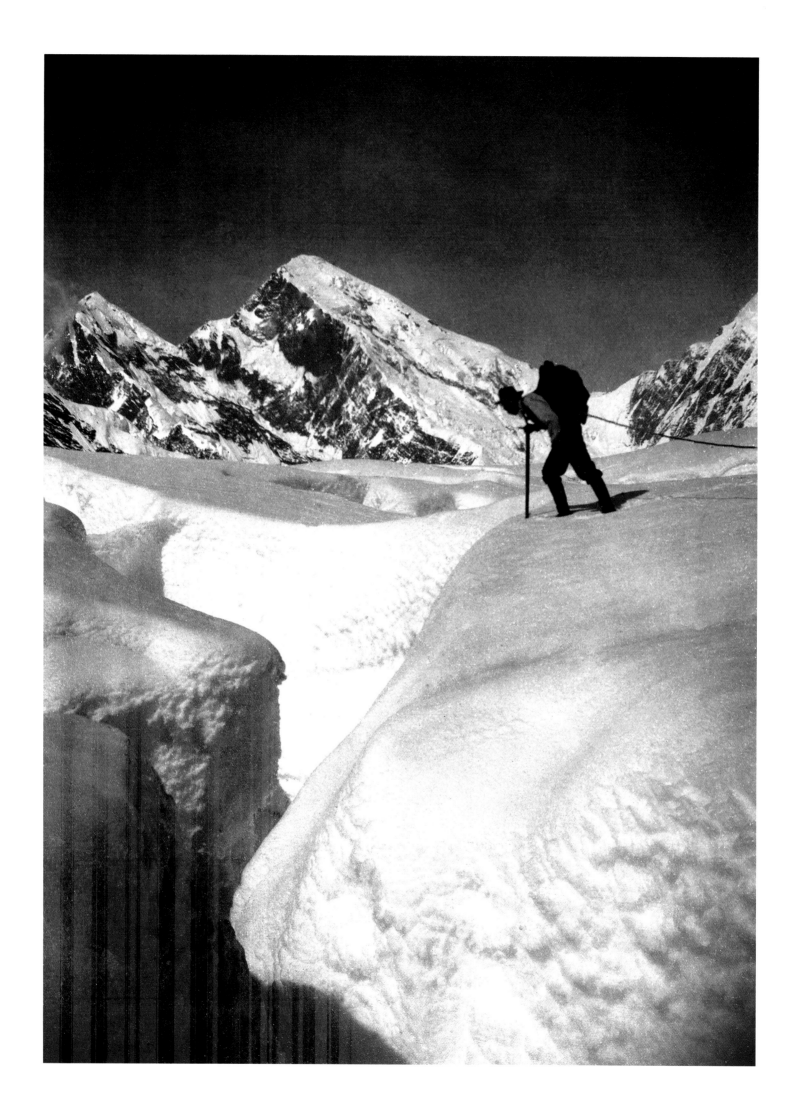

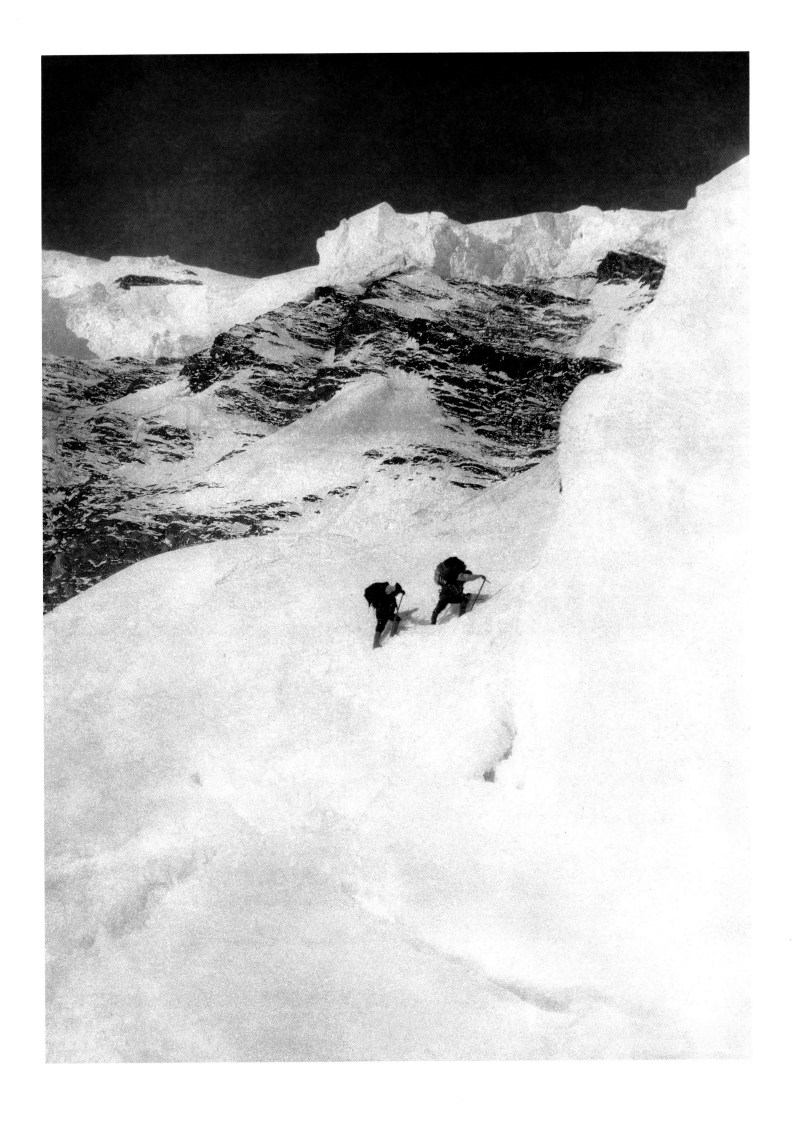

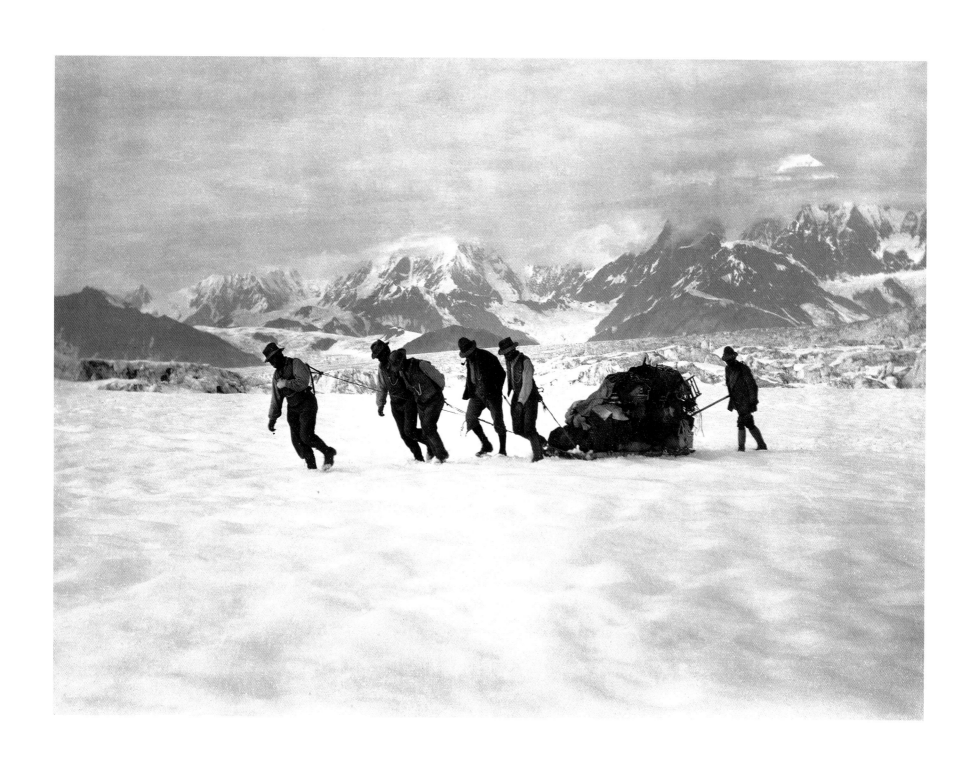

TRAVERSING THE HITCHCOCK GLACIER
ON THE RETURN FROM MOUNT SAINT ELIAS, 1897

58 *(OPPOSITE) SERACS ON THE NEWTON GLACIER, 1897*

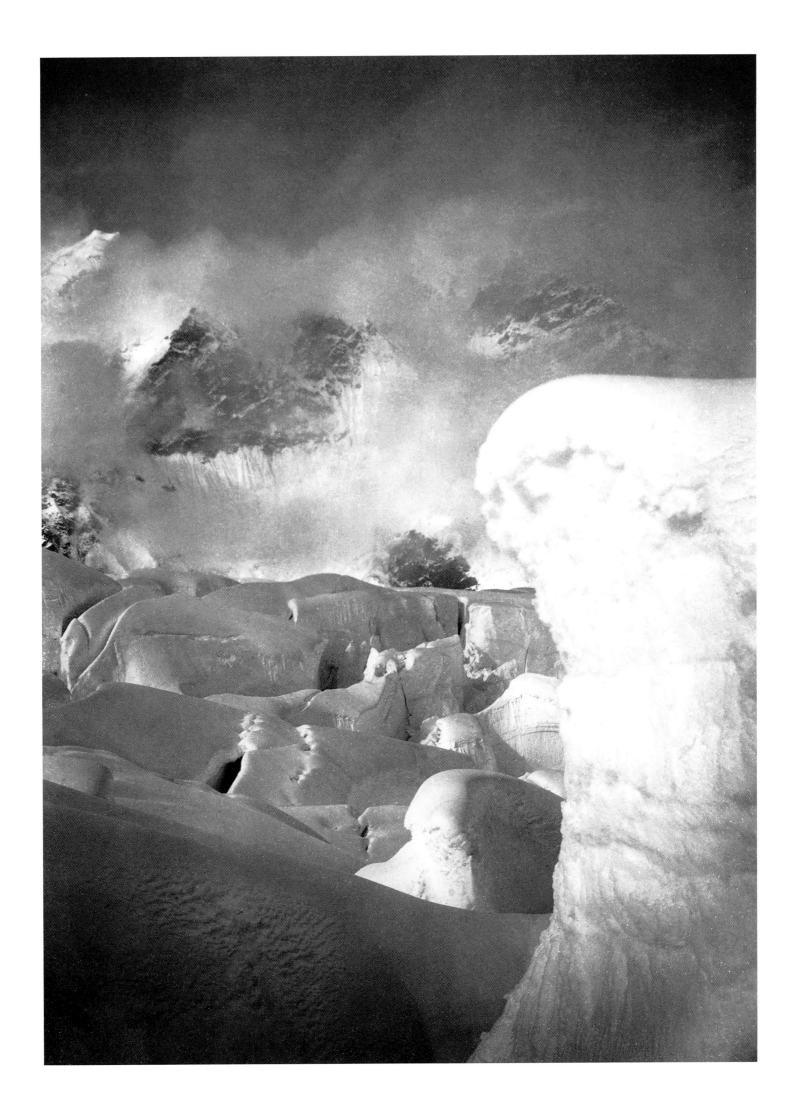

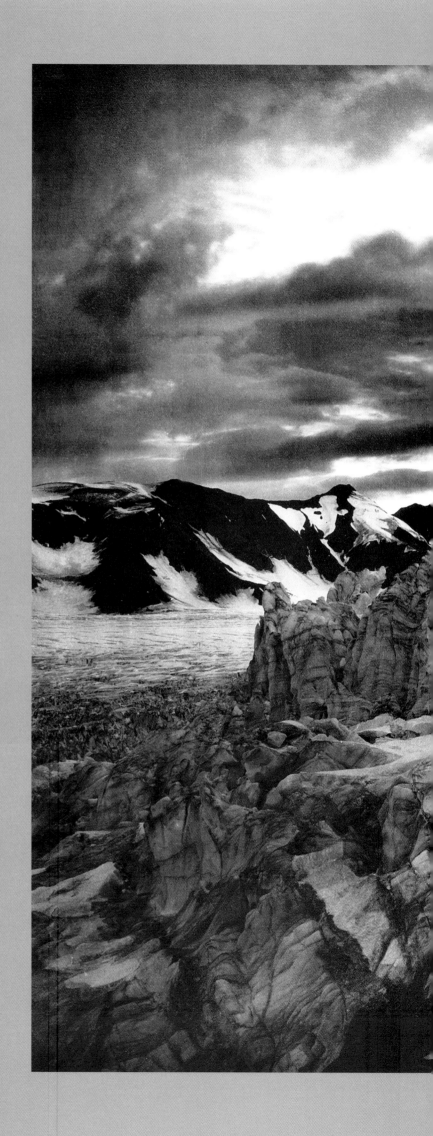

MOUNT SAINT ELIAS AT SUNSET
60 *FROM THE SEWARD GLACIER, 1897*

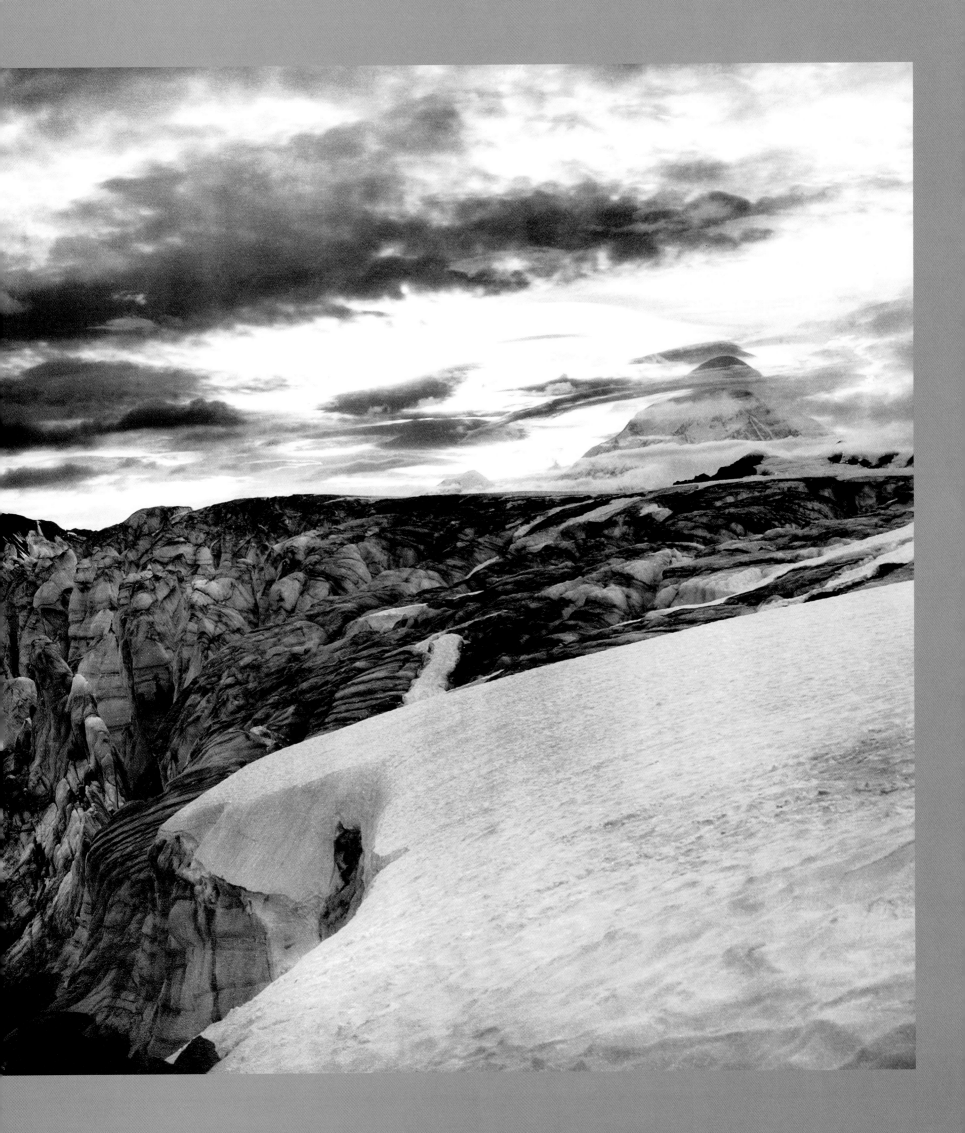

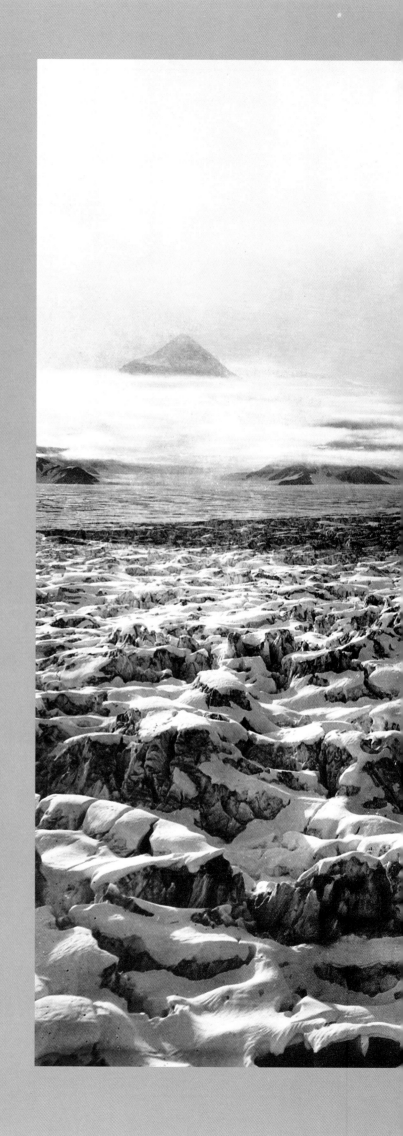

MOUNT SAINT ELIAS, MALASPINA GLACIER,
AND MOUNT AUGUSTA AS SEEN FROM THE
62 LEFT SIDE OF THE SEWARD GLACIER, 1897

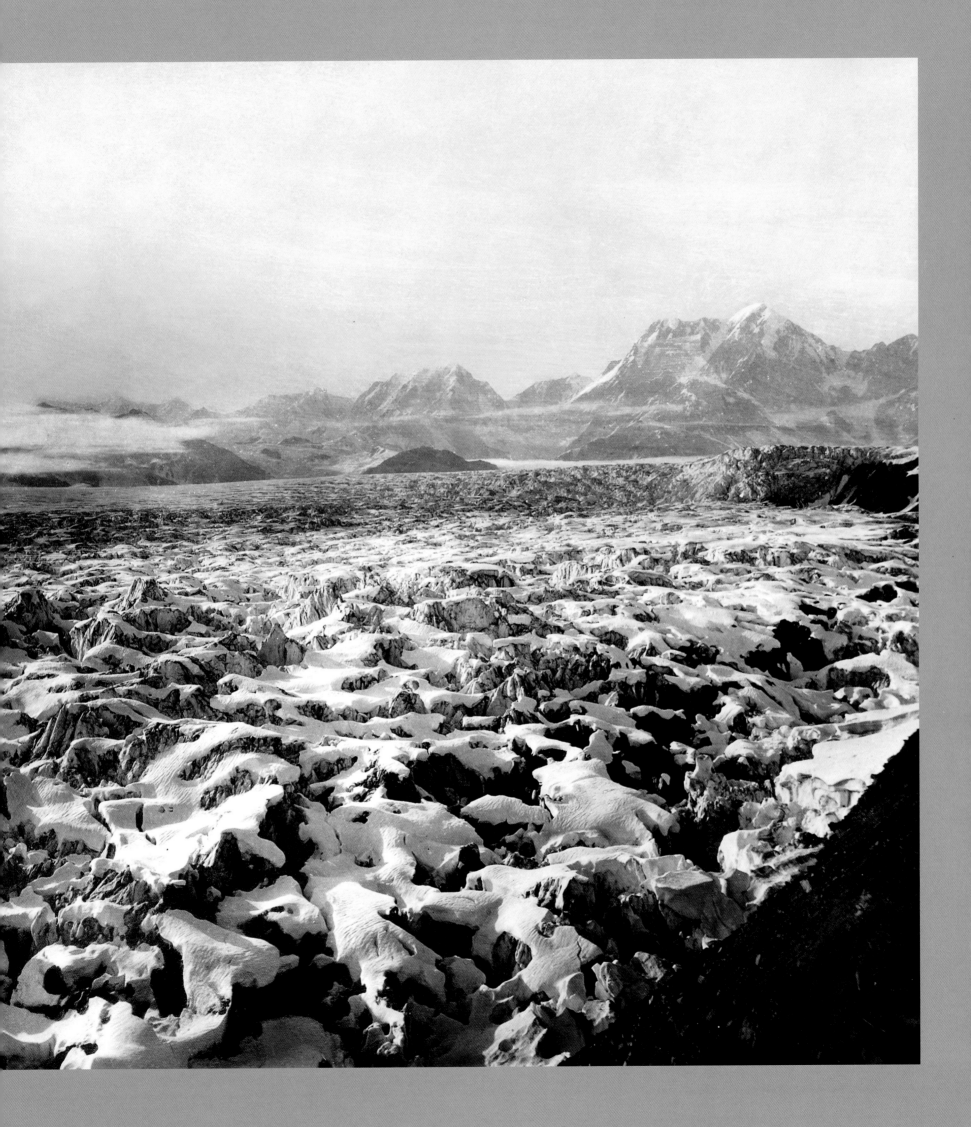

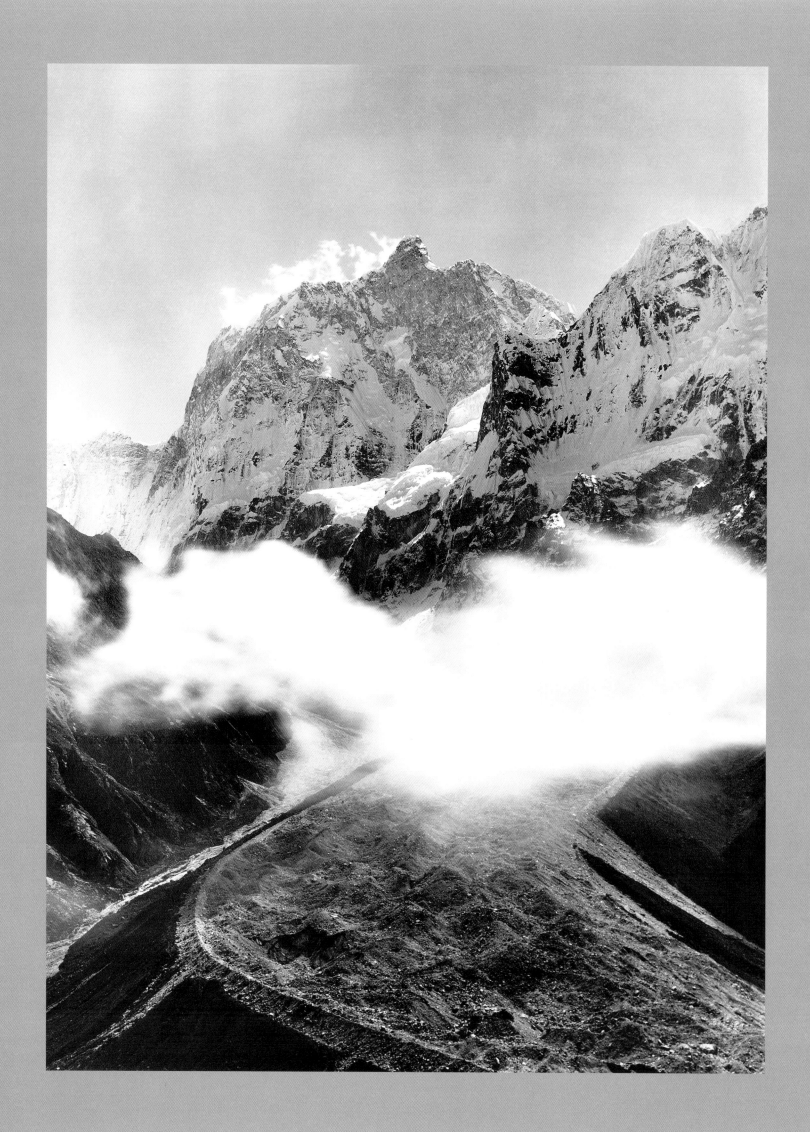

Life is short, and the Tour of Kangchenjunga is long.

(*Douglas Freshfield*, Alpine Journal, *August 1900*)

A distant view of a snowy range . . . has a strange power of

moving all poets and persons of imagination.

(*Douglas Freshfield*, Round Kangchenjunga, *1903*)

The border between Nepal and Sikkim runs along the spine of Kangchenjunga, the third highest peak on earth. The peak's name is Tibetan for "the five treasure houses of the snow," so named for its five distinct summits. One hundred miles to the west is the Mount Everest group, containing the first, fourth, and fifth highest mountains in the world. Clustered around Kangchenjunga is a host of smaller but still impressive peaks: Kabru, Ratong, Siniolchun, Jannu, and dozens of others.

For Douglas Freshfield, the British explorer and writer, this area held a nearly irresistible appeal, and he had contemplated a trip to the region for many years. In 1899, he acted upon this desire and organized the "Tour of Kangchenjunga." For proper visual documentation, he invited Vittorio Sella as expedition photographer. Freshfield wrote:

Dear Signor Sella,

Do not trouble yourself overmuch by my suggestion. I am an uncertain person balancing possibilities—if I can see my way to leave England for 6 months I should be more disposed to do so. Could I hope to get you to bring your equipment and experience, I am very lazy and inefficient in making elaborate preparations. Still it is just worth our while to turn it over in our minds as an idea. . . . I should like to see those great peaks and to go round

Kangchenjunga. I have thought so for 20 years & how it is getting, perhaps it has got, too late!

Yours truly, DWF (Douglas Freshfield, March 1899)

By then Vittorio had been photographing for twenty years, and had earned a reputation as one of the leading mountain photographers in the world. Freshfield knew, rightly, that Sella would do justice to the spectacular terrain of Sikkim and Nepal, which had never received a thorough photographic documentation. The pundit Chandra Das had visited and photographed Sikkim in the late 1870s, but he did not ven-

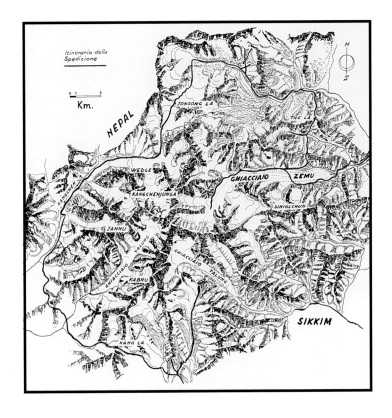

ture to the higher regions. Sella returned with a superb visual record of the trip and its details. Freshfield, for his part, came home and wrote *Round Kangchenjunga*, a true classic in the genre of mountaineering and exploration literature.

Douglas Freshfield was the leader of the expedition team, and Vittorio was the official photographer. Vittorio's brother Erminio came along, as did Erminio Botta and the mountain guide Angelo Maquignaz. The geologist Edmund Garwood accompanied the group to map the region. Freshfield relied entirely on local people for portering assistance. Like the Duke of Abruzzi, Freshfield is under-appreciated for his explorations of unknown ranges, which was his driving passion. He opened up the Caucasus and the Kangchenjunga region for other mountaineers, yet few people know of his travels or his prolific writings. First and foremost an adventurer, Freshfield described the thrill of discovering new lands: *My choice of Sikkim was governed by a very simple and obvious consideration. To be quite frank with the reader, though I am ready to do my humble part in investigating the laws of nature, I love "the glories of the world" best. I have always traveled and climbed for scenery first, for science afterwards, and—let me add—for all that is included under the modern term "record," last (*Round Kangchenjunga, 1903).

The expedition started in Gangtok, the capital of Sikkim, descended into tropical jungles, then headed

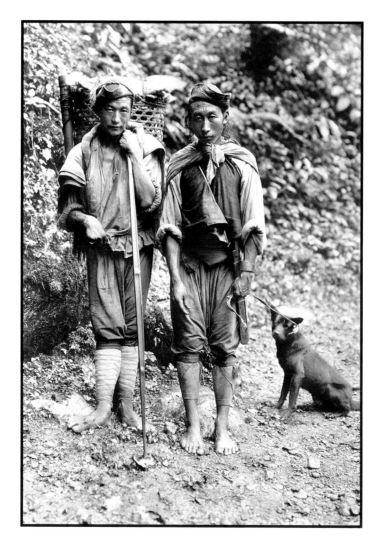

north along the eastern flanks of Kangchenjunga, ascending gradually to the 20,200-foot pass of Jonsong-La. Along the way, the group met with extenuating circumstances that rigorously tested their tolerance—for example, food. In *Round Kangchenjunga*, Freshfield wrote: *Presently we were alarmed by a message that Signor Vittorio Sella was ill, and required assistance. Fortunately, he appeared in person soon afterwards, not much worse for an indisposition which he attributed rather to diet, to "too much cold boiled yak," than to the effects of altitude.* (In his own copy of *Round Kangchenjunga*, Sella penciled in the comment "Is this really necessary?")

The weather too was challenging in its unpredictability: Freshfield makes reference to an "inexpressibly inopportune snowstorm," which had deposited five feet of snow in the mountains, thoroughly quashing their hopes of climbing a peak. For three days, the group waited for the snow to stop falling before they were able to continue. When the storm finally abated, however, the mountains were more spectacularly alive than ever under huge deposits of fresh snow. Wading through five-foot drifts, the group made agonizingly slow progress. For Sella, though, the storm was a blessing: his images of the peaks on the eastern flank of Kangchenjunga are some of his most vibrant.

Freshfield had planned to cross the Kangchenjunga massif at the twenty-one thousand-foot Nepal Gap. Be-

cause of the snow, they were unable to reach their destination, so the 20,200-foot Jonsong-La marked the northern terminus of their journey. This brought them into southern Tibet. For guidance across the northern end of the Kangchenjunga massif, Freshfield was relying on his head porter Rinsing, who had done the crossing once before. Rinsing's memory was not overly reliable, however, and the expedition members held heated debates about the proper route westward into Nepal. The wrong decision could cost them much time, and in these regions, winter can move in swiftly, trapping the unlucky traveler. Finally, Freshfield saw clouds rising from a low valley, and suspected that if the group headed in that direction, they would probably find an opening in the mountains to let them through. In the face of considerable opposition from the Sella brothers, Freshfield asserted himself and was soon vindicated as the team entered the relative safety of Nepal.

For the first half of the journey, Freshfield's team had a letter and the blessings of the ruler of Sikkim. Nepal, however, was a closed kingdom at the time, and they had no permission to be there. Freshfield reasoned that if they met any Nepali officials, he would agree that his expedition had no right to be there, and that by all means they would hurry southward to the first crossing into Sikkim.

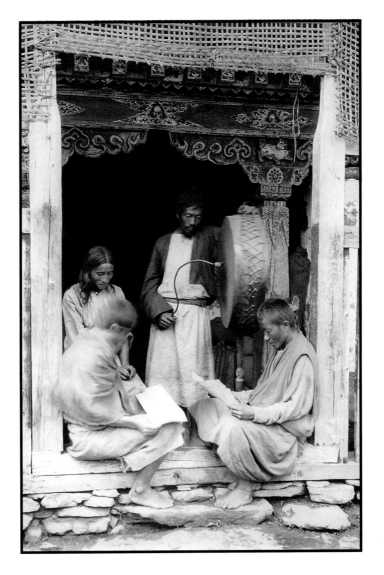

The first villagers they met in Nepal were astonished to learn that this tattered group had come down from the north. The team sped down the western side of Kangchenjunga, marveling at the savage form of the surrounding peaks and the gentle nature of the valleys through which they traveled. They did indeed meet a Nepali official who demanded an explanation, but Freshfield pushed brusquely past, intent on reaching the southern end of the Kangchenjunga range. Some seven weeks after setting out, they returned to Darjeeling, drawing to a close an extraordinary expedition.

Few have repeated Freshfield's trip since 1899 because of political and logistical obstacles, while other areas of Nepal have become completely inundated with trekkers and climbers. For those willing to suffer quagmires of the manmade, bureaucratic kind, however, the tour of Kangchenjunga is a hidden gem.

In the spring of 1998, I was one of a group of eight people to approach Siniolchun with the intention of climbing the peak and repeating, as closely as possible, the trek that Freshfield and Sella had accomplished nearly one hundred years before. Our group did not reach the summit of Siniolchun (see page 75), but we were successful in reaching Nepal Gap—a destination that had eluded Freshfield because of heavy snow and ice.

LEPCHAS PRAYING IN THE BUDDHIST TEMPLE, CHOONTANG, SIKKIM, 1899

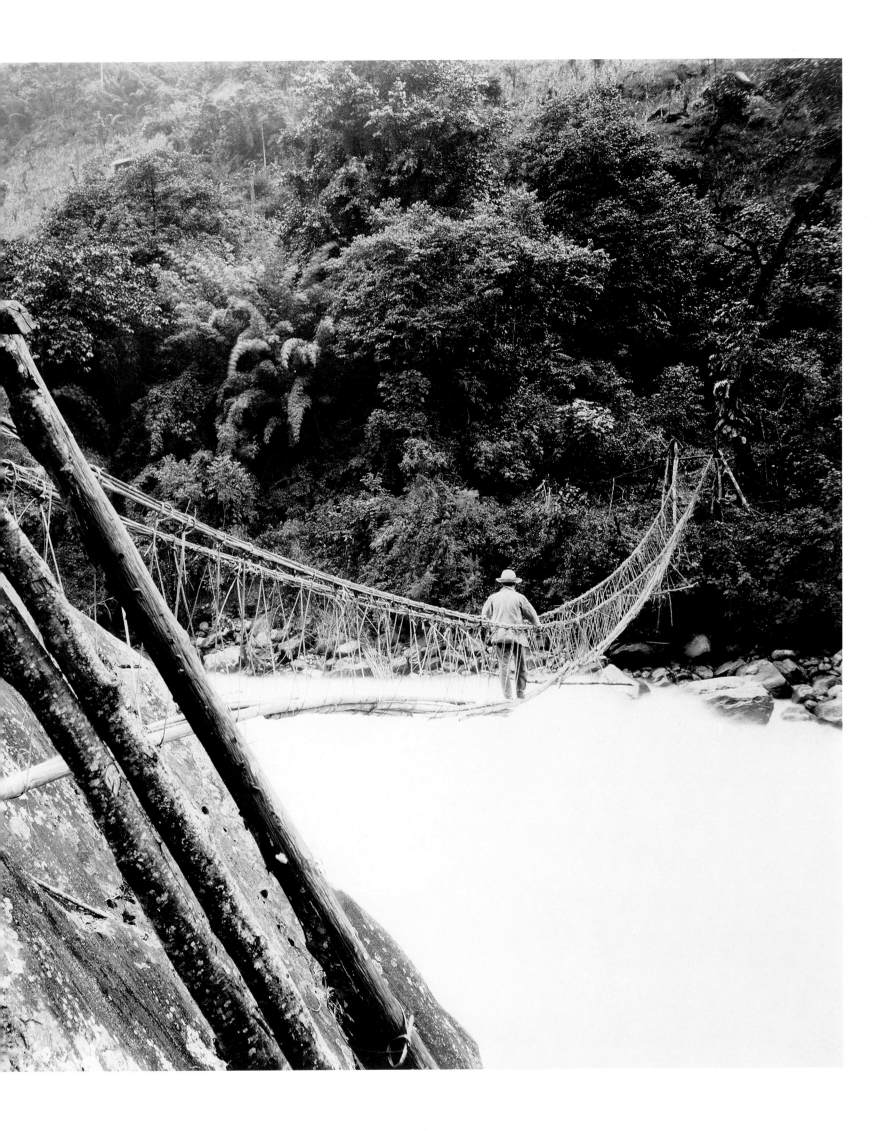

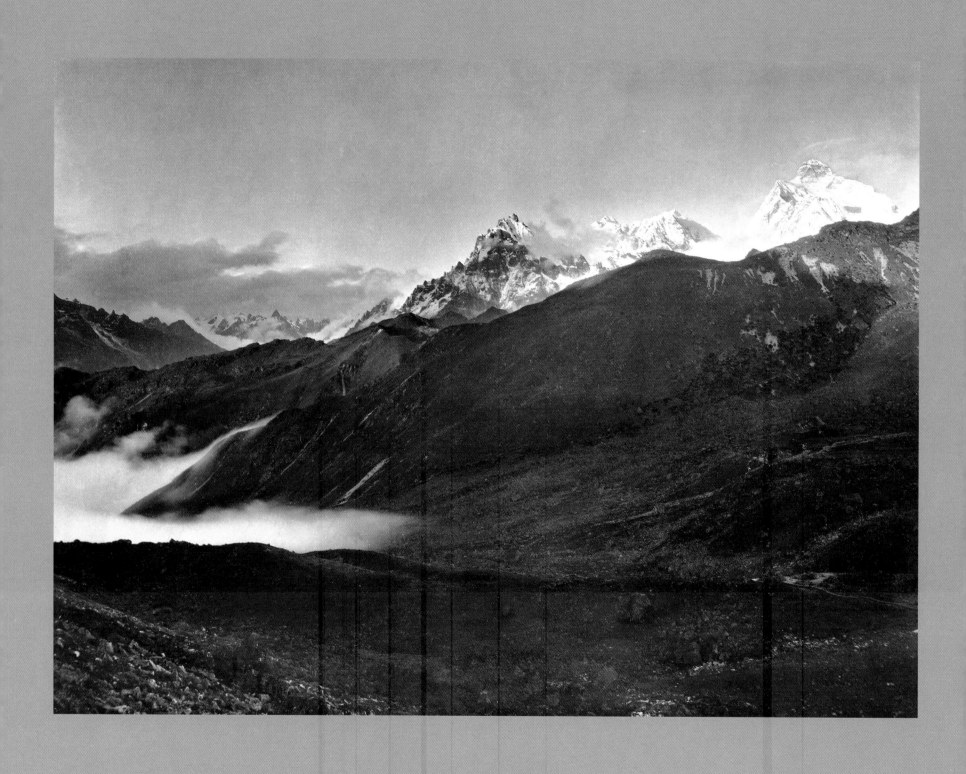

JANNU AND KANGBACHEN VALLEY FROM THE APPROACH TO KANG-LA, NEPAL, 1899

70 (OPPOSITE) PEAK ON THE JONSONG GLACIER, NEPAL, 1899

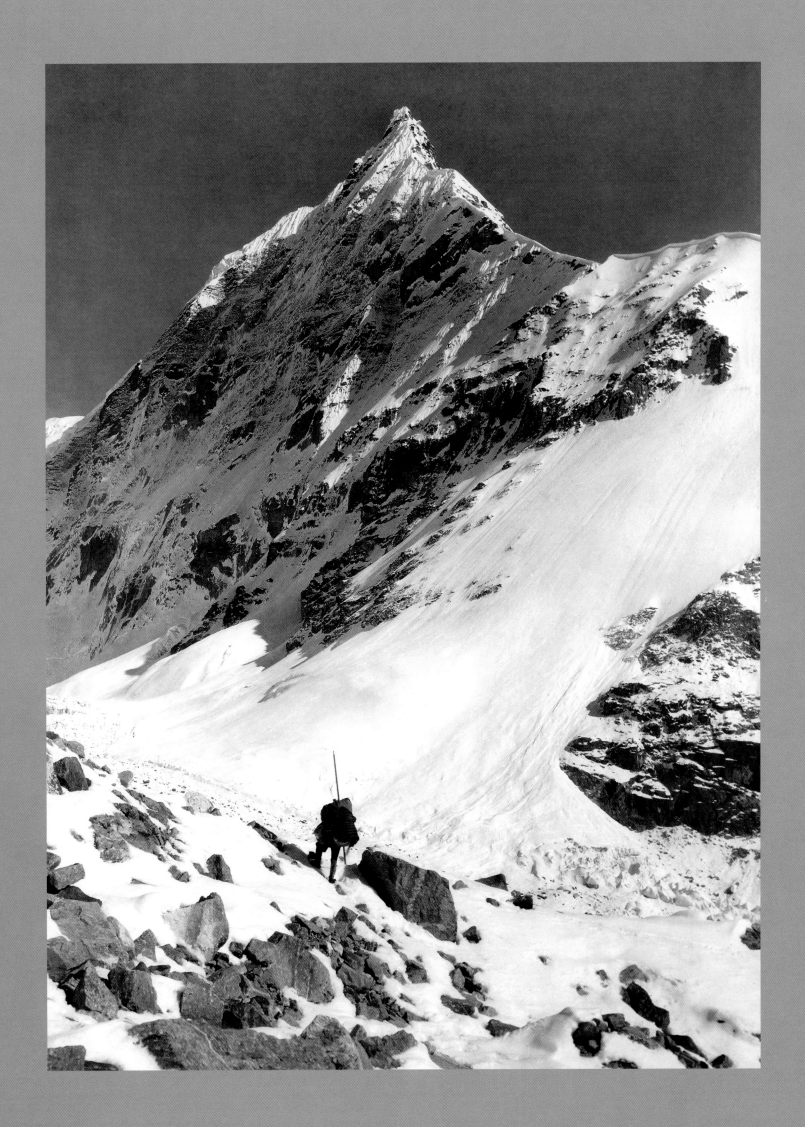

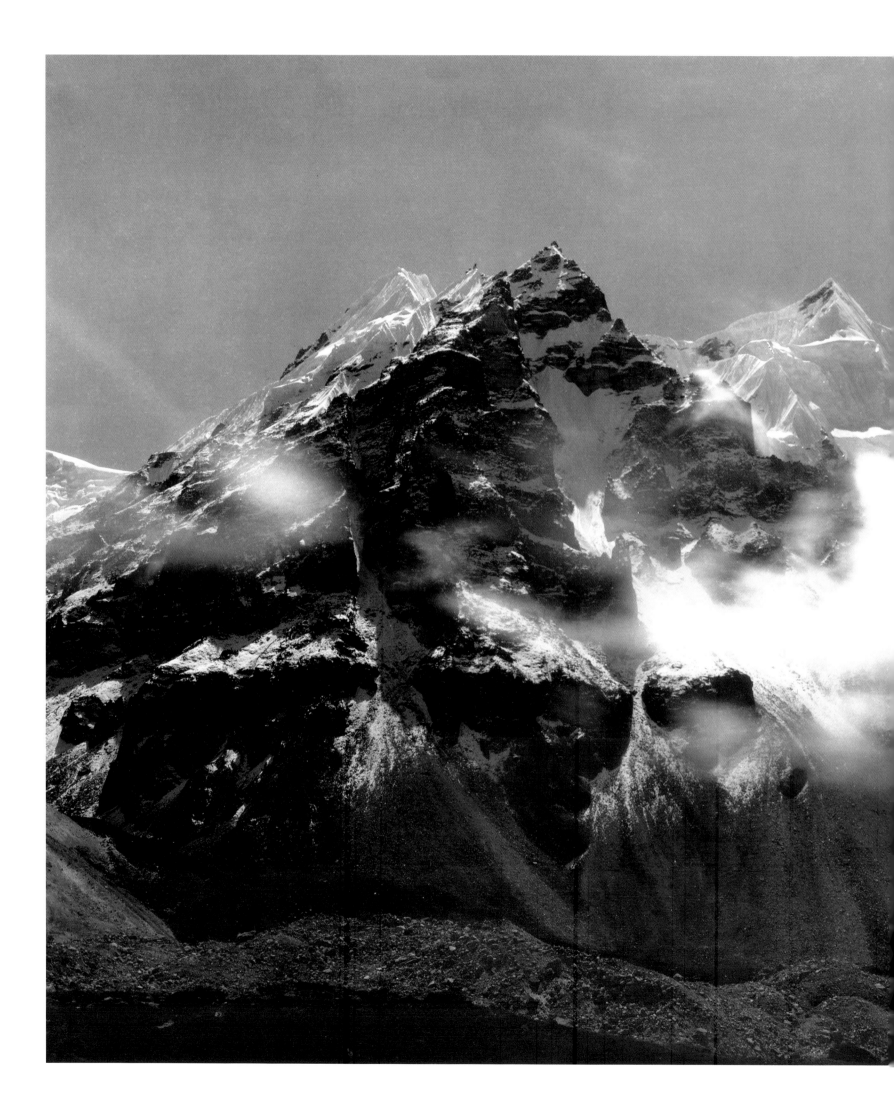

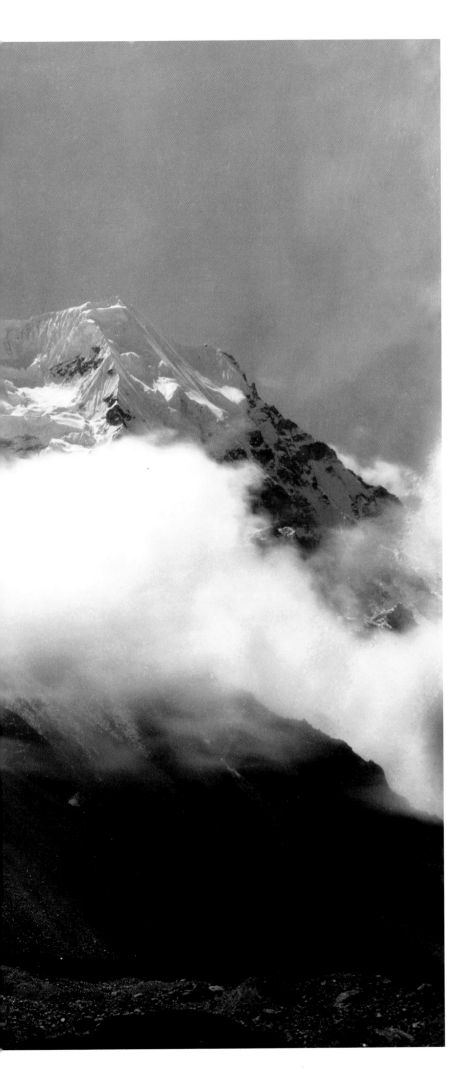

BUTTRESSES ON THE WEST SIDE OF
KANGCHENJUNGA ABOVE KANGBACHEN, OCTOBER 1899

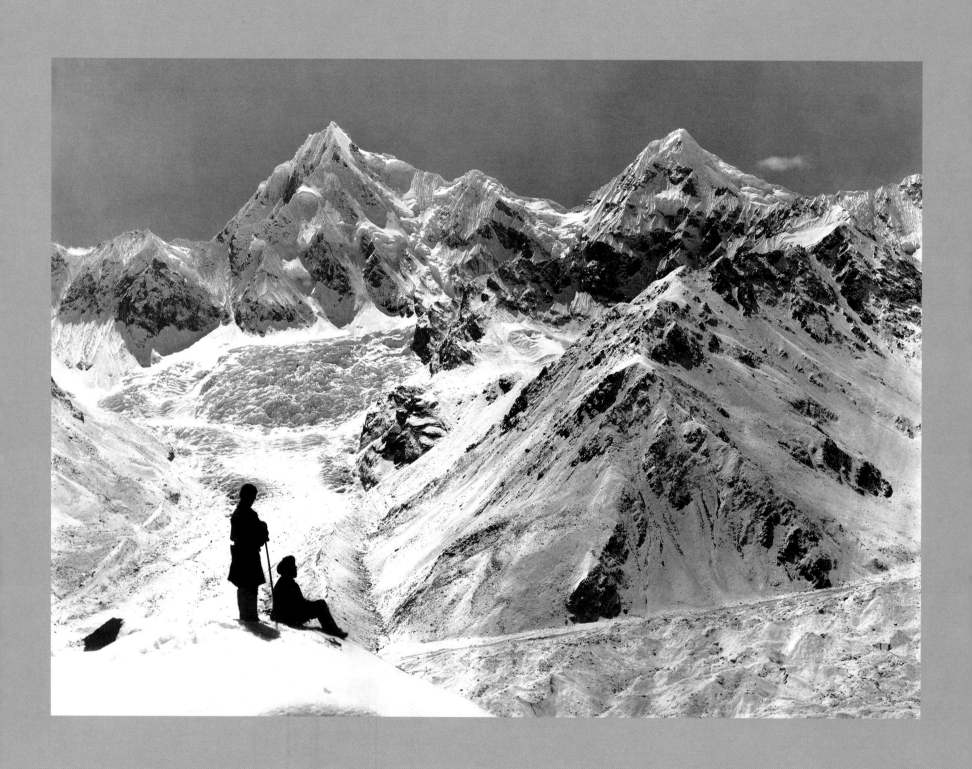

SINIOLCHUN, LITTLE SINIOLCHUN, AND THE ZEMU GLACIER, SIKKIM, 1899

(OPPOSITE) TELEPHOTO OF THE SUMMIT

OF SINIOLCHUN AS SEEN FROM THE ZEMU GLACIER, SIKKIM, 1899

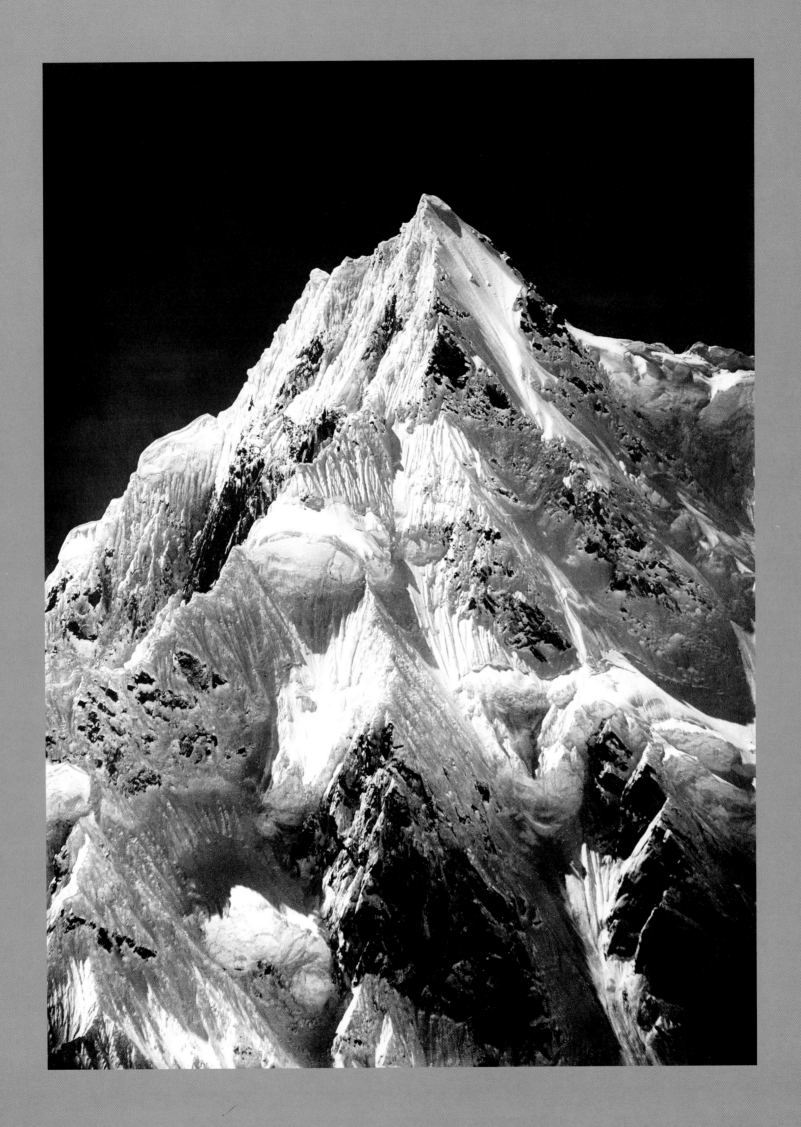

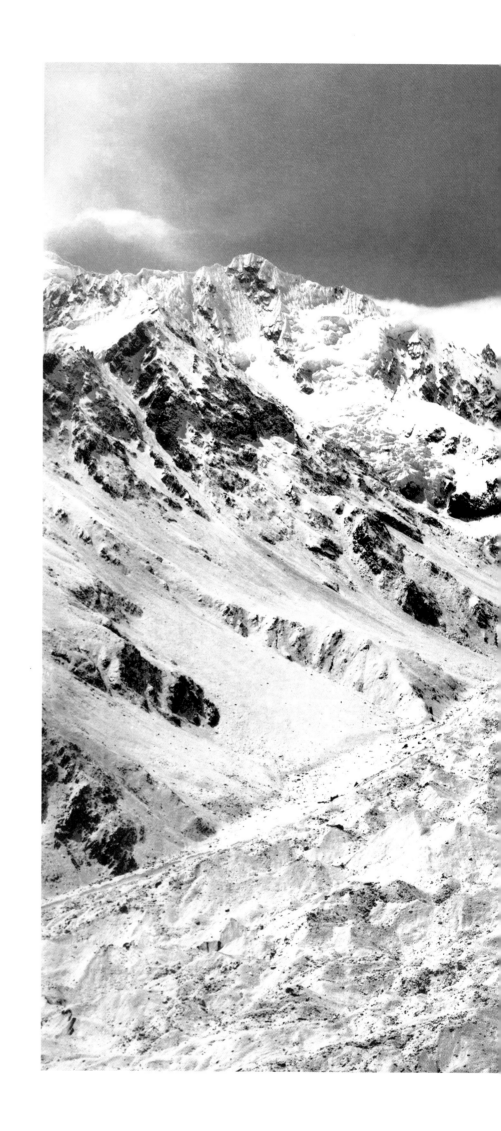

KANGCHENJUNGA AND
THE ZEMU GLACIER, SIKKIM, 1899

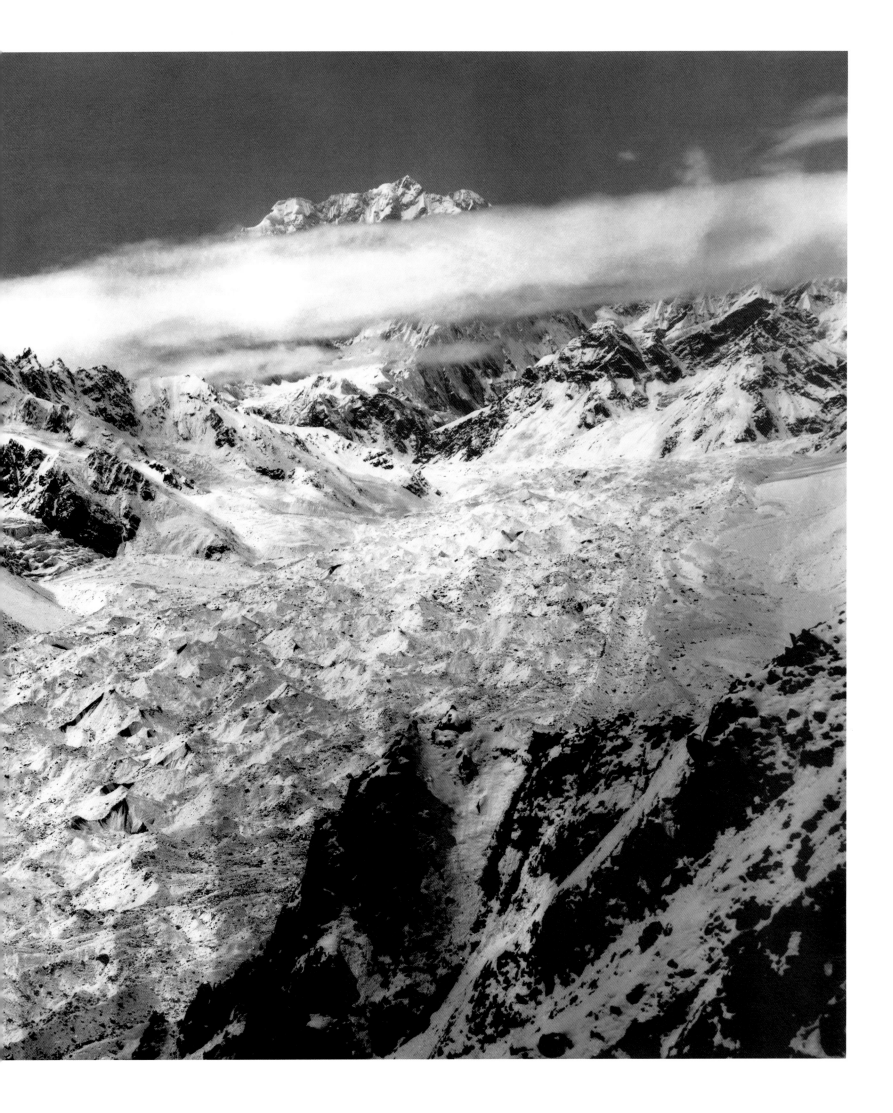

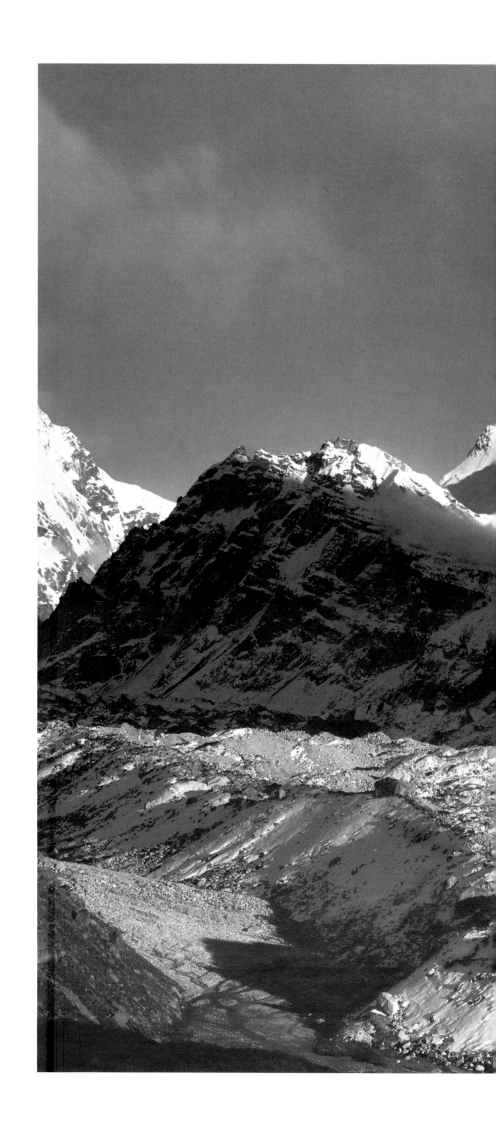

WESTERN RAMPARTS OF
KANGCHENJUNGA AT SUNSET, NEPAL, 1899

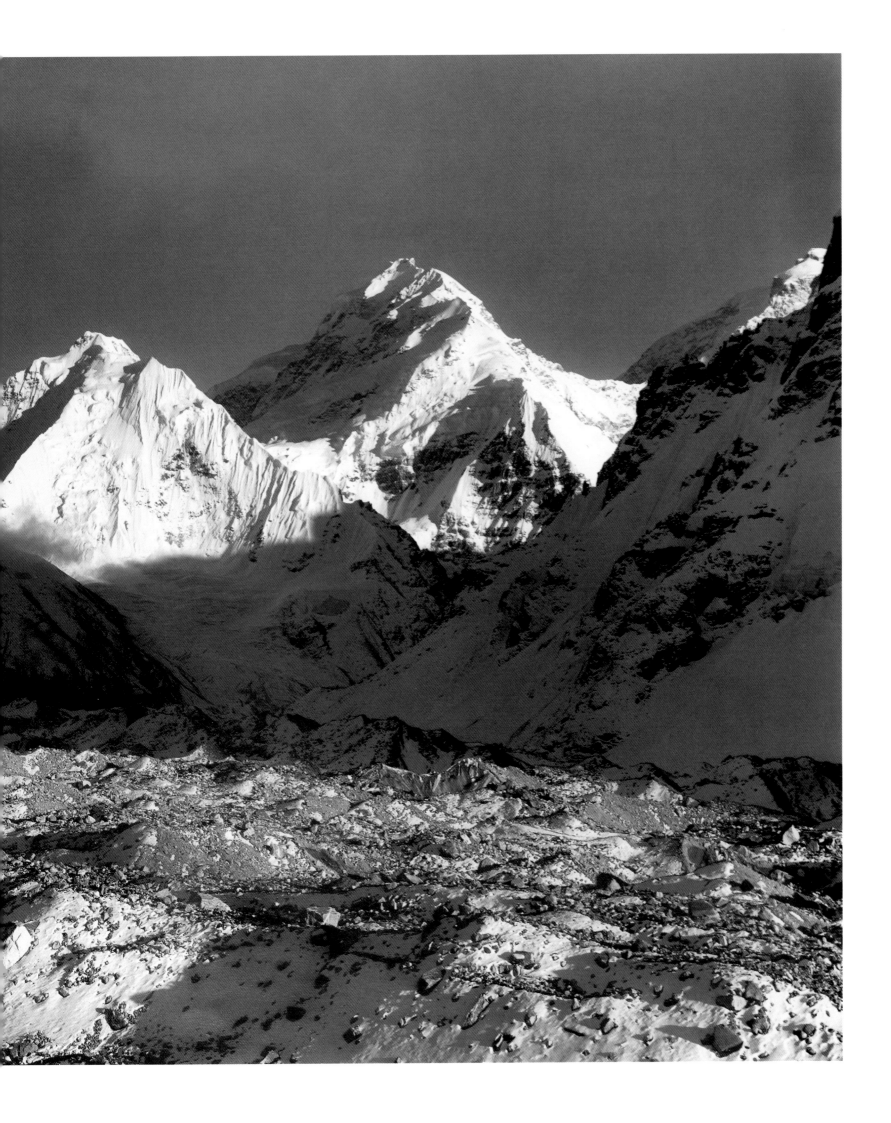

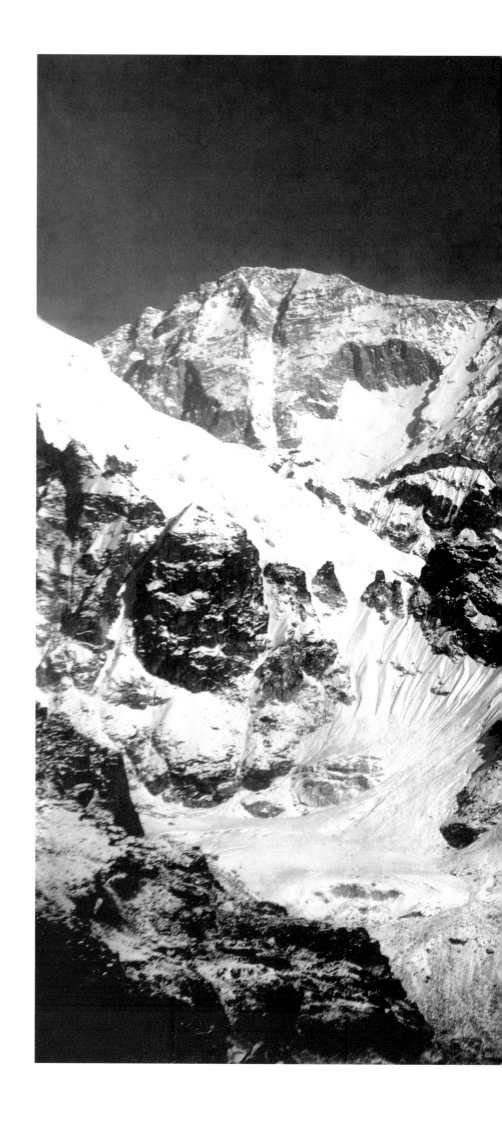

TELEPHOTO OF KANGCHENJUNGA
80 *AS SEEN FROM JONGRI, SIKKIM, 1899*

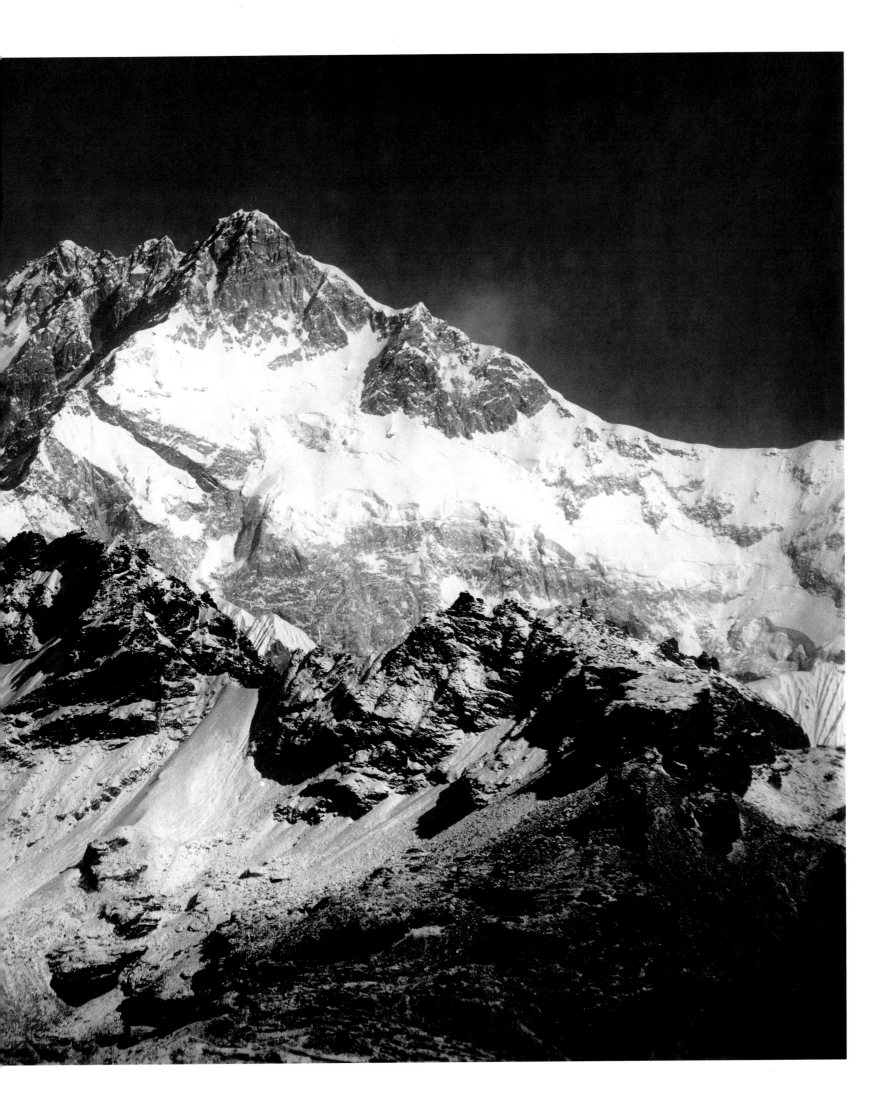

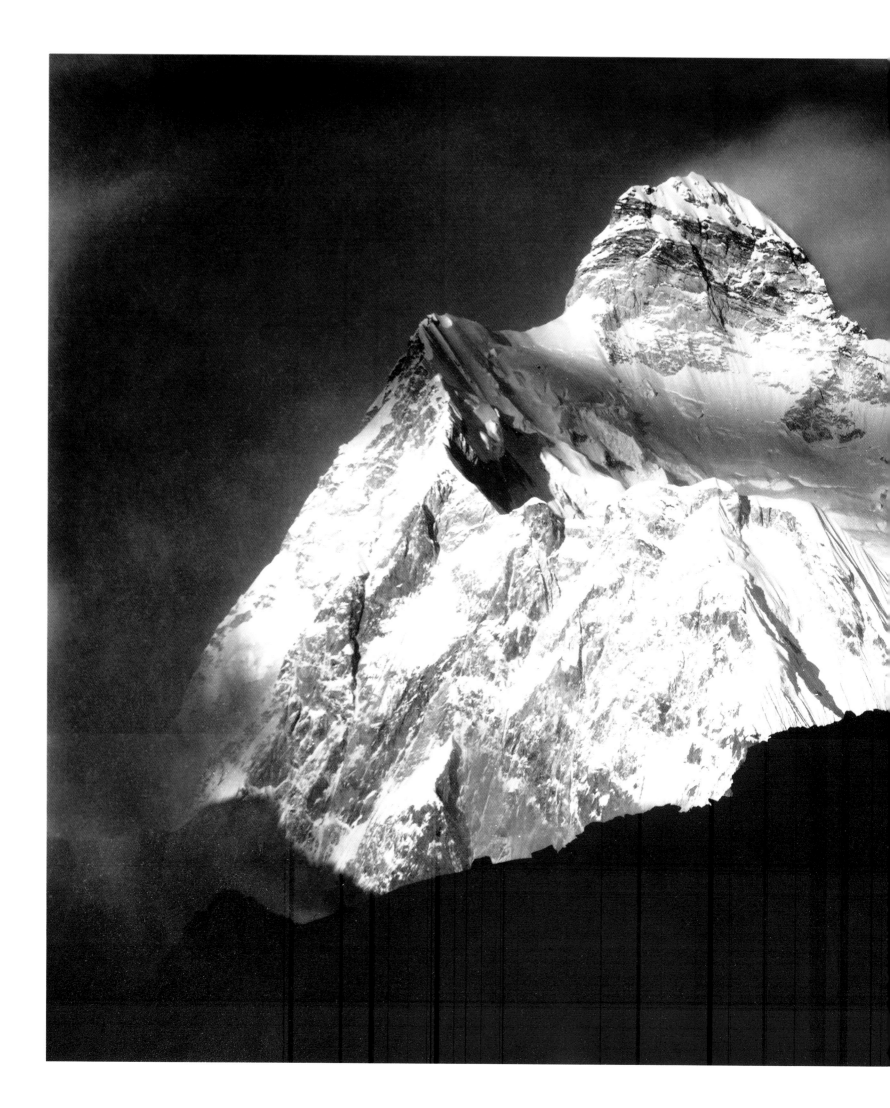

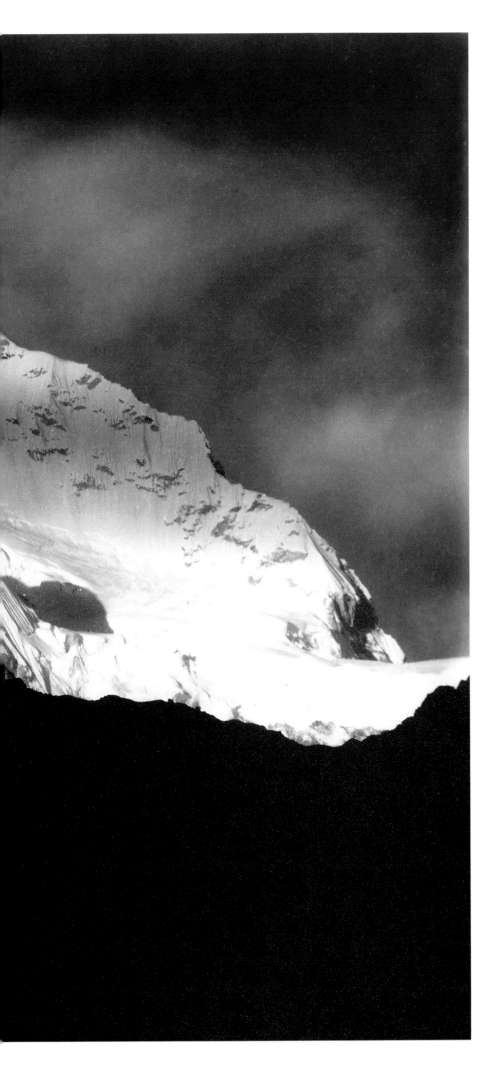

TELEPHOTO OF THE SUMMIT
OF JANNU AT SUNSET, NEPAL, 1899

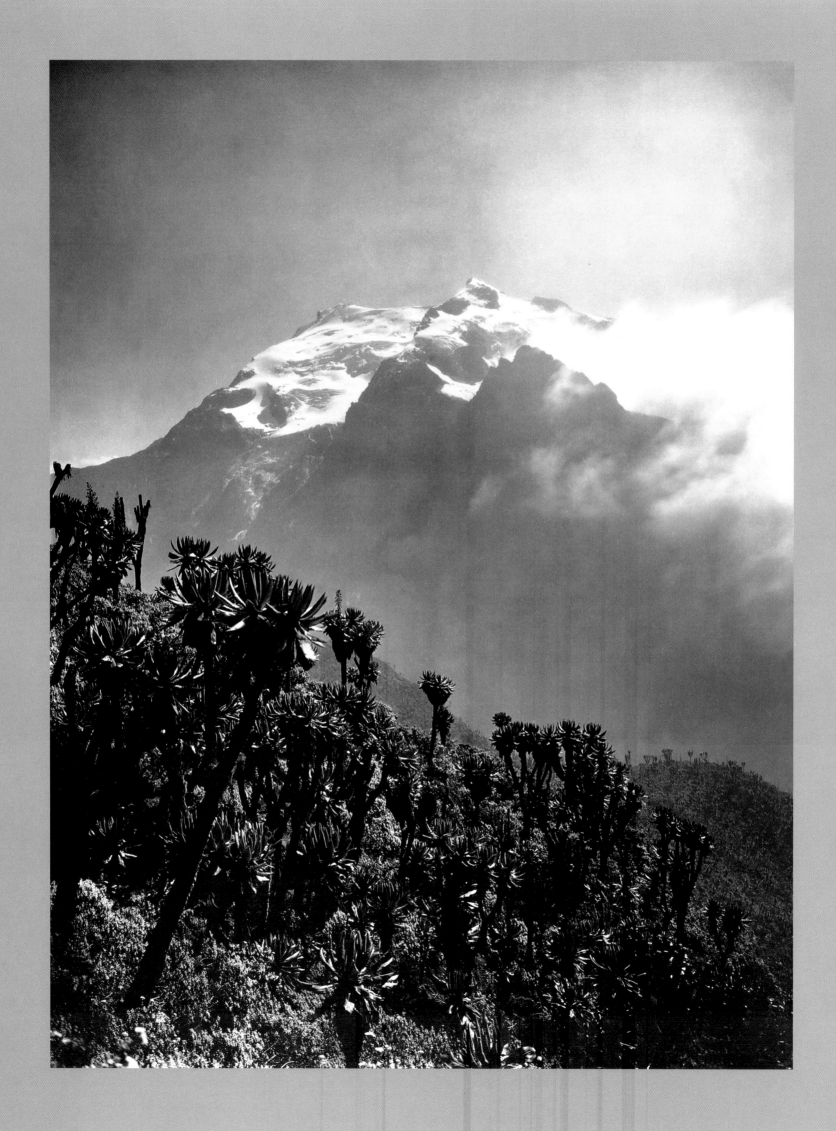

Douglas Freshfield said, "You may be familiar with the Alps and Caucasus, the Himalaya and the Rockies, but if you have not explored Ruwenzori then you still have something wonderful to see and do."

(Douglas Busk, The Fountain of the Sun, *1957)*

Few sights will seem more incongruous, even to a seasoned world traveler, than the juxtaposition of glaciated peaks within tropical jungles. Outside the Ruwenzori of Uganda, few areas of the world feature such a geographical oddity. Known also as the Mountains of the Moon, the Ruwenzori challenge every preconception about mountain environments. As remote mountain ranges often do, the Ruwenzori have lurked in Western legend for thousands of years. Speculation about their existence began with the ancient Greeks: *As early as 500 BC, the Greek dramatist and poet Aeschylus had written of "Egypt nurtured by the snows." Then, in AD 120, the Syrian geographer Marinus of Tyre had recounted the remarkable story of a Greek merchant named Diogenes who claimed to have arrived, after a twenty-five-day journey inland from the east coast of Africa in the middle of the first century AD, at "two great lakes and the snowy range of mountains whence the Nile draws its main sources." It was from this account of Diogenes' legendary adventure that in AD 150 Claudius Ptolemy, the most distinguished geographer and astronomer of his age, had gone on to produce his celebrated early map of Africa. On it the two great lakes, placed side by side just to the south of the equator, are shown to be watered by the high Lunae*

Montes, or "Mountains of the Moon" (H. W. Tilman, Snow on the Equator, *1937).*

The mysterious allure and the unexplored state of the Ruwenzori exerted a strong pull on the Duke of Abruzzi, who planned an expedition for 1906. As he had done on the 1897 trip to Mount Saint Elias in Alaska, he invited Vittorio Sella along as expedition photographer. The early years of the twentieth century revealed much about the Ruwenzori, due in part

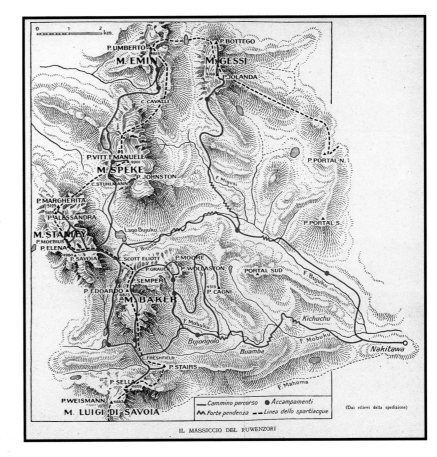

to the efforts of the Duke and Douglas Freshfield, Sella's regular traveling companions. In 1905, a year before the Duke and Sella went to the Ruwenzori, Freshfield was there, trekking across the range and into the deeper recesses of Uganda. Like Freshfield's expedition to Sikkim and Nepal in 1899, the trip was fraught with unforeseen difficulties. Freshfield wrote: *Hours passed, while thunderstorms of unusual vigor broke upon us. Moritz and I sat under our umbrellas, like moist toadstools. . . . Next morning it still rained. Before long the path, hitherto fair, entered at once the upper glen and the bamboo zone and became execrable. Frequent halts had to be made while our men reopened a track between the dripping stems of the bamboos. At each halt a fire was lighted, and we clustered around it, shabby Europeans and shivering natives, a sorry spectacle. The track got worse and worse—it was an alternation of almost perpendicular sodden banks and deep bogs.*

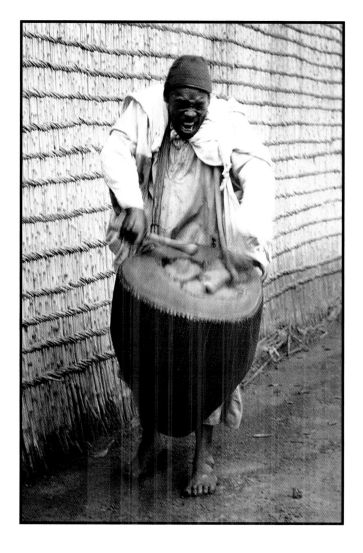

We either sank up to our knees and were held fast in black sludge or stumbled over stumps and stems. We had hoped for mountaineering, and found ourselves mudlarking! ("Toward Ruwenzori," Alpine Journal, *August 1906).*

Freshfield's predicament was not all bad, of course. The true explorer knows that what you find is what you get; and soon enough Freshfield was able to find virtue in his singularly strange surroundings. He was in a special place, and he knew it. He continued: *I lingered a moment, and when I started found that [my companions] were already well ahead and had passed the so-called cave where*

the first explorer left a rope. I was still stiff from my mule-tumble of a fortnight before, and, feeling confident that this was only a reconnaissance, gave up the pursuit, and spent my time in nursing the fire, catching glimpses of the upper peaks, contemplating the glacial source of the Nile, which vindicated so triumphantly Ptolemy against his critics, and reflecting what a very odd corner of the world I had got to.

Although Freshfield had intended to climb the major peaks, poor weather prevented him from doing so. Instead, he made a thorough reconnaissance of the lower reaches and jungles of the Ruwenzori. With so many untouched summits, however, the temptation to ascend must have been great. He knew that other climbers had their sights set on these untouched pinnacles, and ventured the following prediction: *The natural history collectors from the British Museum (in the area later in 1905) will probably conquer several of the summits. Whatever they leave in the way of virgin summits will doubtless fall to the Duke of the Abruzzi. Princes have formidable means of courtship.*

In the event, Freshfield was quite correct. The range met its master in the Duke of Abruzzi. When he arrived in 1906, all the highest summits were still unclimbed—a condition he wasted little time in rectifying. With limitless resources and his typically comprehensive travel plans, he mounted an expedition that could almost be compared with a military operation. For the first time, the glaciers were explored, and the major summits were sur-

DRUMMER DRIVING AWAY EVIL SPIRITS FROM THE CHIEF'S HUT, 1906

mounted, mapped, and photographed. His expedition was at the time rightly held to be a model of organization in exceptionally difficult terrain and weather. So far-reaching were the results of the Duke's expedition that other mountaineers to some extent lost interest in the strange mountains. Twenty-one years elapsed before people stood again on the highest summit, Mount Margherita.

Although Sella photographed all the mountains of the Ruwenzori, the intense humidity and cloudy weather did not allow him a broad choice in points of view. However, his documentation of the unique conjunction of the tropical forest and lakes with their dramatic mountainous backdrop was extensive. Also while in the region, Sella made close-up botanical studies; he was one of the first photographers to do so. And, as always, he documented the local people, this time working with a small camera, which increased his dexterity and allowed him many more opportunities to photograph. He returned to Italy with a trove of images, the likes of which his contemporaries had rarely seen: princesses with tribal scarification, villagers sitting outside grass and mud huts, and young drummers smiling straight into the camera.

Since Freshfield and the Duke visited the Ruwenzori mountaineers have indeed paid little attention to the Mountains of the Moon. The range doesn't offer enough of a challenge: little virgin ground remains, and the ascent of the

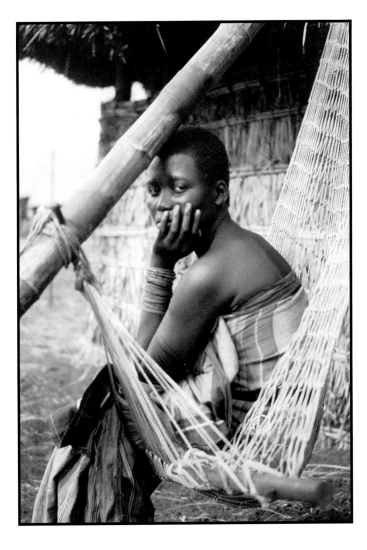

peaks is relatively easy. In addition, the weather conditions on the mountain are horrendous, and political instability in the surrounding areas poses another set of dangers.

It is said, only half-cryptically, that Sella may have enjoyed the last clear weather to be recorded in the Ruwenzori. People willing to overlook these deterrents, however, will find that the landscape remains as singular, almost otherworldly, as it was nearly one hundred years ago. H. W. Tilman gave the classic description of the splendidly unearthly region: *The upper slopes of the Ruwenzori, from ten thousand feet to the snowline, comprise a world of their own—a weird country of moss, bog, rotting vegetation, and mud, on which flourish grotesque plants that seem to have survived from a past era; the vegetation of some lost world inhabited by dinosaurs, pterodactyls, and mammoths. Here are seen gaunt giant groundsel crowned at the top with spiky heads like half-eaten artichokes; tough leafless shrubs with white everlasting flowers called* helichrysum; *gray, withered and misshapen tree heaths, tumescent with swollen growths of moss and lichen oozing moisture; monstrous freaks of nature bred from the union of mist and morass; a slimy barrier serving to enhance and make more desirable the fresh purity of the snows which lie beyond.*

Such are the Mountains of the Moon—vying not with the austere splendor and sublimity of the Alps or the Himalaya, but by their position, mystery, traditions, and matchless scenery, ranking, surely, amongst the wonders of the world (Snow on the Equator, 1937).

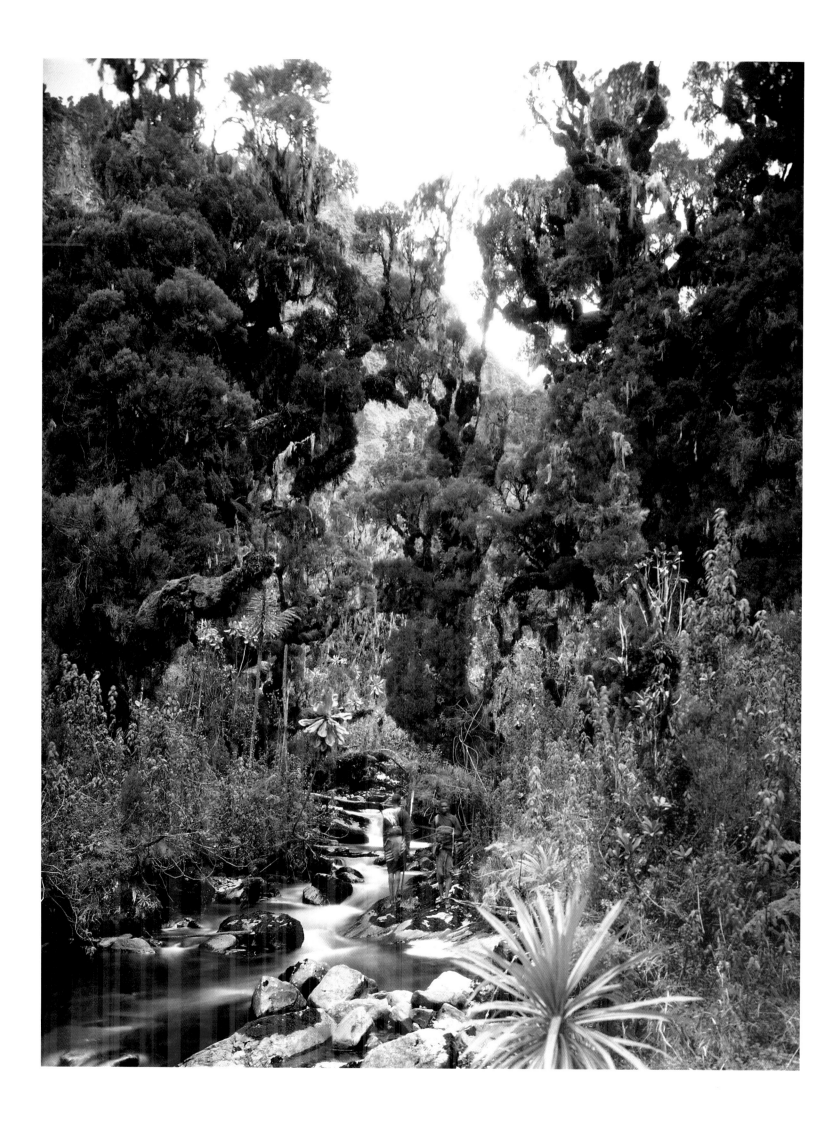

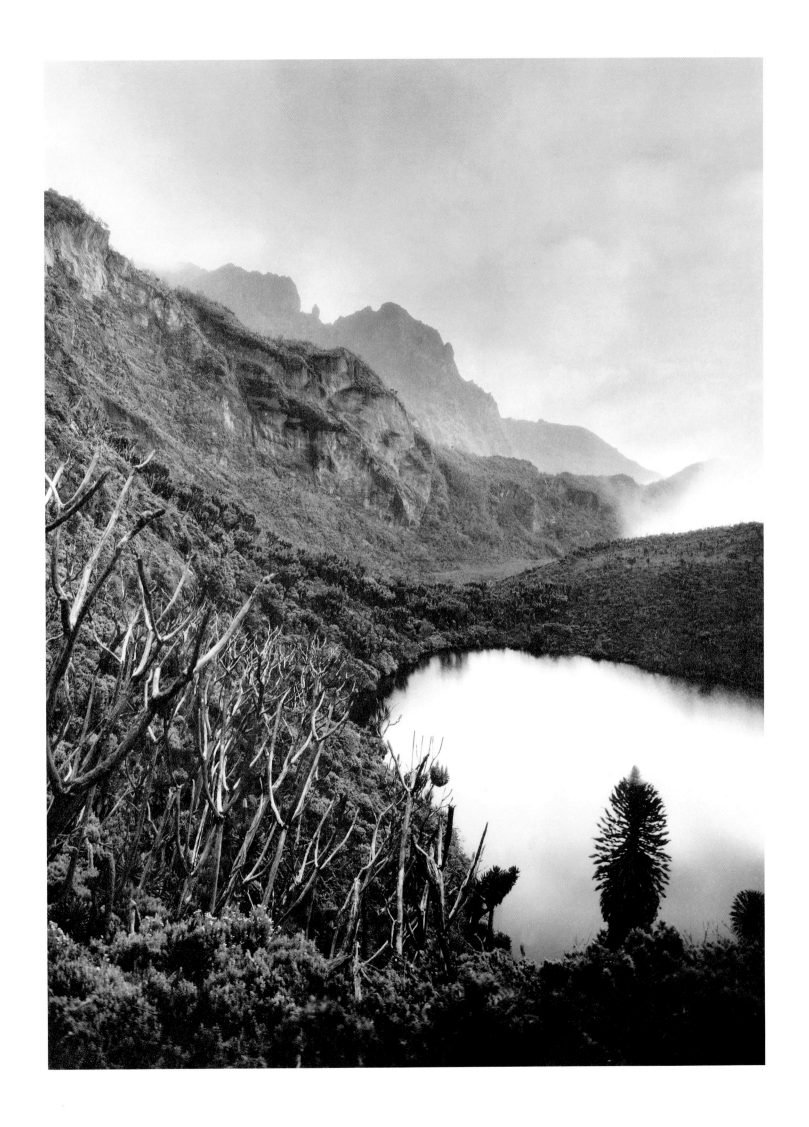

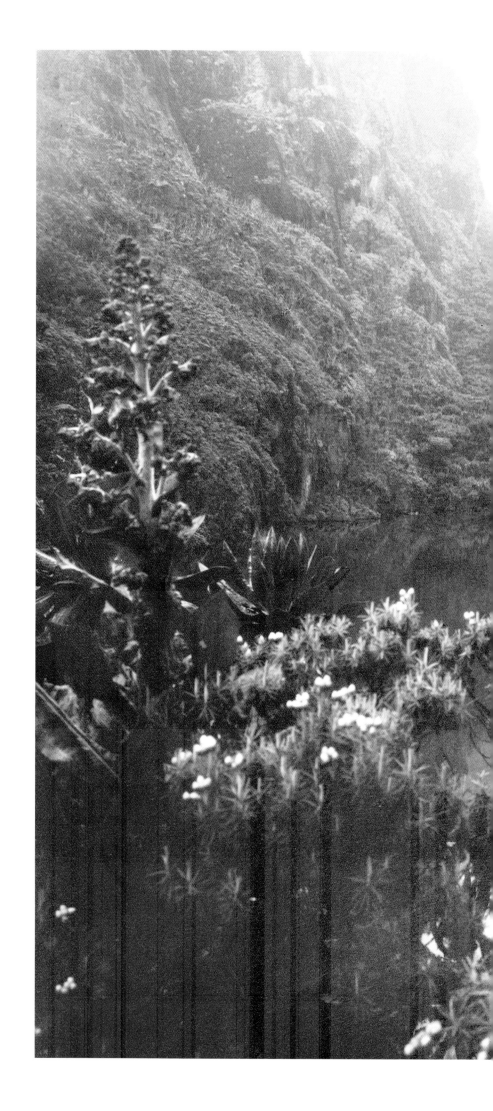

MOUNTAIN LAKE AND FORESTED VALLEY, 1906

(PREVIOUS, LEFT) FOREST OF HEATHERS, SENECIOS,
AND LOBELIA, MOBUKU RIVER VALLEY, 1906

(PREVIOUS, RIGHT) LAKE IN A HIGH
90 VALLEY TO THE WEST OF MOUNT BAKER, 1906

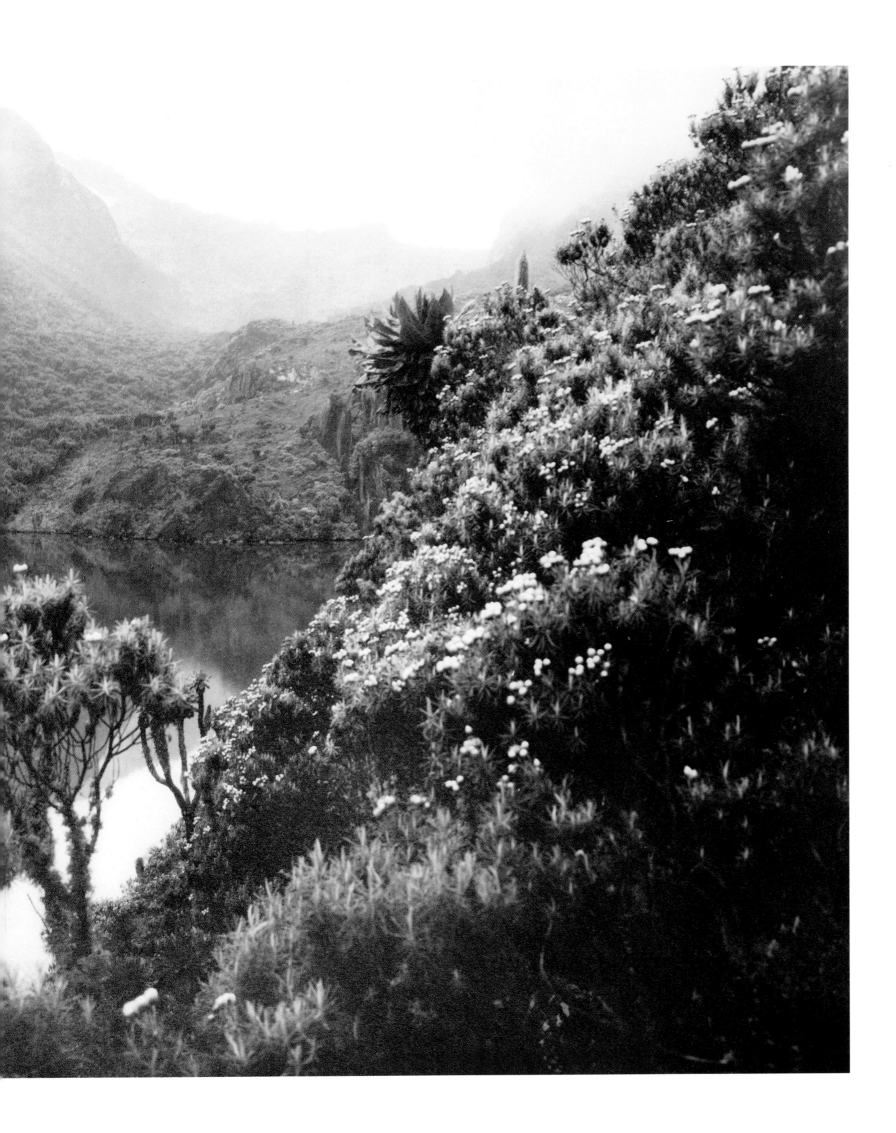

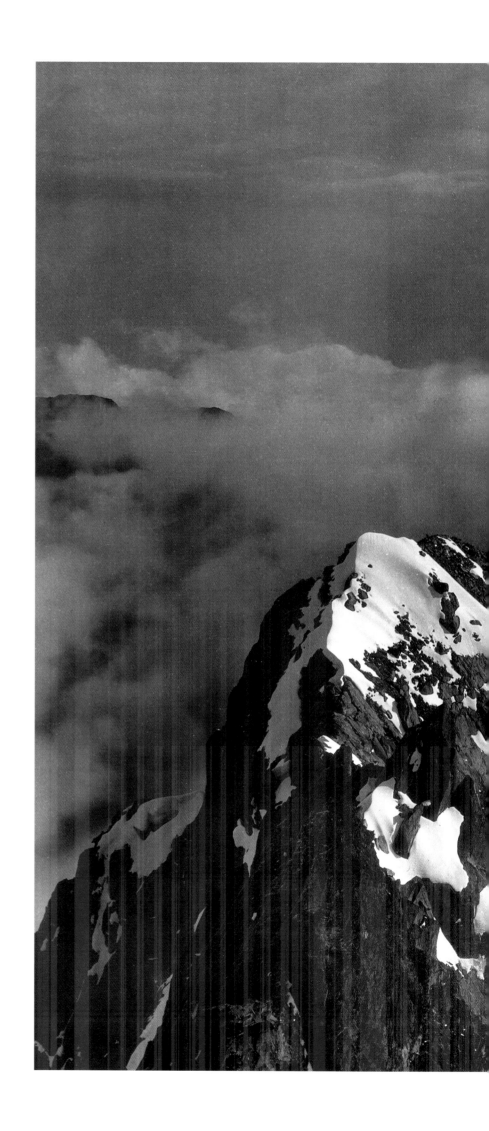

SEMPER PEAK, MOUNT BAKER GROUP,
92 AS SEEN FROM EDWARD PEAK, 1906

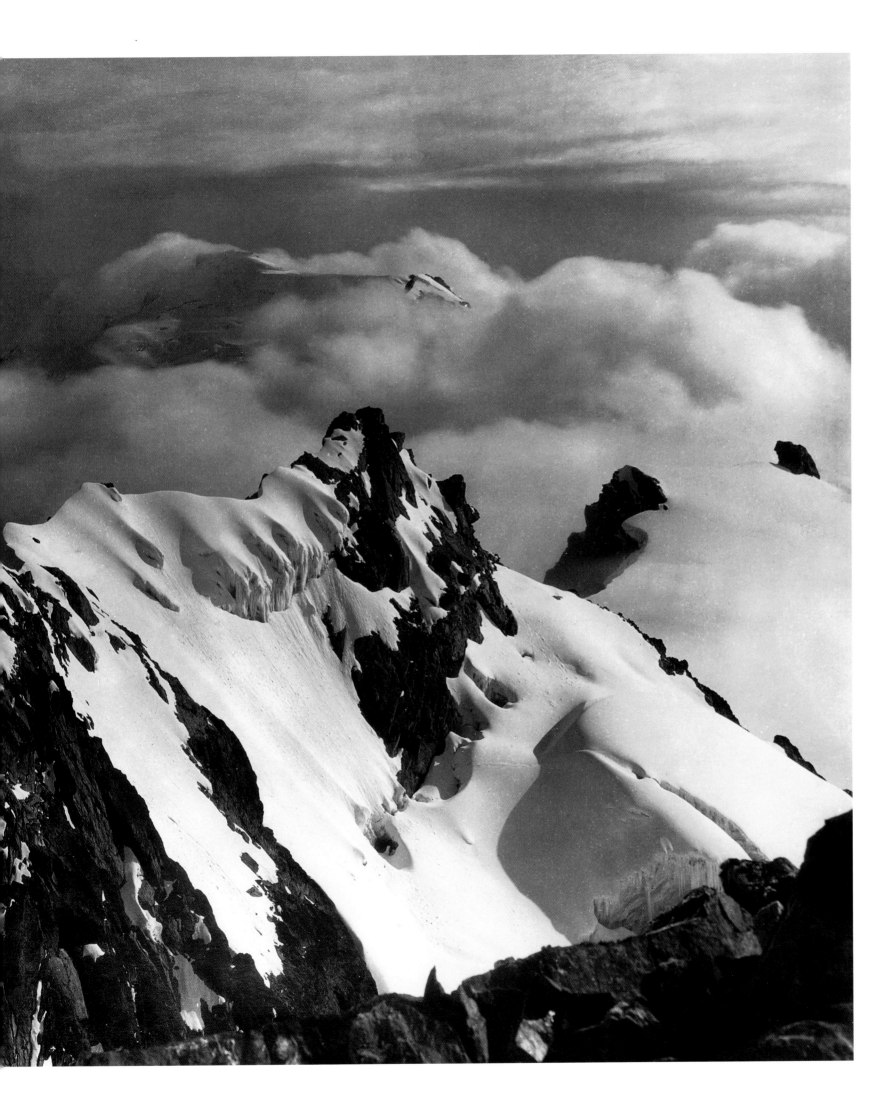

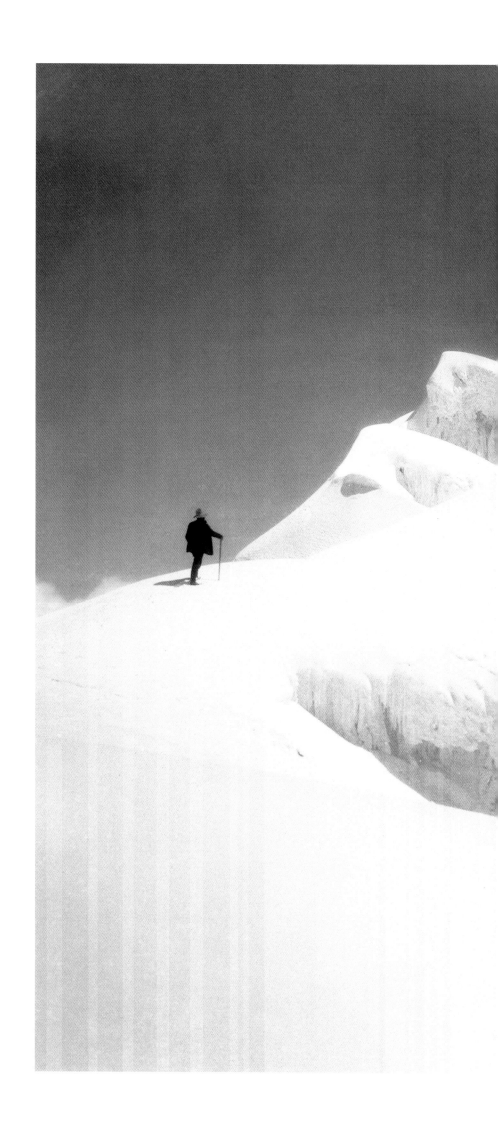

APPROACHING PUNTA ALESSANDRA, 1906

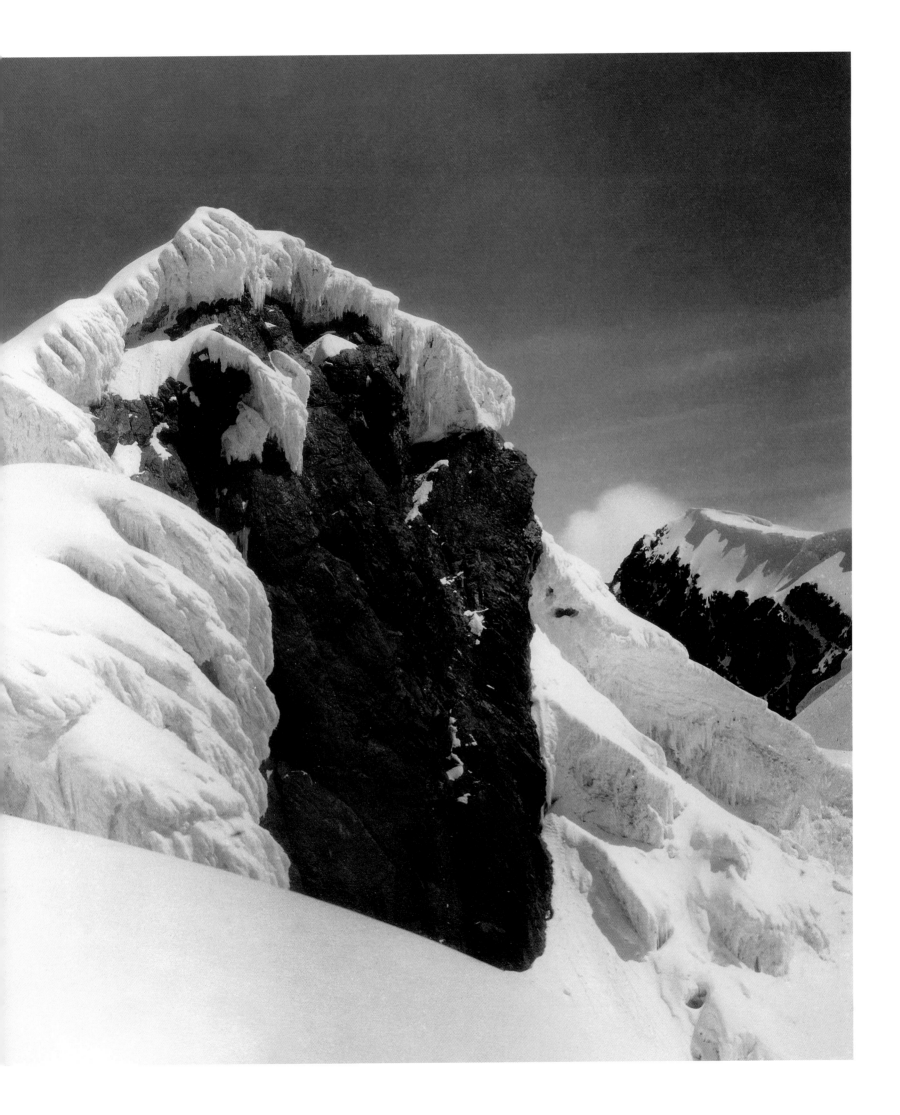

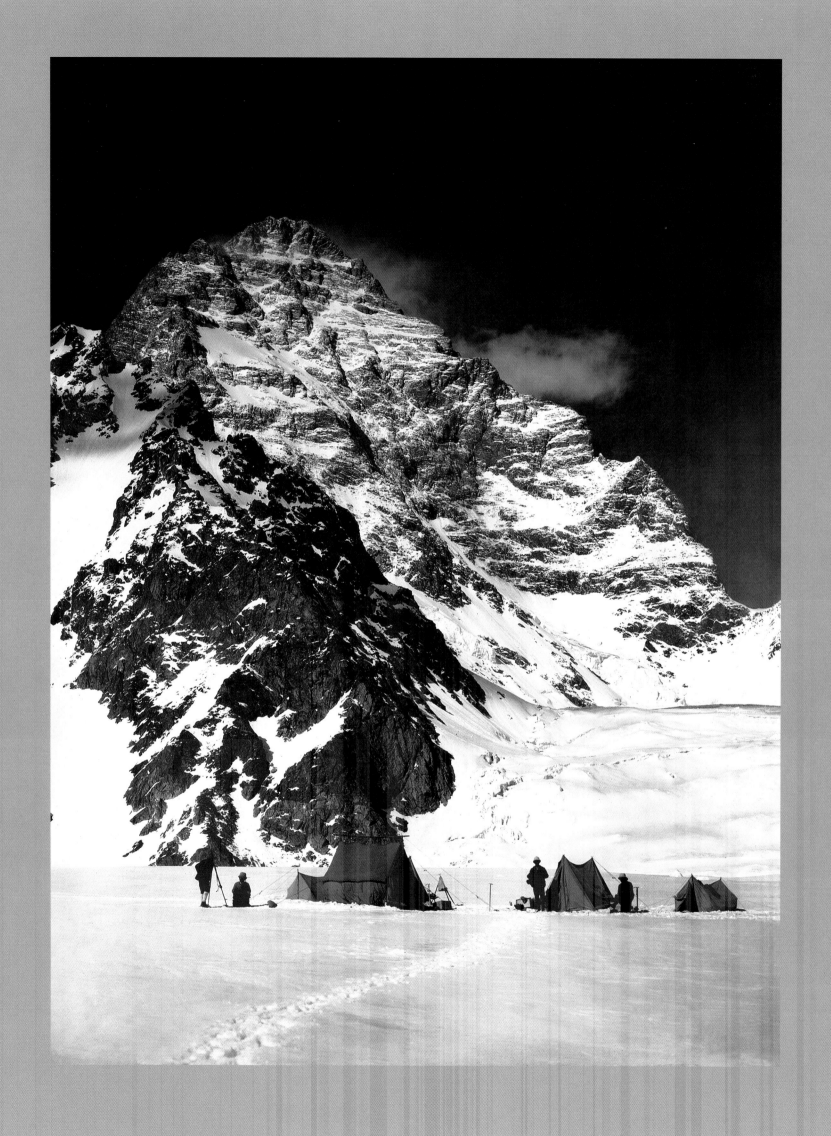

K2—lower than Everest by a half-dozen rope-lengths—is intolerant of human presence.

It's been called the savage mountain, the mountain of mountains, the hardest mountain in the world.

The atmosphere near the summit contains one-third the oxygen of sea-level. Arctic cold and hurricane winds

batter the mountain year round. Vertiginous walls of rock and ice ring the mountain. . . .

In fact, the fascination the mountain holds really has nothing to do with climbing. K2 represents an ordeal.

To climb it is to confront your own mortal fears; K2 is the geologic personification of angst.

(Greg Child, *"A Margin of Luck,"* Climbing, *February/March 1991)*

The Karakoram rank among the wildest mountains on earth. The cirque of mountains that forms the core of the range contains a wild array of huge peaks: Masherbrum, Broad Peak, Mustagh Tower, the Gasherbrum group, and the monarch of them all, K2. At 28,250-feet high, only 750 feet lower than Mount Everest, this formidable mountain is considerably harder to climb. There is a much lower success rate in reaching the summit, and a frightening death rate among climbers on the peak: in 1986 alone, eleven climbers lost their lives.

Nothing lives here. The nearest villages are bleak and dusty settlements some fifty miles down the Baltoro Glacier. There are some recorded native names for K2, including Dapsang, Laufafahad, and Chogori—Balti for "Big Peak." Westerners—in the habit of renaming mountains that already have perfectly good native names—have tried to label the peak with other names, such as Montgomerie, Prince Albert, and Godwin Austen, in honor of Henry H. Godwin Austen, an early explorer of the region; but these have never stuck. In fact no one has improved on the simple designation given from afar by early surveyors of the range: "K" for Karakoram, "2" for the second

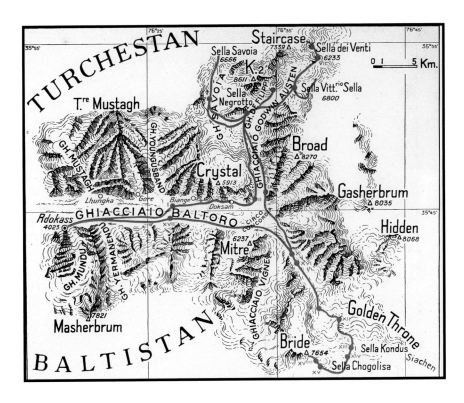

peak indicated. Such simplicity befits a mountain that presents the simplest challenge of all: surviving a trip to the summit and back.

For audacity alone, the 1909 K2 expedition should establish the Duke as a visionary adventurer. His plan to climb K2 in 1909 was as fearlessly ambitious as it would have been had the Wright brothers ventured to cross the Atlantic Ocean on their maiden flight. As he had on his expeditions to Mount Saint Elias and the Ruwenzori, the Duke invited Sella, knowing that his photographic record would be unsurpassed. Al-

though he was approaching his fiftieth birthday, Sella felt the appeal of the Karakoram strongly and overcame his reluctance to leave the comforts of San Gerolamo for seven months of strenuous travel in a distant range.

The Duke, as usual, did a thorough job planning and carrying out the trip. Traveling by land and sea to what was then known as Kashmir, the team reached the heart of the Karakoram only six weeks after leaving Italy—including 350 miles of foot travel. Reaching Concordia, the remarkable confluence of glaciers in the heart of the Karakoram, they im-

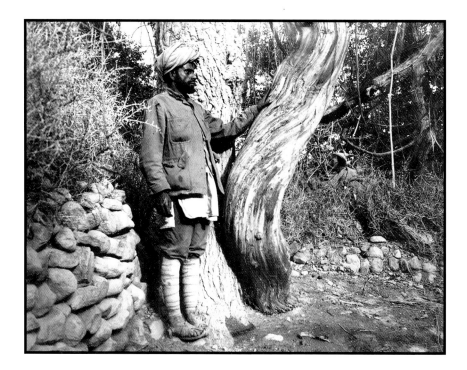

mediately set about their full agenda of scientific, geographic, photographic, and of course, alpine objectives.

The Duke's team was only the second ever to approach K2 with the hope of climbing it. In 1902, a somewhat unusual expedition, led by Aleister Crowley, the British necromancer, made an attempt of sorts on the peak. The strangest moment came when Crowley pulled a gun on a companion in a misguided attempt to force progress. Not surprisingly, a fist fight ensued, and the team descended soon afterward. Needless to say, the summit of K2 remained inviolate when the Duke arrived in 1909.

They began their assault on the great peak after they surveyed three-quarters of the base, deciding to ascend via the southeast ridge (now known as the Abruzzi Ridge). The team was as strong a group as could be assembled, but this time the Duke had set his sights too high. The expedition made it only four thousand feet up the peak, wisely abandoning the effort at about twenty thousand feet, nearly nine thousand feet below the summit. As consolation, the Duke attempted to climb Chogolisa, a twenty-five thousand-foot peak, and reached an altitude of approximately 24,500 feet—higher than any human had ever climbed before. This record would remain unbroken until a team of British climbers surpassed it during their attempt on Mount Everest in 1922.

On Chogolisa, Sella captured a wonderful image of three climbers making their way through the icefall, the entire scene soft in an ethereal glow (see page 111). The summit was virtually guaranteed, but as so often happens, the weather took a turn for the worse. Heavy snow was followed by unusual warmth, which dangerously increases the potential for avalanche. The Duke, excruciatingly close to the top, was forced to turn back.

Despite the fact that the group did not claim a summit, the trip was a notable success. The Duke demonstrated that the biggest mountains in the world can be reasonably attempted, even if a successful ascent might require several tries. Sella produced a portfolio of images that stands alone for its time—a striking record of the majesty of the Karakoram, arguably the single finest visual representation of a mountain range that has ever been done. Drawing on thirty years of experience as a technician and an artist, Sella captured K2 and its retinue of massive peaks from all sides and in all moods. The stark detail and the near-mystical proportions of these

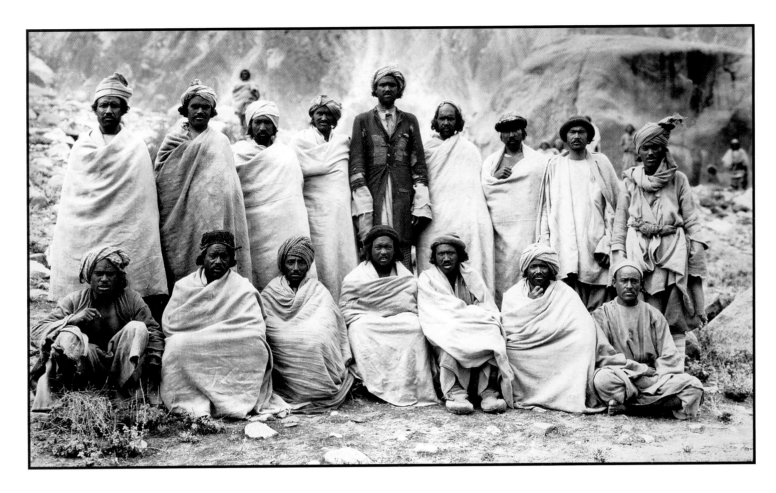

enormous mountains are perfectly presented: the tents at the base of the fourteen-thousand foot western wall of K2 (see page 96), the image with the small figure in the right center, the progression up to Mustagh Tower and K2 (see pages 112–113), and the panoramas that encompass such enormous subjects (see pages 107–110). These photographs have an undeniable power to impress the viewer with the vastness of the Karakoram and the position of people moving among the greatest mountains on earth.

The Duke's expedition had the Karakoram all to itself in 1909. K2 was not seriously attempted again until the late 1930s, when two American expeditions came close to reaching the top. In 1938, Dr. Charles Houston and Paul Petzoldt reached twenty-six thousand feet, but prudently decided to retreat in the face of a shortage of supplies and the lateness of the season. This expedition proved that small, competent teams could make significant progress on a peak as large as K2. In 1939, an expedition led by Fritz Wiessner came within 750 feet of the top, in a controversial near-miss that counts

as one of the greatest achievements in mountaineering history. Debate continues to this day over the events of that expedition. In 1986, Fritz Wiessner summed it up rather sadly by saying "The mountains never let me down; men did." K2 was finally climbed in 1954 by an Italian team, an event worthy of great national pride.

Today, the peaks of the Karakoram are awash in the bright colors of climbing teams from around the world. However, they are not alone there. The Indian and Pakistani armies are fighting a protracted battle in a border dispute around K2. The presence of platoons of soldiers entrenched among the spectacular peaks of the Karakoram makes the mountaineer's pursuits seem very nearly sane in comparison. Their proximity creates a jarring contrast to the gentlemen mountaineers of Vittorio Sella's time—men who climbed the world's great peaks with nobility of purpose, surpassing drive, and a humility and respect often lacking today. Fortunately, the pristine splendor they encountered will exist forever unchanged in Sella's magnificent photographs.

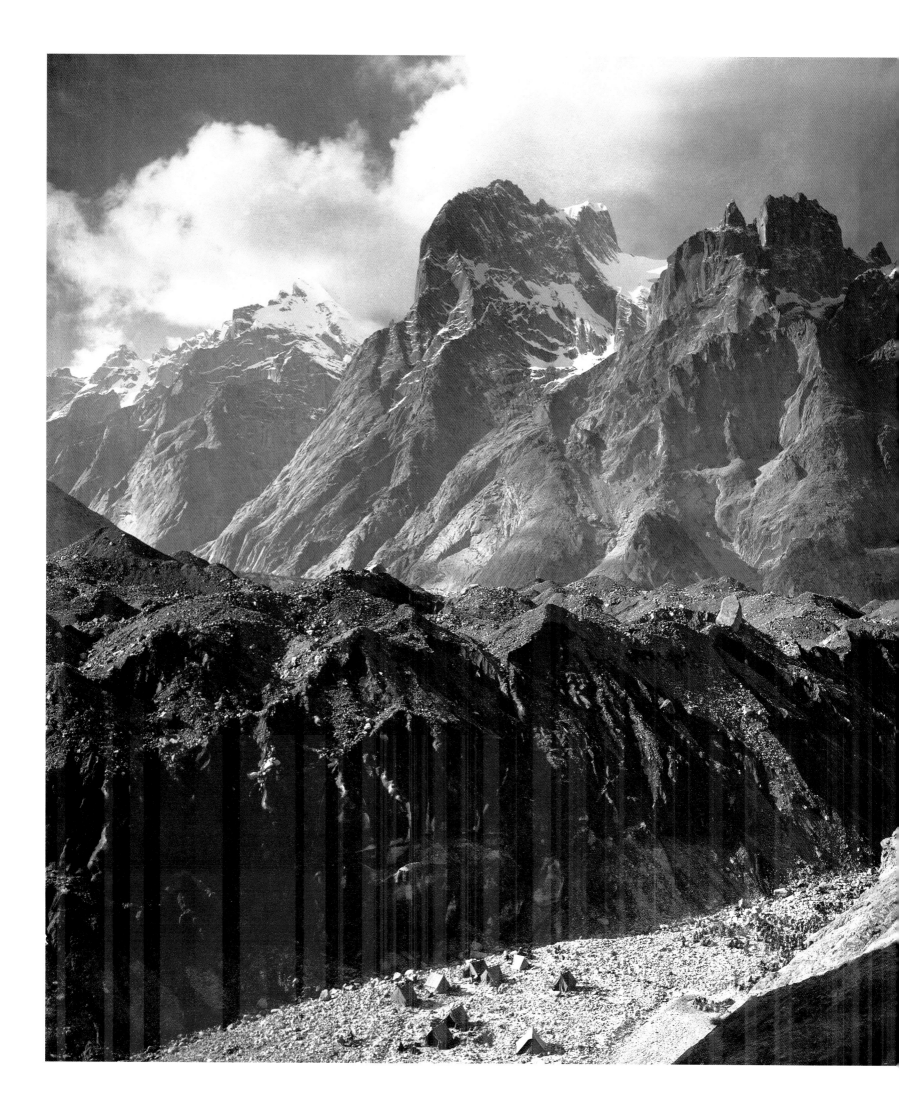

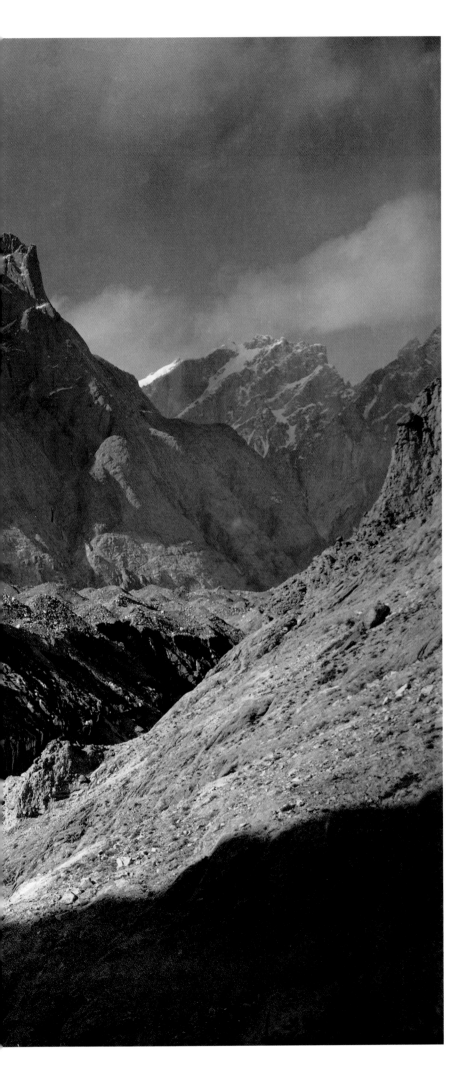

CAMP BELOW LILIGO ON THE BALTORO GLACIER, 1909

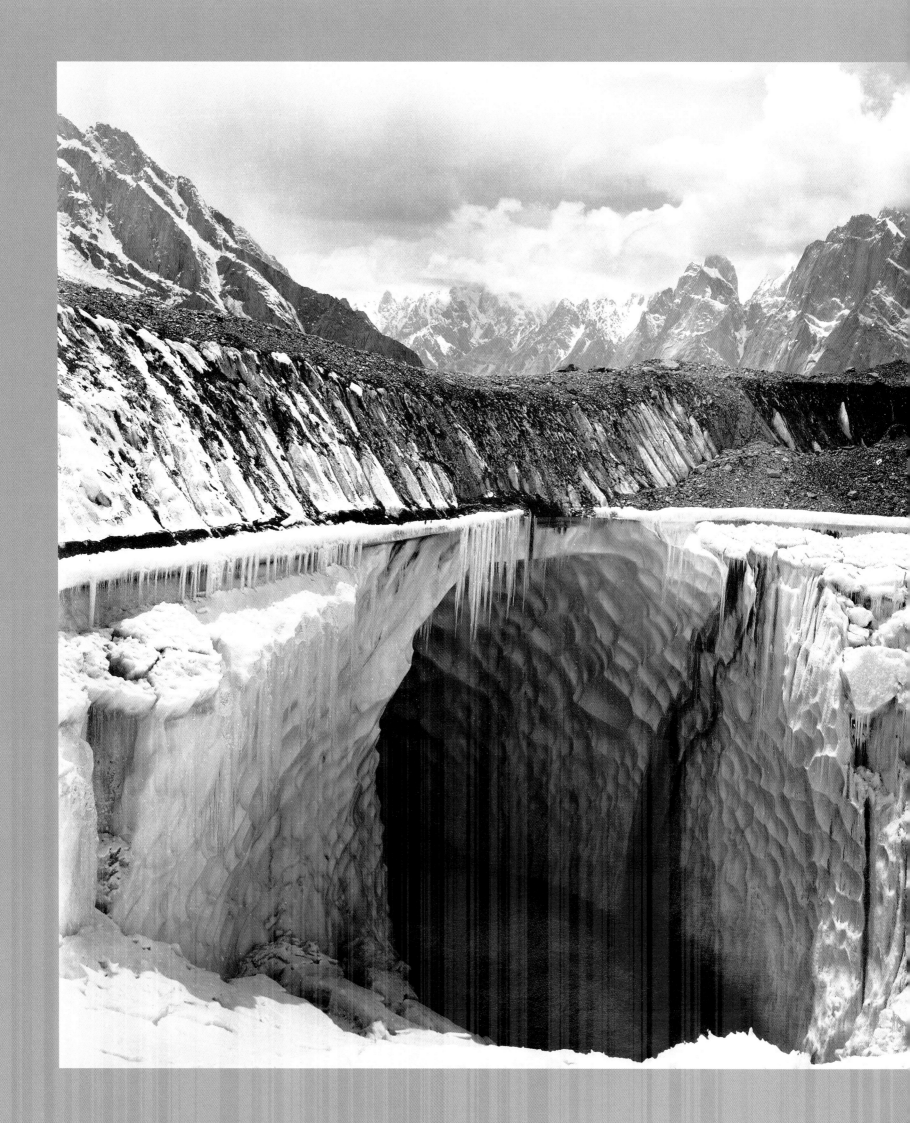

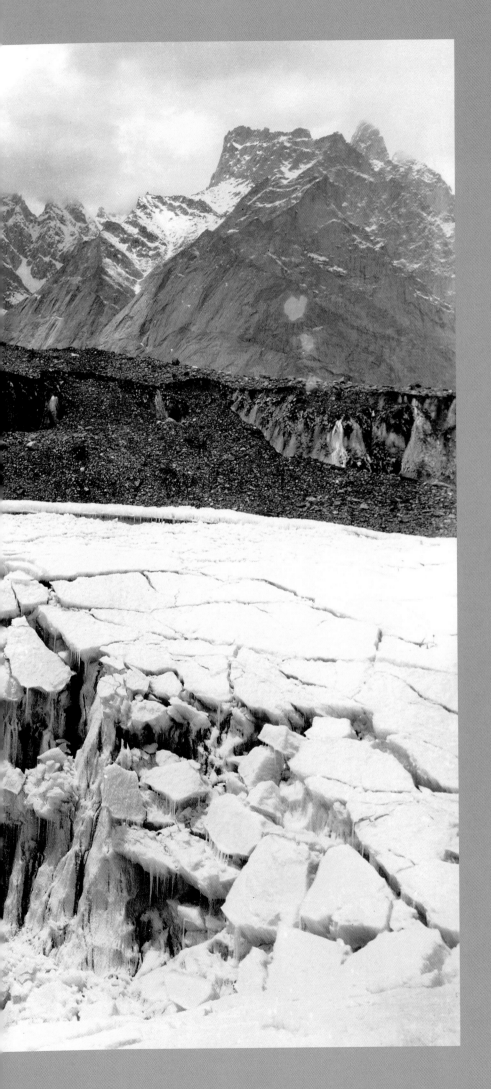

MORAINE LAKE ON THE BALTORO GLACIER ABOVE URDUKAS, 1909

(NEXT, LEFT) GLACIAL LAKE ON THE BALTORO GLACIER, 1909

(NEXT, RIGHT) WEST FACE OF GASHERBRUM IV, 1909

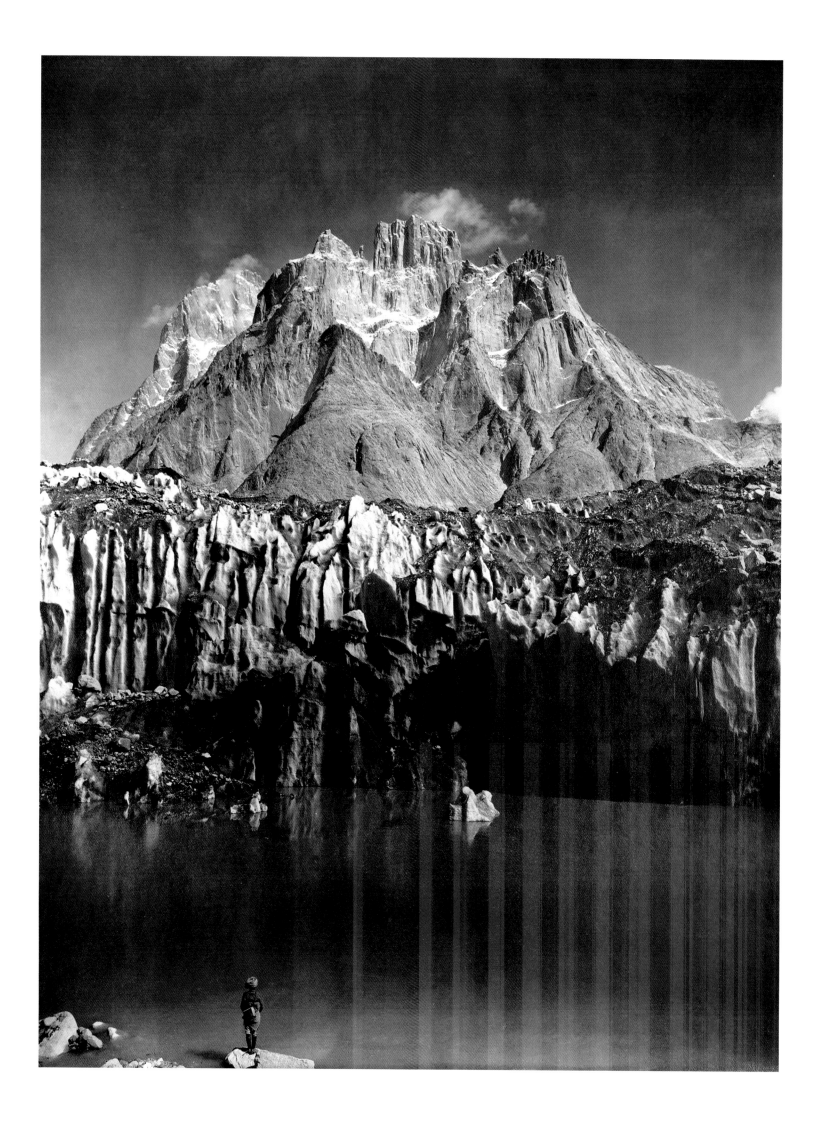

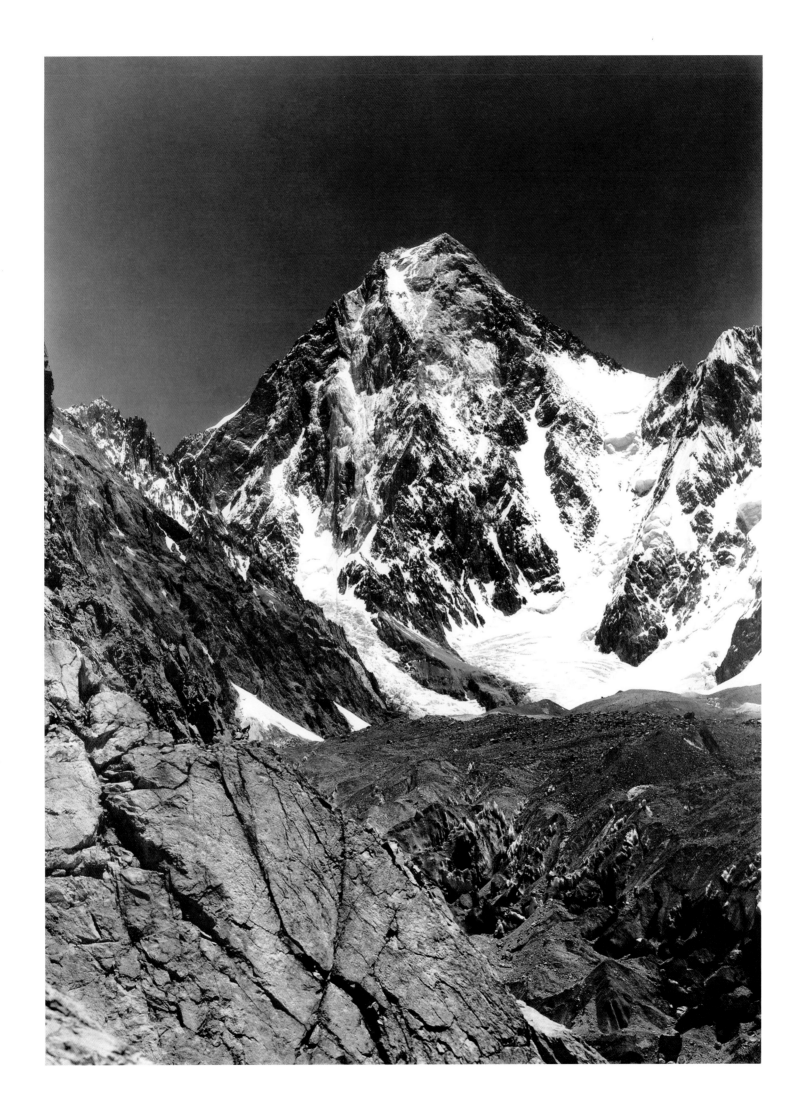

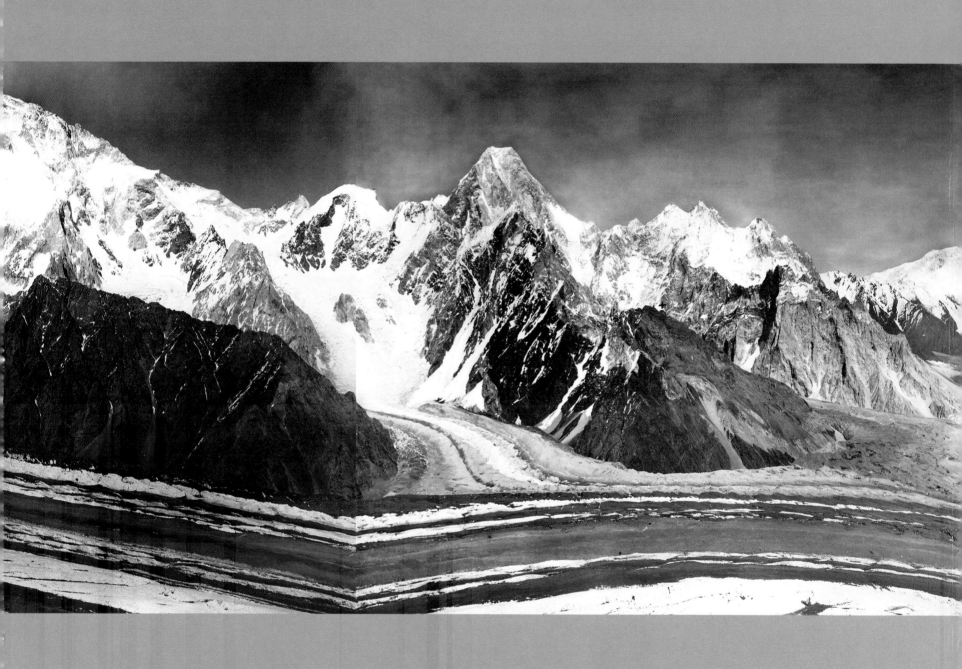

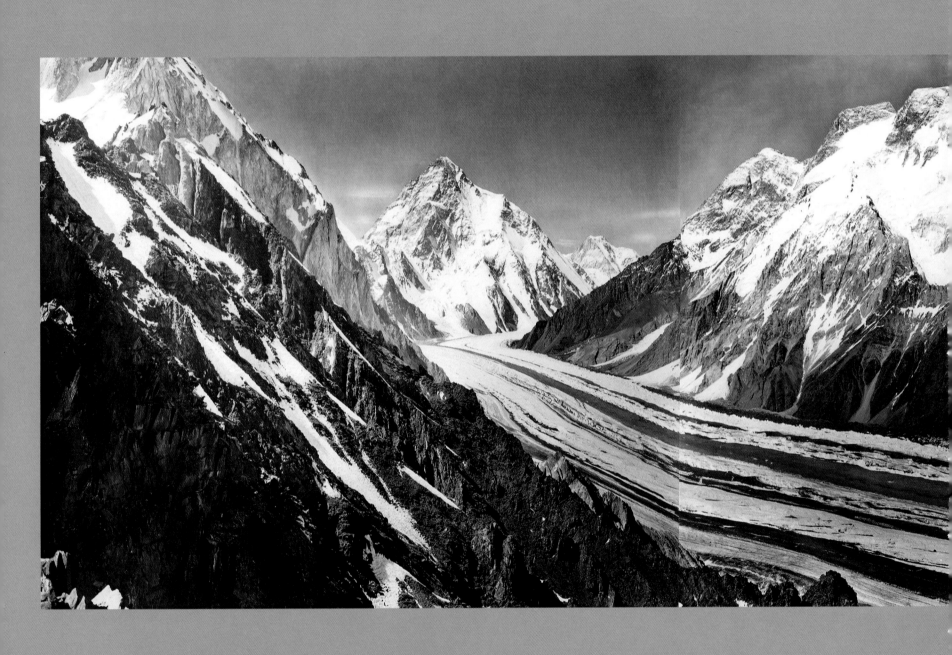

107 *PANORAMA OF THE BALTORO GLACIER; K2, BROAD PEAK, GASHERBRUM IV, 1909*

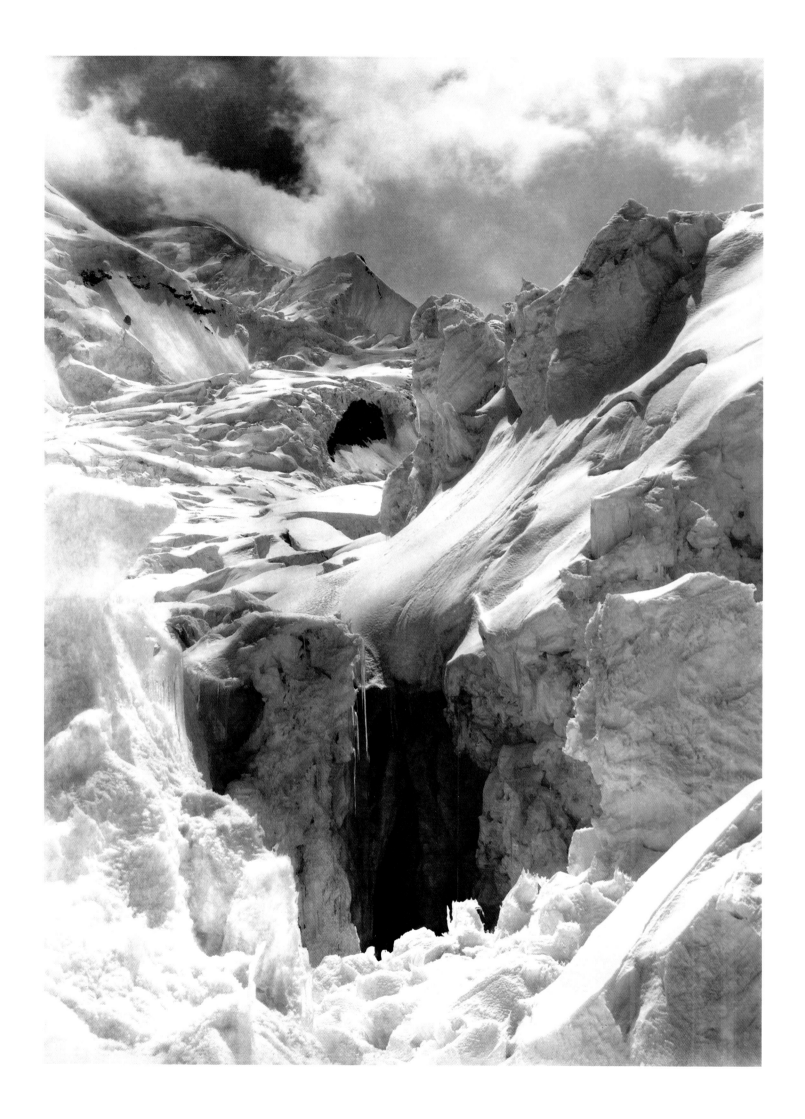

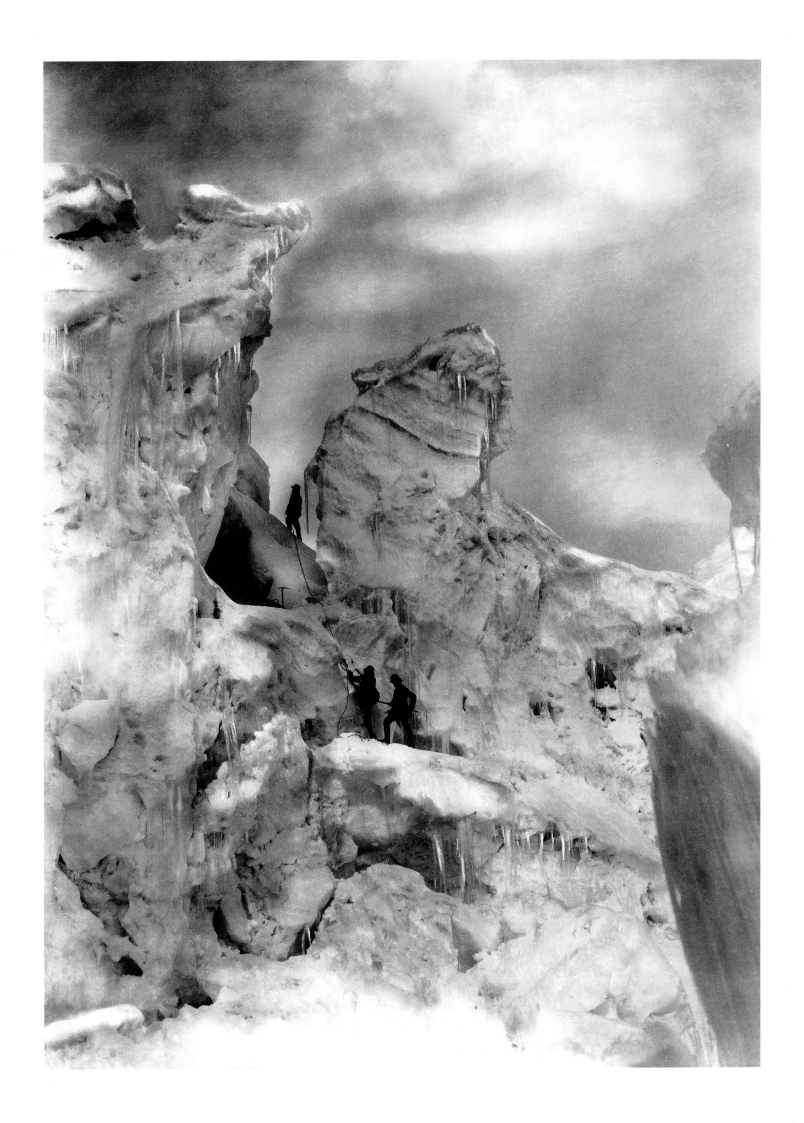

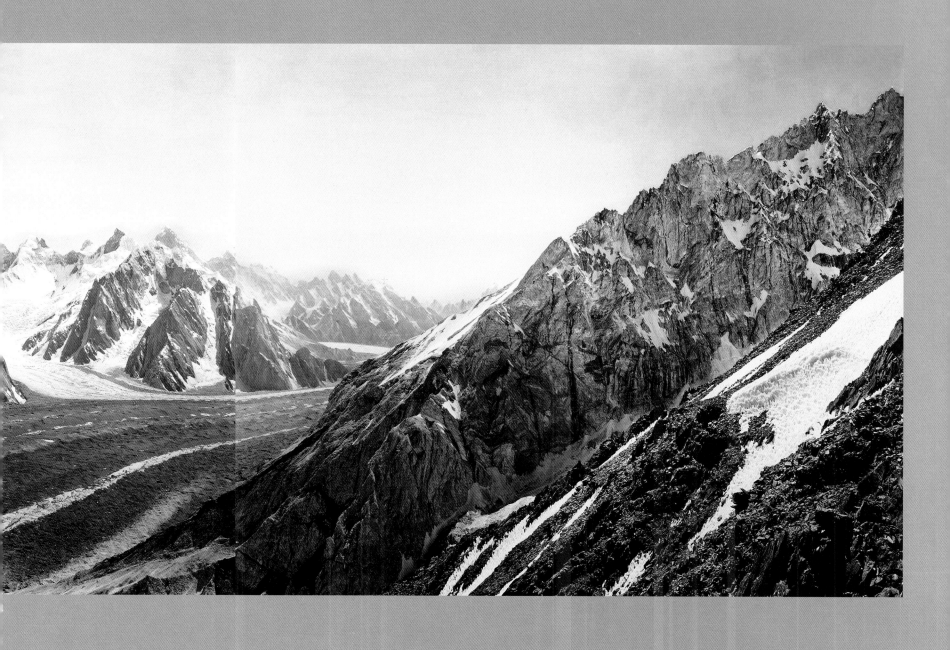

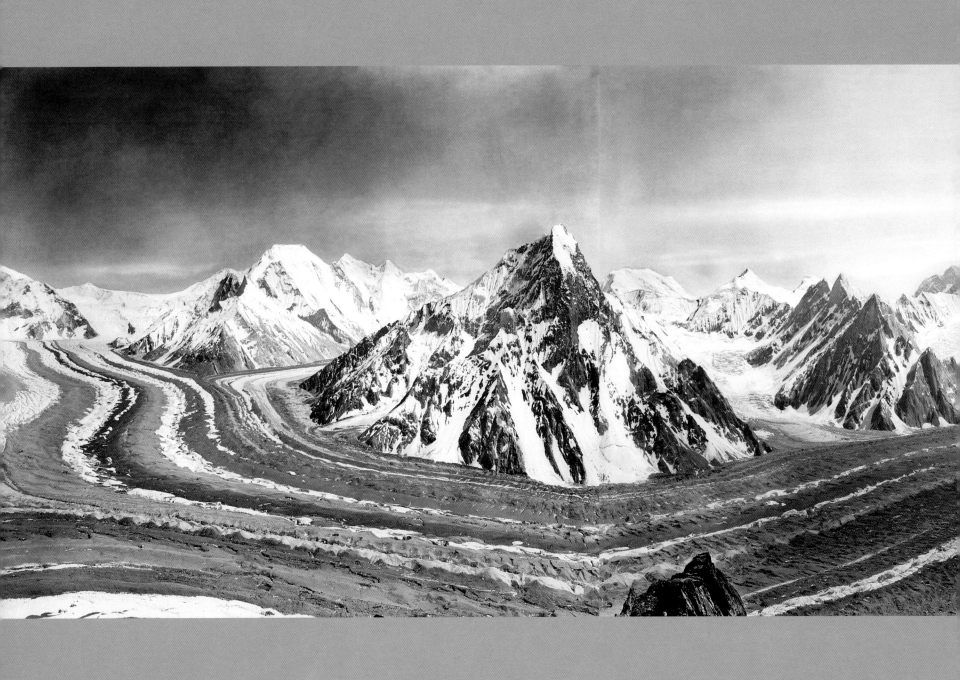

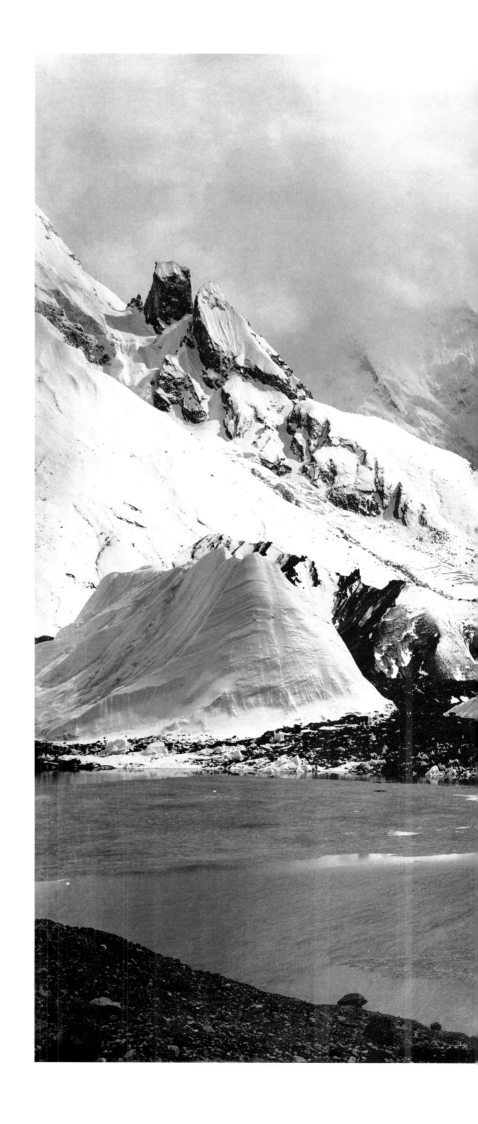

*(PREVIOUS, LEFT) CHOGOLISA GLACIER
ICEFALL, 1909*

*(PREVIOUS, RIGHT) THE DUKE OF ABRUZZI
AND GUIDES CLIMBING THROUGH THE
CHOGOLISA ICEFALL, 1909*

*MASHERBRUM IN GATHERING STORM
AND A MORAINE LAKE AS SEEN
112 FROM THE BALTORO GLACIER, MAY 1909*

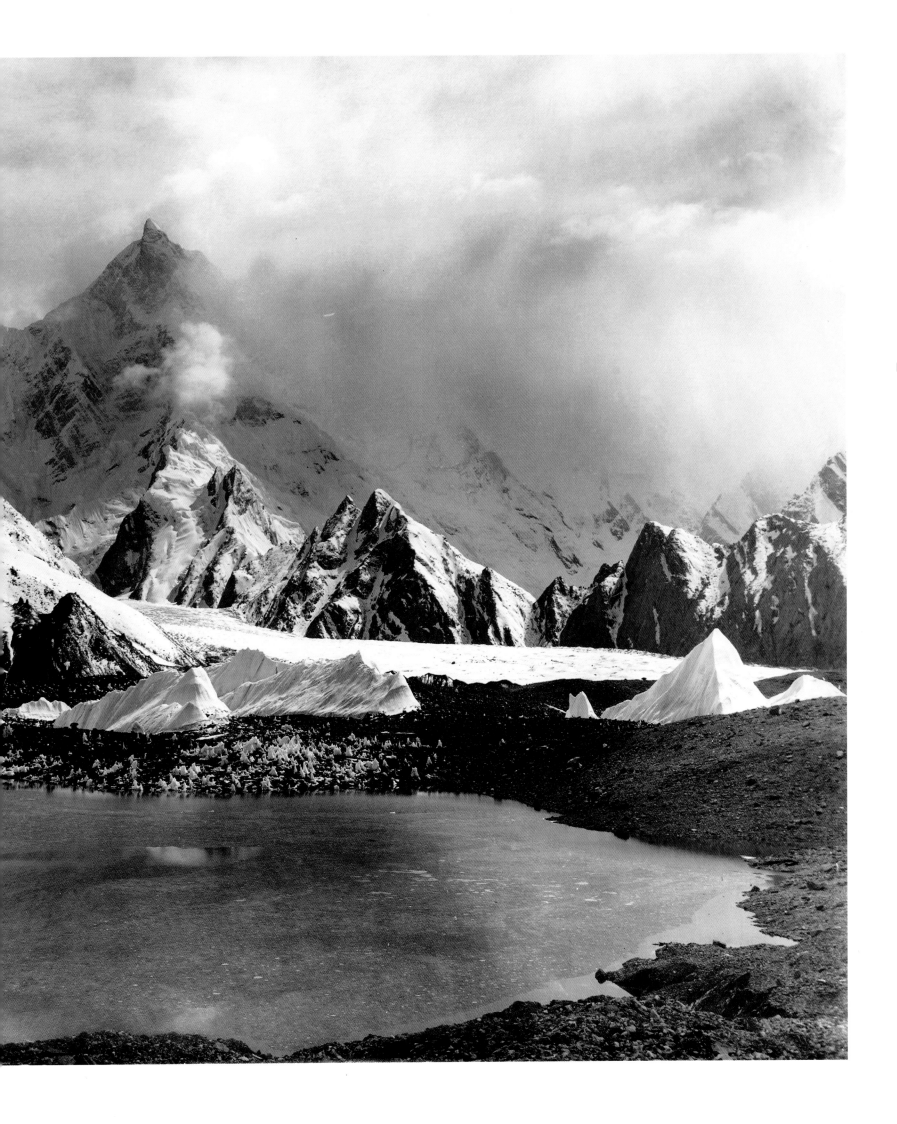

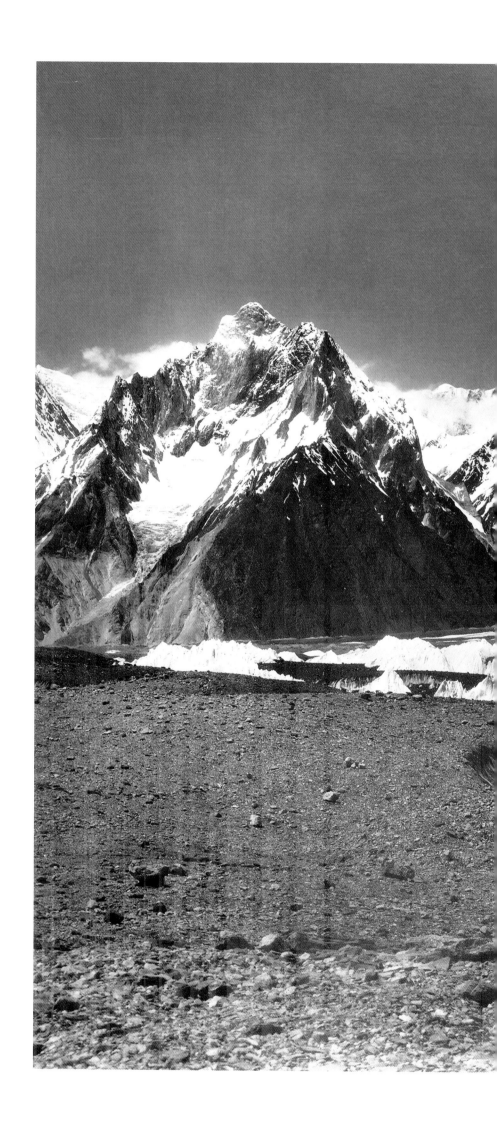

K2 FROM THE MIDDLE MORAINE
OF THE BALTORO GLACIER, 1909

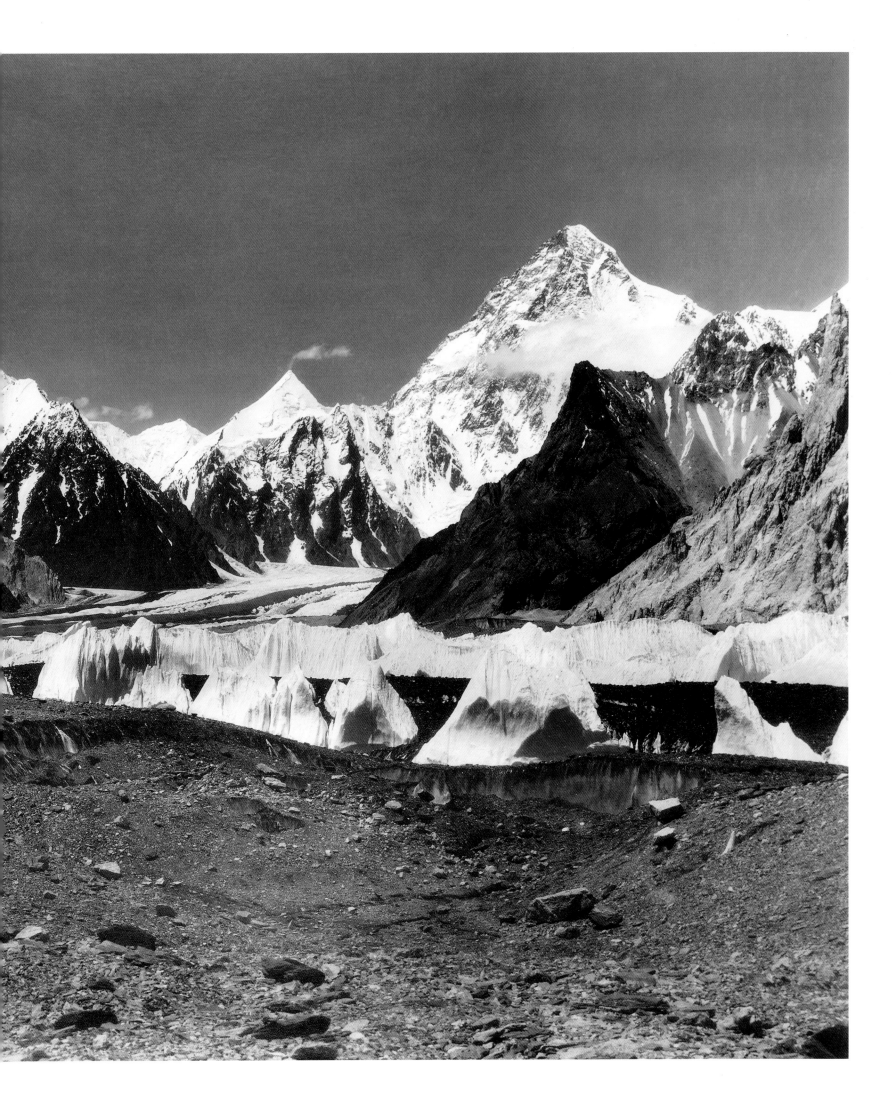

CAMP BELOW BROAD PEAK
116 ON THE GODWIN AUSTEN GLACIER, 1909

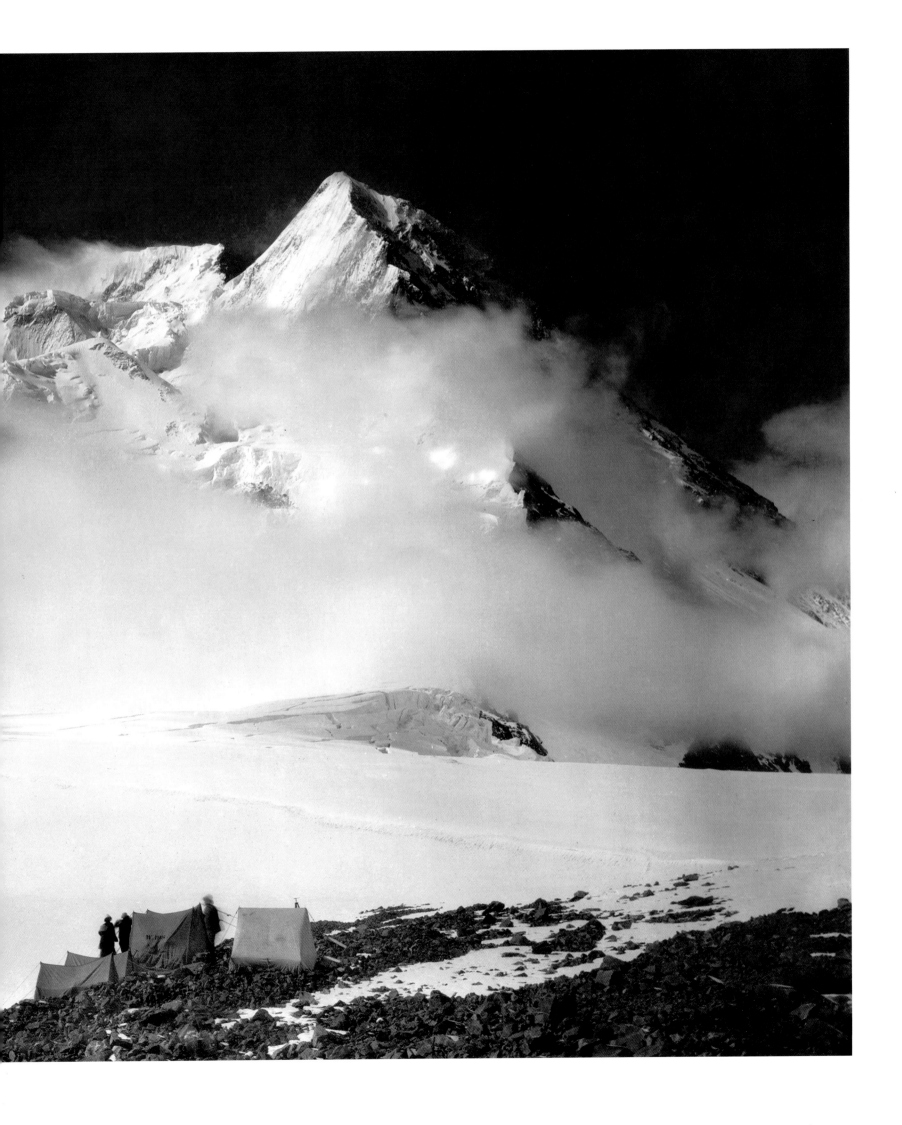

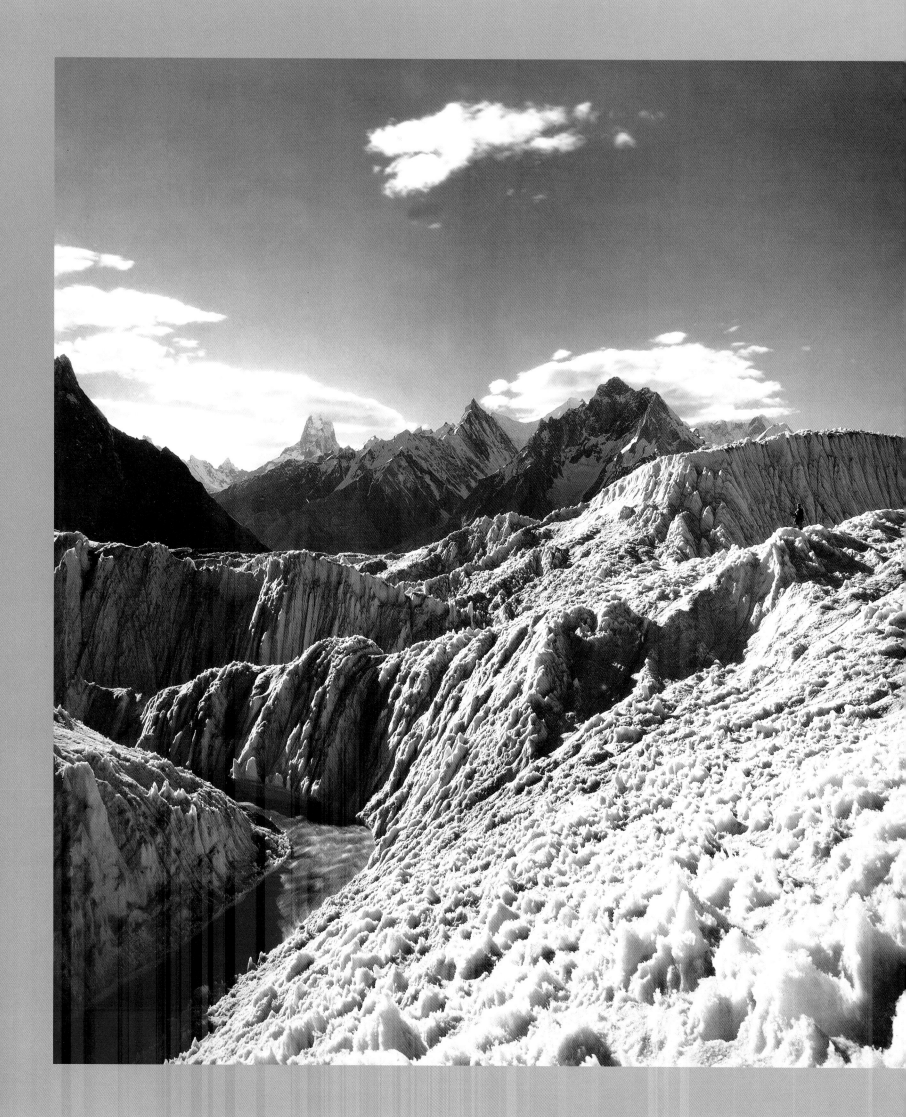

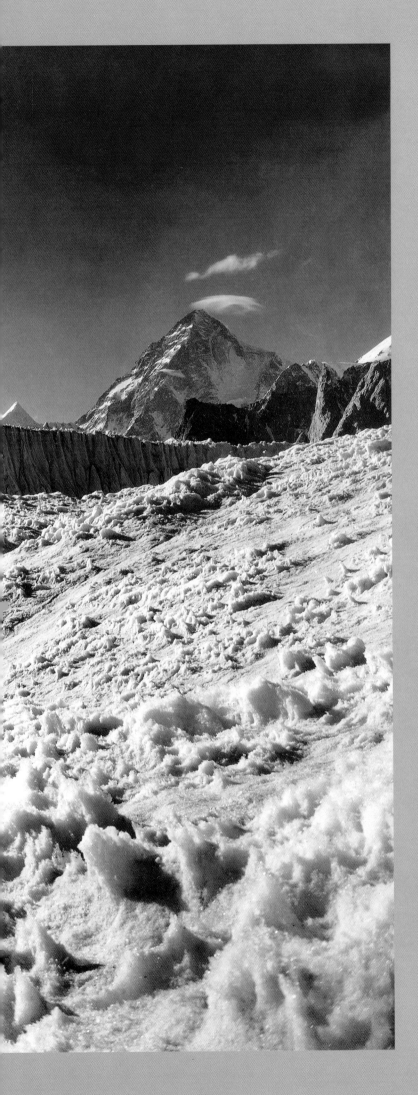

THE CONFLUENCE OF THE BALTORO AND VIGNE GLACIERS
WITH THE MUSTAGH TOWER AND K2 IN THE BACKGROUND, 1909

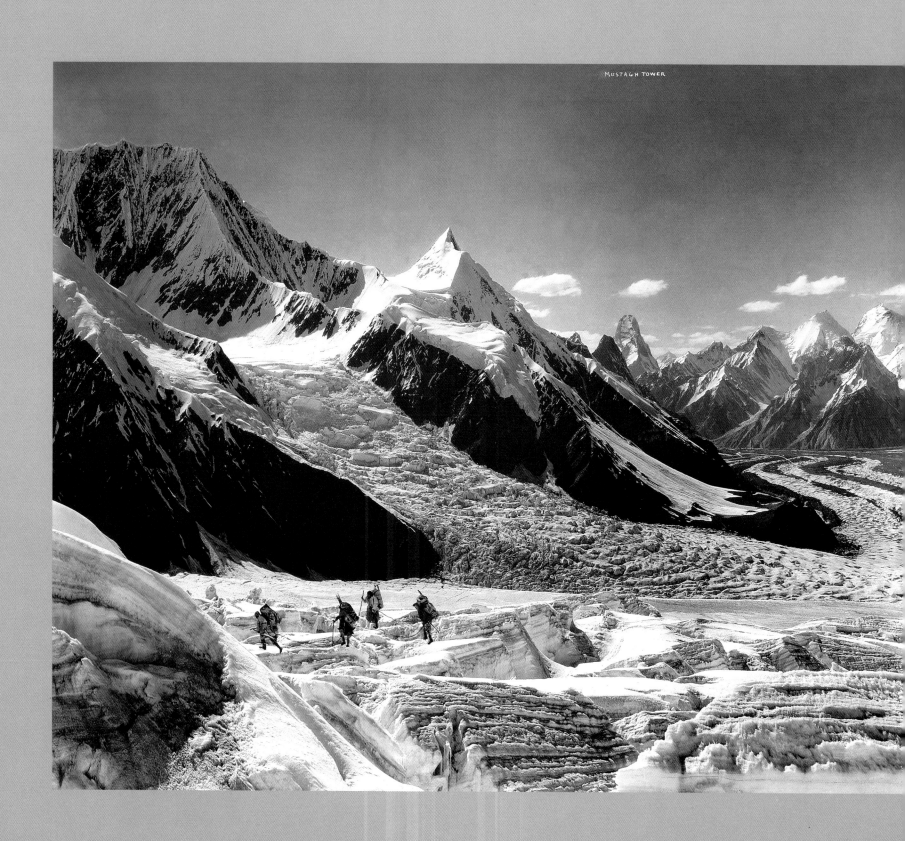

MUSTAGH TOWER

120 *PANORAMA OF THE BALTORO GLACIER WITH MITRE PEAK, MUSTAGH TOWER, AND K2 IN THE BACKGROUND, 1909*

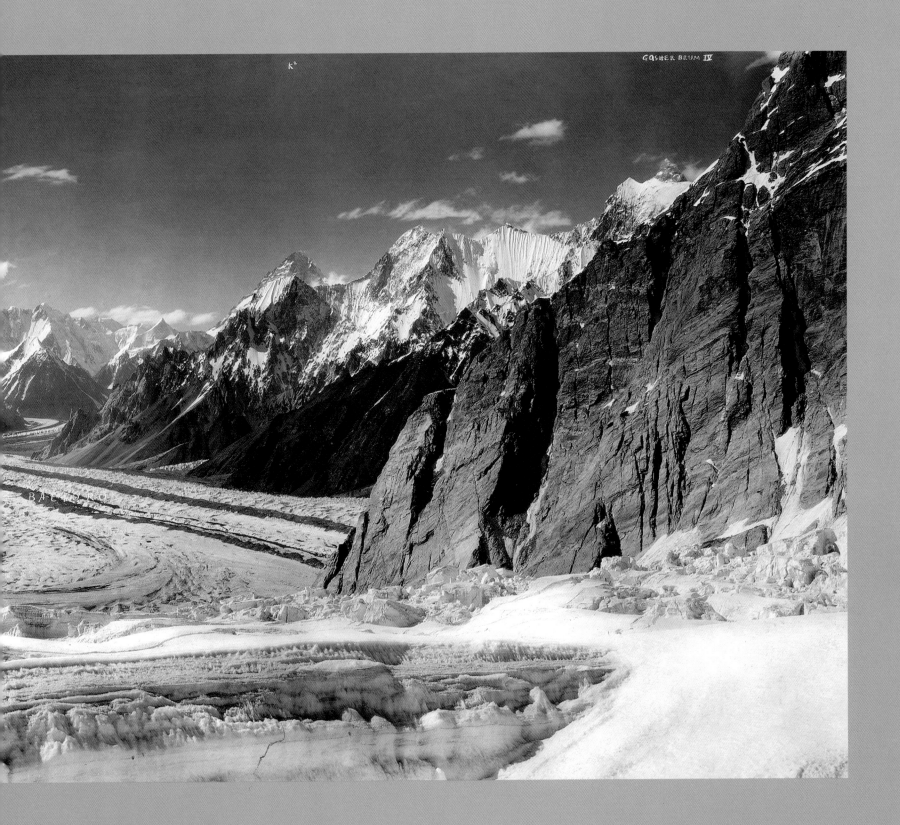

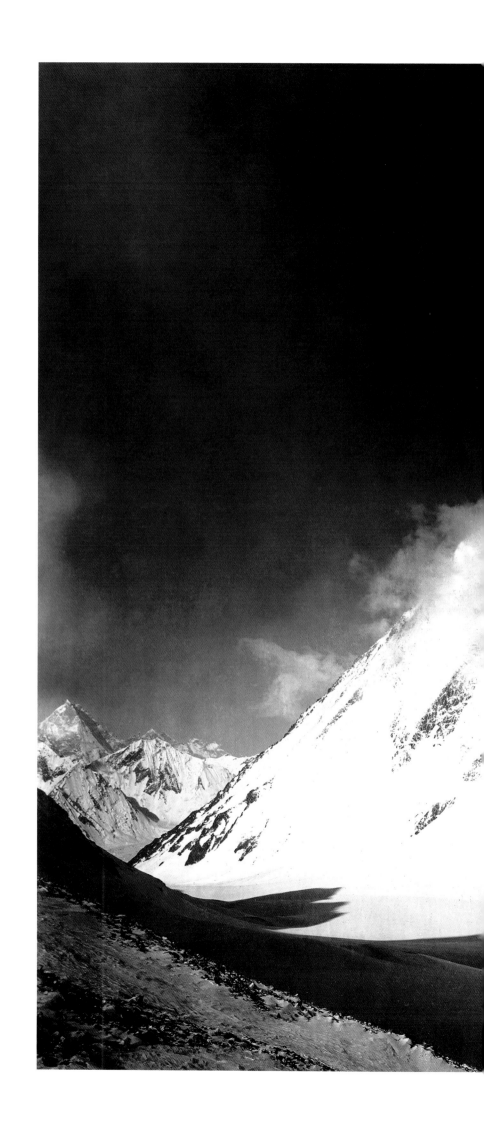

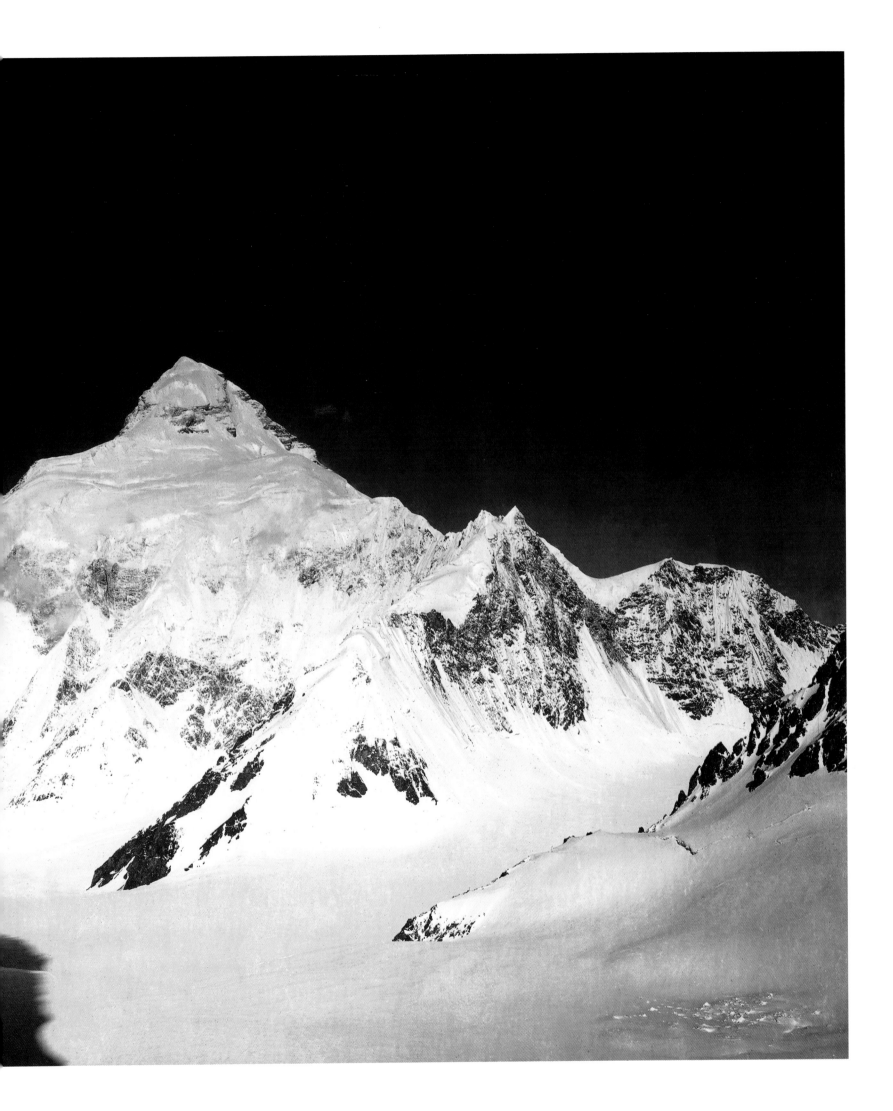

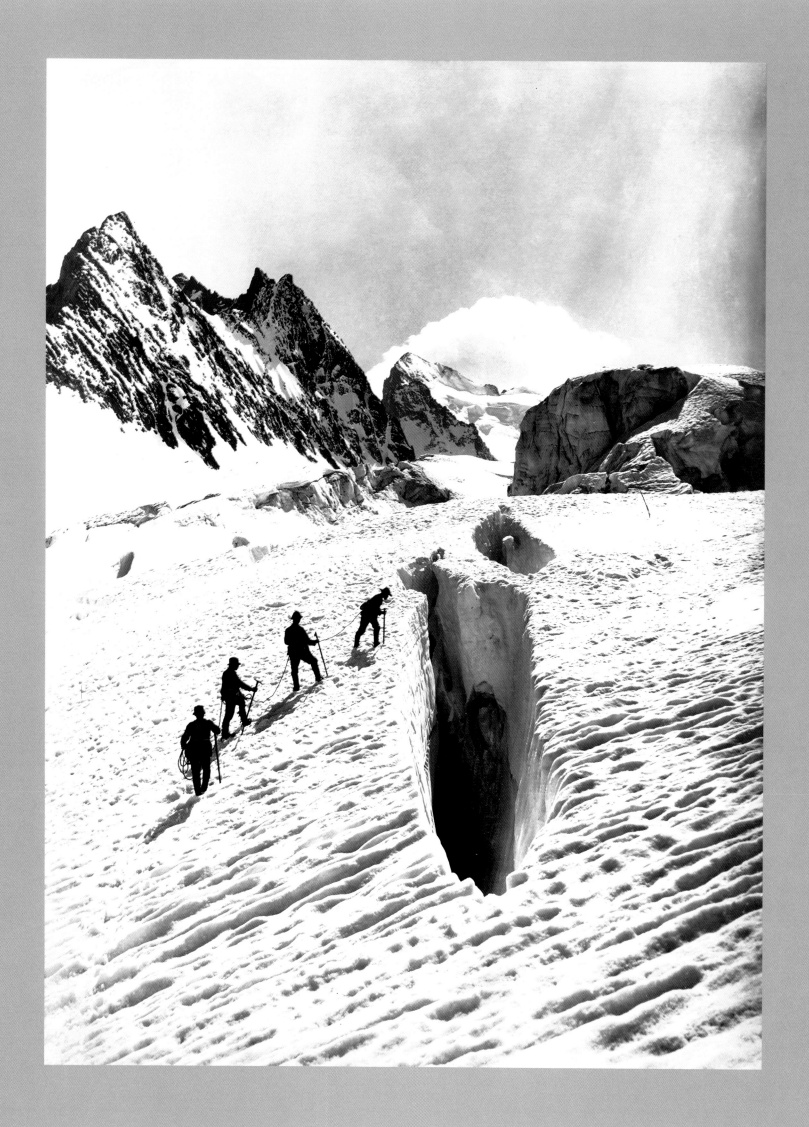

PICTURING THE SUBLIME:
THE PHOTOGRAPHS OF VITTORIO SELLA

BY WENDY M. WATSON

Vittorio Sella grew up in the shadow of the Italian Alps where picturesque valleys descend from the high mountains to a plain marked by an ancient glacial moraine. Like so many Italian artists since the Renaissance, Sella's geographical origins lay at the heart of his future attainment. His name itself—which means "saddle" in Italian—reflects the shape of the curving mountain ridge occupied by his ancestors centuries before the family settled in the town of Biella, where Vittorio was born. In a sense, he was predestined to devote his life to the depiction of vertiginous landscapes, both at home and far beyond the borders of his native Italy, in Asia, Africa, and North America.

Three years before Vittorio's birth in 1859, his father, Giuseppe Venanzio Sella, a well-to-do textile manufacturer, authored the first Italian-language treatise on photography.[1] It was the invention of photography two decades earlier and his father's own fascination with the new medium that forged the link to Vittorio's future. In 1863, his uncle, the statesman Quintino Sella, founded the Italian Alpine Club, today over three hundred thousand members strong. After the death of Giuseppe Venanzio in 1876, it was Quintino who took responsibility for his nephew's upbringing. The influence of these two dynamic figures on the life of Vittorio Sella was profound. So profound, in fact, that late in his life Vittorio tersely summed up his achievements in a single sentence: "My only merit is that I have loved the mountains since I climbed them as a boy with my uncle, and that I took photographs of them."[2]

This modest statement does not begin to describe the power of Sella's arresting images, described by alpinists and photographers alike as the greatest mountain photographs ever made. But Vittorio Sella was a man of few words—taciturn and restrained in demeanor, communicating his thoughts and emotions primarily through the lens of his camera. "I have always been by nature . . . a man not of study but of action . . . from my boyhood an enthusiast of the beauties of nature and a dreamer about scientific and mechanical discoveries. In school, my favorite reading was about adventurous travel and big game hunting in wild and far-off places."[3]

There is a certain irony in the fact that this quiet man from a small town in northern Italy pursued a career as adventurous as the stories that had captivated him as a schoolboy, one that took him to places where few Europeans had ever gone, to the ends of the earth, to the roof of the world. Using cumbersome photographic equipment and experimental technologies, Vittorio Sella worked resolutely to make photographs that would convey the moods and forms of these remote places and their inhabitants. The challenges—both physical and aesthetic—were enormous, but photography provided Sella with the means to capture images that even

the climber might not apprehend at the moment of their making. In one of his accounts about photographing in the Caucasus, he wrote: *I can see fixed on paper the vision of a lost instant. I recognize scenes I had not been able to admire on the spot. And, in such details, I sometimes find the elements of beauty. The toil and accidents of a climb often blind our eyes to the beauty of the highest regions. Our mind cannot retain a true notion of the views we admired. We know we felt up there the strongest emotions, we remember but dimly the truth of the sites which fascinated our senses. Photography helps to choose, to detail, and to idealize such elements as can form a beautiful alpine scene.*[4]

Sella was not the first to photograph at high altitude, nor would he be the last. But he lived at a critical moment in history when the eighteenth century's notion of mountains as concrete representations of the sublime intersected with the burgeoning scientific investigations of the modern era. Reviewing an exhibition of Sella's work in Boston in 1893, one critic wrote: *All the pictorial efforts that have been made to give an idea of the sublimity and beauty of the upper regions of the Alps pale their ineffectual fires beside the photographs of Mr. Vittorio Sella, now on exhibition in the galleries of the Boston Art Club. Painters have vainly tried the impossible task and it has remained for the indomitable Italian alpestrian to carry his camera to the very summits . . . for the purposes of bringing down to us the pictured marvels of those terrible heights. . . . It testifies in a most convincing manner to his skill, his taste, his industry, and his courage. . . . The structure of the mountains is graphically revealed, and the imposing forms of the cliffs and ridges . . . of so many almost inaccessible heights, affords much rich material for the scientist and explorer.*[5]

The cultural ambiance into which Vittorio Sella was born was a vibrant one. Affluent and successful in business, his family placed a high value on education and intellectual pursuits as well as outdoor activities like hiking and climbing. A handwritten note found behind a shutter in the family's villa at Lessona outlined a rigorous summer schedule of lessons for Vittorio and his sister Giuseppina: every day except Sunday the children were given a series of hour-long lessons in reading, music, English, German, Italian, calligraphy, and drawing, with periods set aside for recreation and work. His great-aunt had been a pupil of the Swiss landscape painter Alexandre Calame whose Alpine scenes were highly prized and, as a youth, Vittorio himself studied with the painter Luigi Ciardi. He had obviously gained some degree of facility as an artist by 1882 when two of his landscapes—a charcoal drawing and an oil painting—were included in an exhibition in Biella.

The family's private library was a rich resource for the study of literature, languages, classics, history, geography, the sciences, and philosophy, as well as for the tales of mountaineering and adventure that Vittorio so loved. Although not a scholar by nature, he was highly inquisitive and could hardly have remained unaffected by the far-ranging interests of his extended family. This cultivated environment had an obvious impact on Vittorio's formation as a photographer and upon his lifelong curiosity about every detail of the natural world, from the smallest insects to the highest peaks, whether at home in Italy or far away in the Himalayas or equatorial Africa.

By his own admission "deficient" in his youthful studies of Greek and Latin, Vittorio was at the same time fascinated by optics, geography, and the natural sciences, as well as chemistry and photography. His studies of the works of natural scientists like Alexander von Humboldt—a remarkable explorer and sometime mountain climber—provided firm grounding for his participation in the expeditions of Sir Douglas Freshfield and the Duke of Abruzzi. Not surprisingly, Vittorio was also drawn to the seminal works of alpine literature—Horace Bénédict de Saussure's *Voyages dans les Alpes* (1787), John Tyndall's *Glaciers of the Alps* (1860), and Edward Whymper's classic accounts of the 1860s and 1870s which made him the best known of all mountaineers of the period. In these and other

alpine classics, Vittorio found a combination of a deep love for the mountains and a systematic scientific approach that resonated in his own mind.

As Vittorio's career advanced, he retained an acute awareness of the aesthetics of landscape painting, mentally comparing his own photographic *vedute* with those of contemporary and earlier artists. Writing about one of his views of the Caucasus, Vittorio lamented that his camera was not up to the task, which in his opinion required "the brush of Calame" for an accurate portrayal.[6] Temperamentally introverted, he seldom revealed his deepest feelings about his aes-

casus in 1890, he read Peter Henry Emerson's just-published *Naturalistic Photography for Students of the Art*, in which the author championed photography as an art ranking second only to painting.[8] What particularly caught Vittorio's eye in this revolutionary work were passages from a letter of Jean François Millet in which the painter speaks of nature and its relationship to absolute beauty: *We should accustom ourselves to receive from nature all our impressions. . . . Truly, she is rich enough to supply us all. And whence should we draw, if not from the fountainhead? . . . Men of genius are gifted with a sort of divining-rod; some discover in nature this, others that, according to their kind of scent.*[9]

 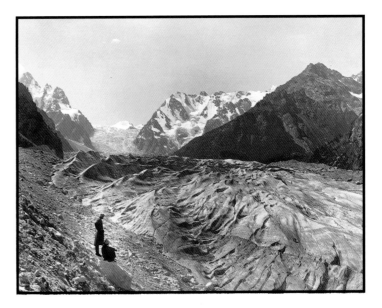

thetic sensibilities or those of others. A rare anecdote, conveyed in a letter to his wife, records his despair about his fellow explorers' disregard of the extraordinary surroundings: *In spite of the alpinistic, geographic, and photographic success, it does not give me any satisfaction because of the daily disappointment about the sentiments and the moral quality of almost all of my companions, in whom you would not find a speck of poetry or of interest in the really beautiful things even if you looked for it with a microscope.*[7]

Sella clearly viewed his photographs as more than mere scientific documents even though he never openly declared his work to be "art." On the eve of his departure for the Cau-

Too modest to declare himself a "man of genius," Vittorio apparently found an important touchstone in Millet's appraisal of the natural world as the primary source of inspiration, and he transcribed these passages into the front of his Caucasus diary as a reminder.

By 1856, when John Ruskin wrote that "mountains are the beginning and end of all natural scenery," Alpine locales had already become veritable magnets for men with cameras.[10] Ruskin himself claimed to have made the first "sun portrait" of the Matterhorn in 1849 which he asserted was the first photograph ever taken of any Swiss mountain.[11] Soon afterward, Friedrich von Martens, a friend of Vittorio's father, began mak-

ing Alpine and glacier views, and exhibited a panorama of Mont Blanc at the 1855 Paris Universal Exhibition.[12] Others, including the renowned Bisson brothers, Ernest Edwards, Adolphe Braun, Samuel Bourne, and Vittorio Besso, ventured forth into the rugged terrain to bring back images for the delight of those who would never leave the comfort of their cozy salons back home in Paris, London, or Turin.

But why the rush to conquer these vertical realms and to record them with the new photographic technology? It was no accident that the beginnings of mountaineering as a sport coincided with the recognition that mountains were, in fact, beautiful.[13] And the development of photography coincided with that very moment in the history of natural philosophy which has been called the era of moralized mountaineering.[14] Those "high and hideous Alps . . . those uncouth, huge, monstrous, Excrescences of Nature"[15] of the seventeenth century had by the early nineteenth century become the subject of a vast literature of exaltation. Byron, for one, saw the Alps as "Palaces of Nature . . . the greatest manifestations on earth of the Power that had created them"[16] and Wordsworth interpreted all mountains as physical embodiments of the eternal. In the past, travelers rushed over the Alpine ranges on their way to Italy, seeing the snowy peaks as mere obstacles in the pathway to Culture. Under the influence of these writers, however, there was a new appreciation of mountains as something magnificent and consequential, something worthy of serious contemplation.

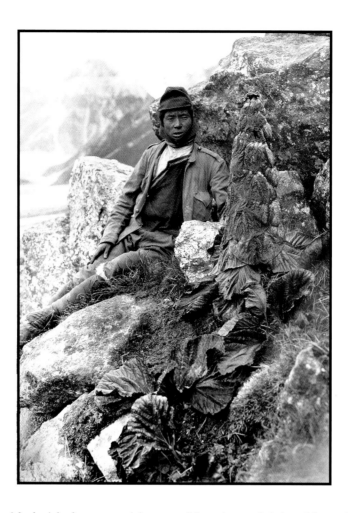

Descriptions of mountains as dizzying, terrible, sublime, awesome, primeval, and majestic flowed easily from the pens of Byron, Wordsworth, Shelley, and other Romantic writers. Shelley, author of a remarkable poem about Mont Blanc, described his feelings upon seeing the mountain for the first time as "a sentiment of ecstatic wonder, not unallied to madness."[17] The works of these poets and philosophers filled the Sella family bookshelves, along with volumes by naturalists, alpinists, and explorers. Although we cannot know exactly which of them Vittorio read, it is evident that he shared many of their emotional and aesthetic attitudes. His breathless account of arriving at the summit of the Matterhorn for the first time echoes Shelley's own words: "The view was magnificent. We reveled in its inconceivable majesty without attempting to analyze each detail. Our emotion, which was almost sacred, cannot be described."[18]

The "mountain brotherhood between the cathedral and the Alp" of John Ruskin was felt deeply by Sella and by many other adventurers, writers, and artists.[19] As early as the fourteenth century, Petrarch chronicled his ascent of Mont Ventoux in southern France, casting it as an allegory of man's earthly passage and his striving for a higher spirituality.[20] The original purpose of his climb had been to enjoy the view from the summit, but his actual experience upon reaching the top caused him to reflect upon the essential vanity of Man's earthly pursuits. Generations of mountaineers have since done the

PORTER WITH RHUBARB PLANT, ZEMU GLACIER, SIKKIM, 1899

same, often treating these vertical quests as spiritual or philosophical exercises.

The new approaches to science, theology, and art that emerged from the eighteenth century were accompanied by a new set of emotions that were aroused by the physical grandeur of mountains. "Sublime" became the watchword of the time and the Alps became the temple of that sublimity.[21] To Wordsworth and others of the Romantic era, alpine pinnacles became symbols of the heights to which the imagination of man could aspire, toward the unattainable goals of understanding infinity, eternity, and the vastness of God.[22] With those concepts came an awakening of interest in landscape and natural scenery, and a linkage of the arts—poetry, painting, photography, and even the art of travel—in the effort to convey the emotions that accompanied the full experience of Nature.[23] In this new philosophical arena, the Alps also became the admired locus of an austere, primitive virtue untainted by the incursions of man and modernity.[24] Vittorio Sella was heir to these philosophical trends which take concrete form in his photographs. And his approach was governed by rigorous technical and aesthetic standards that he termed "la realtà severa"—severe reality.

Sella's earliest photographic efforts involved chemical experiments based on his father's treatise and gleaned from other photographers in Biella, especially Vittorio Besso. The young man learned to prepare his own wet-collodion plates and tried his hand at portraits and views. A milestone in his career came in the summer of 1879 when he set out to create a panoramic photograph from the summit of the Monte Mars, a 8530-foot peak above the nearby religious sanctuary of Oropa: *Making use of a black tent or curtain, with yellow glass, and passing several days and nights on the very summit of the moun-*

tain in July 1879 with one assistant, a workman from the factory, I was able to carry out my undertaking fairly well, with an immense camera obscura and stand lent to me by the photographer Besso. There were many difficulties as it was necessary to carry all the material including basins, bottles, and canvas buckets, to sensitize each of the 30 x 36 cm plates at the right moment, to carry out the necessary exposure, and then to develop, fix, and wash them. I remember clearly that because of the changeableness of the weather I was able to expose only a few plates in the early morning, and that

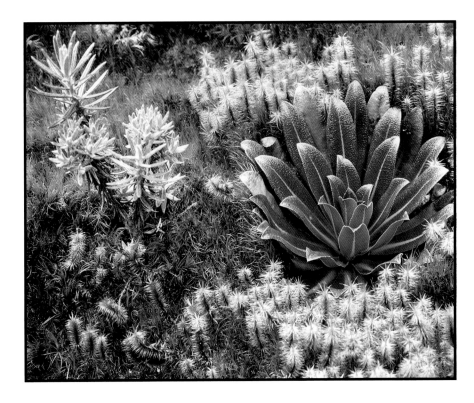

I had to make several ascents of the mountain from Oropa to photograph the panorama.[25]

His efforts yielded a sweeping view of the Alps from Mont Blanc to Monte Rosa, and the arduousness of the process set the stage for his future expeditionary work.

Vittorio continued to experiment and learned to use dry plates that could be prepared in advance, greatly easing his work in the mountains. In March of 1882, he succeeded in making the first winter traverse of the Matterhorn—a "magnificent feat" for which he was warmly congratulated by the Alpine Club in London—and in July he returned to the moun-

tain to make a twelve-plate panorama. Now he was off and running. "From 1880, I made up my mind to combine photography with Alpinism, and I took almost no interest in the lower parts of the mountains, and confined myself to photographic work on the summits, and to those higher regions of the Alps which were little known and had not been photographed."[26] This project stretched out over fifteen years, during which Sella used primarily a large-format camera that accommodated 30-by-40-centimeter glass plates. The camera was or-

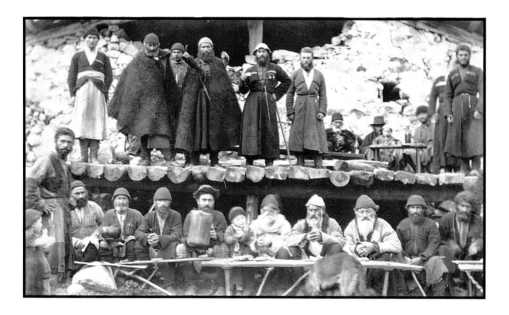

dered from Dallmeyer of London in the fall of 1882, and represented a reversal of the trend toward lighter, more manageable photographic equipment.[27] Despite the inconvenience of the cumbersome apparatus, Vittorio steadfastly believed that the larger size and the proportion of these negatives were more appropriate for his particular vision, especially with regard to horizontal views. Others agreed. In 1890, the explorer Douglas Freshfield wrote: *Signor V. Sella several years ago took up the photography of the high peaks, in which he has been recognised throughout Europe as the one rival of Mr. W. F. Donkin. Their methods indeed were different. Mr. Donkin made portability of apparatus his first object; while Signor Sella indulges himself in a large camera and glass plates by which he is able to obtain in some ways more perfect results, particularly in atmospheric effects and snow texture.*[28]

Sella's mountain pictures, like those of the Bisson brothers, Adolphe Braun, Aimé Civiale, Donkin, and others found a receptive audience among mountaineers and armchair travelers alike. The year 1882, already a momentous one for Vittorio Sella, also marked his transition from dilettante to professional photographer. In September, he wrote to the London dealer Spooner to inquire whether he would be interested in selling his photographs.[29] Soon, Vittorio was showing his work in exhibitions and receiving a steady flow of orders from clients in Italy, France, Germany, and England. Donkin's prominent mention of the Matterhorn panorama in an article in the November 1882 *Alpine Journal* provided another boost to his growing reputation.[30]

The increased interest in mountain climbing and scientific exploration produced a vogue for images of the more remote regions of the world. By 1888, the annual exhibition of mountain paintings and photographs at the Alpine Club in London had become so popular that "the rooms were inconveniently crowded," according to one reviewer. While the audience for these shows had been minimal a decade earlier, the same writer noted that it had since multiplied at an "alarming" rate.[31] The combination of photography with the nineteenth-century enthusiasm for travel of every sort fundamentally altered the way people saw their world. With photography, that world had become a much smaller place, and the public's fascination with distant and inaccessible places became ever greater.

For traditional Grand Tour travelers of the eighteenth and nineteenth centuries, Italy—and especially Rome—had been the destination of choice. Europeans were still, in a sense, discovering their own continent. Once there, they eagerly

acquired images of the monuments, ruins, and scenery that were the objects of their ritual quest.[32] In the eighteenth century, those took the form of painted or engraved *vedute* by famous artists like Piranesi, Pannini, and Canaletto, or watercolors and drawings by lesser lights. After about 1850, though, photographs rapidly displaced views in other media and became the most popular and economical visual mementos of Italy. The Alinari brothers, Carlo Ponti, Giorgio Sommer, Robert Macpherson, and many others did a brisk business in souvenir photos which could be framed, seen through stereo-viewers, or placed in albums for enjoyment back home in London or New York.

Compared to these photographers, however, Vittorio Sella was engaged in an entirely different pursuit. Rather than focusing his lens on the art and monuments of his native land—recognized high points of human cultural achievement—he concentrated instead on nature. Embarking upon a grand tour of his own design, Vittorio turned northward to the Alps and later toward ever more exotic regions of the world. Unlike his colleagues in Rome and Florence, he worked under difficult, even perilous circumstances, far from a convenient studio or comfortable home. The laborious making of the Monte Mars panorama was just a prelude to the formidable challenges he would experience on expeditions to the Caucasus, the Himalayas, Alaska, and Africa. But Vittorio, a stoic by nature, appeared to relish adversity both in travel and in picture-making. One reviewer underscored this point, observing that the beauty of Sella's images was signif-icantly enhanced by the "spice of danger" involved in their creation.[33]

Vittorio realized that the audience for his photographs went beyond that inner circle of Alpine enthusiasts and that his images satisfied a growing public appetite for information about the planet. "Functioning like human sight to offer empirical knowledge mechanically, objectively, without thought or emotion," photography was indeed the perfect expression of the epistemological shift toward rationality, skepticism, and natural observation that began in the sixteenth century.[34] To this way of thinking, photographs were the next best thing to being there, providing a way to share experience, gain knowledge, and learn the truth about far-off places that few had seen at first hand. As one contemporary journalist wrote in 1893: "Climbers have hitherto been the only ones to see these things, and it is the distinction of Mr. Sella that he has brought such a rare sensation within the reach of all. There is a peculiar and inexplicable fascination about the grim Siberian wastes of the wind-swept peaks and the lonely upper slopes of the snow-covered Alps which none but the fanatical mountaineer may fully appreciate."[35]

Critics of alpine photography habitually divided the field between those whose views were picturesque and visually pleasing and those who aimed for topographical detail. Vittorio's images were usually singled out for praise on both fronts. His aim—paralleling that of artists in other media—was to blend the visual record of a place or experience with other, more ineffable qualities ranging from the artistic to the scientific,

the intellectual, or even the spiritual. The joining of photography and mountaineering inevitably led to a divergence of opinion about the value of the new image-making technique and about its relationship to drawing and painting. Photographs increasingly vied for attention in the annual alpine art exhibitions that had historically focused on watercolors, oil paintings, and drawings. While some lauded their aesthetic qualities, others found them wanting. Even Donkin was heard to say that "no photograph could equal a really good sketch."[36]

Douglas Freshfield was among those expedition leaders who believed in photography as the most effective medium for depicting the great ranges of the world. He singled out Sella and Donkin for praise, saying that both showed how "artistic sense and intimate knowledge of the mountains may be brought into play in an art some might deem mechanical."[37] By contrast, the climber-photographer William Abney bluntly stated that "the only photographs I advocate are what I may call photographic maps of a country—maps of peaks, maps of ice, maps of snow, maps of trees, and so on—and if there happens to be a feeling for art in the operator he can so arrange his view that the reproductions shall give aesthetic pleasure as well as be useful."[38] Although there were clearly areas of disagreement, most mountaineers were united in their opposition to what they disparagingly termed "that modern school of art-photography"—meaning pictorialism—with its too strident use of velvety chiaroscuro.

Two essential genres emerge in the oeuvre of Vittorio Sella: the sublime mountain pictures made on his Alpine climbs and during the expeditions with Freshfield, Abruzzi, and others; and the more literal images that record local inhabitants, the environment, camp life, and expeditionary activities. Vittorio's high mountain pictures have a kinship with paintings made by an artist for his own delectation, while the documentary pictures seem more detached, more objective

in nature. Created in response to the scientific goals of the expeditions, the latter were meant to illustrate and support data gathered during those campaigns, and were conditioned in part by those requirements. Vittorio's deep curiosity about the natural world came strongly into play here. His diaries, for example, include many notations about the flora and fauna that also appear in the pictures he took of plants encountered along the way (see page 129). One look at these images, however, tells the viewer that his interest in them was not merely scientific but also aesthetic. On the other hand, Vittorio was clearly able to separate his interests when he wanted to, as is evident from a notation on the back of his 1899 photograph (see page 128) of a Sikkimese porter perched next to a plant growing on a rocky hillside. While a modern eye is drawn toward the figure of this intriguing man from another era, Vittorio's inscription reads simply "rhubarb plant."

The expeditions in which Vittorio Sella participated were part of a wave of exploration that began in the eighteenth century and burgeoned in the nineteenth. Some campaigns were undertaken for reasons of colonization or imperial domination, or were based on missionary zeal, and photographers were often employed to provide the visual record. The expeditions in which Sella participated, on the other hand, were more intellectual in nature, or were based on mountaineering adventure. His documentary photographs, if they can be called that, were never intended as tourist souvenirs in the manner of Francis Frith's, but were meant instead to provide the empirical evidence—the visual "truth"—of the expedition members' experiences.[39] As such, they were included in the lengthy accounts of the journeys that were published to summarize their findings.

Vittorio studied people and their ways of life in all the places he visited, becoming an amateur ethnologist of sorts. His initial trip to the Caucasus in 1889 was an eye-opening experience in this regard (see pages 38–39). Journal entries

record his uncensored responses to the people he met in these isolated villages, ranging from respectful interest to outright revulsion. Describing their curiosity about the Europeans' scientific equipment, he wrote that "one of the locals (maybe a prince) with extremely civilized manners and an aristocratic aspect asked me, after seeing my barometer, what the height was of Chegem, the Elbrus, and the other mountains."[40] Other comments were less than complimentary. He described the *indigeni*, or natives, as having "coarse faces with a savage look" and in another passage remarked that "the locals of Soanezia are avaricious by nature . . . and live under most miserable conditions possible."[41] These en-

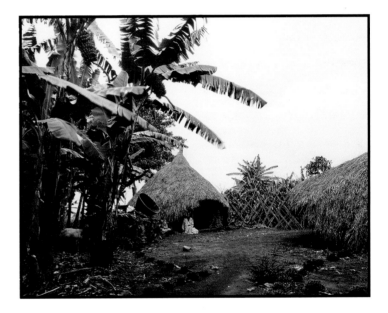

apart. In characterizing his alpine images, one cannot surpass Ronald Clark's assessment that Vittorio "could always, it seemed, see the essentials of a mountain scene and then so utilize the effects of sun, shadow, and atmosphere that those essentials were composed within the bounds of the ground glass plate as though on a painter's canvas. It was something far more complex than merely 'having an eye for a good picture,' something more than instinctively knowing the elements of good composition. It was almost as though Sella had some magic ability to visualize what should—rather than would—be the main features creating the effect he desired, and to grasp these from the atmosphere and build his pic-

counters had a profound impact on him. Back home in Italy, he produced an important pictorial study of the rural peoples of Monte Rosa and Gressoney.[42] His experience of "the other" in the distant valleys of the Caucasus had evidently prompted a new vision of pastoral cultures closer to home. Later in Africa, he used a good proportion of his film making similar studies of local people and their customs.

But it is primarily as an interpreter of mountain scenery that Vittorio Sella is remembered, and his work in this arena remains unsurpassed. In the end, it is the fusion of technical capability and aesthetic vision that sets his mountain images

ture round them."[43] In diary entries, one glimpses a sort of "optical unconsciousness" at work in his high-altitude photography, as he describes the "desire to capture with the camera the fleeting image of that meeting of cloud and mountain, to reproduce faithfully the atmosphere of the panorama even more accurately than it can be seen by the eye or retained by the mind."[44]

Other factors contributed to the success of Vittorio's mountain pictures apart from his instinctual artistic vision. Like every photographer, he faced the inherent limitations of the medium, but was also attentive to the opportunities for

(LEFT) CROSSING THE SHIGAR RIVER ON A GOAT-BLADDER RAFT, KARAKORAM, 1909

(RIGHT) BANANA TREES WITH GRASS HOUSE, UGANDA, 1906

visual ordering. He was highly sensitive to issues of proportion and format, for example, changing cameras or the orientation of the negative to accommodate particular subjects. Although one might expect to find more vertical photographs in the work of a mountaineering photographer, Vittorio more often followed the historical preference of landscape painters, turning his plates on the horizontal (see pages 26, 30, 31). When the image warranted it, however, as in his views of Siniolchun (see page 75) or a gigantic tree in Sikkim (see page 135), he chose the upright format.

Vittorio's fascination with broad panoramic effects was shared by numerous photographers from the earliest days of photography.[45] The taste for panoramas may have been fueled by the very inability of the human eye to perceive reality in this fashion, and there was historical precedent for it in other media as well. Painted and three-dimensional panoramas or dioramas were among the most popular entertainments of the early nineteenth century and played a significant role in shaping the public's understanding of scenery from the Holy Land to the high Alps.[46] The preternaturally broad view of this format, of course, resembles what the mountaineer would see from a summit once he had arrived, and what he might be inclined to preserve for later recollection.

Vittorio's 1890 view from the Elbrus is undoubtedly one of his most impressive of these works (see pages 45–48). Made during an expedition whose primary goal was to remap the region, it served as a remarkable record of the Caucasian range, and stands on its own as a stunning visual image. In Freshfield's words: *The picturesque effect is greatly heightened by a shining floor of clouds, the roof of the lower world, which cover the valley of the Baksan and the distant steppe. . . . Above the clouds which lie at about 9,000 feet, the main chain, with its great spurs, its lateral ranges, and its glacier basins, is spread out in the clearest detail as far as the central group. . . . The photograph has the precision and conveys much of the information of a relief model on a great scale. . . . Those who have never seen a great mountain view may look upon this presentment and form some accurate idea of the reality; those who have said that there is nothing to be seen or learnt on great peaks may look at it—and repent.*[47]

The minimalist nature of high altitude landscapes, of course, conditioned Sella's fundamental approach and his pictorial language to a great degree.[48] Unlike a painter who has virtually infinite freedom in the choice of color, arrangement, and handling of his materials, Vittorio was challenged to create successful compositions out of observed facts. He developed a masterful control over his exposures, obtaining a subtle balance even in images composed primarily of rock, snow, and sky. He was also fascinated by the possibility of conveying reality as it was perceived by the human eye, and experimented with different toners and pigments to create coloristic effects in some of his prints.[49] Sella's choices of apparatus and technique made possible an intense clarity of detail that echoed the alpinist's

first-hand experience and rivals the achievements of modern-day photographers.

Although he was more restricted than most other photographers in his selection of a vantage point, Vittorio used a variety of compositional strategies. He gave careful consideration to camera placement, framing, and the inclusion of the human figure in his mountain views. Some are characterized by centrality and symmetry, like the stupendous view of Ushba rising above a sea of clouds (see page 36), or his moody depiction of Jannu

(see page 82). Quite often though, he applied conventions that hark back to the Claudian landscape tradition (perhaps learned during his youthful painting lessons), which make use of strong diagonals that draw the viewer's eye inward (see page 76). A sense of structural tensions characterizes some of Vittorio's most successful images, like the dramatic view up the Karagom Glacier in the Caucasus (see page 127) in which sloping mountainsides and wavelike glacial forms draw the composition tightly together, strengthened by the gaze of the two figures at the left.

The more painterly elements of the photographer's palette included the changes in light and weather conditions, the passing of time, and the movement of clouds. Finally, patience, tenacity, and a passionate sense of commitment were among his most potent artistic tools. Many passages in Vittorio's diaries tell of hours and even days spent waiting to capture a certain effect, or even to allow for the making of any

photographs at all. "After three hours of hopeless waiting in rain and sleet, [Sella and his companion] finally descended to the tent leaving the camera where it stood. The entire next day was spent on the ridge, crouched under the snowfall, close to the camera."[50]

W. F. Donkin once remarked that for the inexperienced eye it was difficult to appreciate the immensity of the Alps, and that photographs of them often were marred by a lack of scale. Vittorio's adept use of the human figure helped to resolve this problem and at the same time conveyed a sense of atmosphere or adventure. Although his figures are in most cases unidentifiable, they play a prominent role, guiding the eye through the composition or serving as intercessors who represent the viewer within the picture itself (see page 36). In snowy regions like the Himalayas, they stand out against the blinding white snow (see page 74), while in the Ruwenzori they are embedded deep within the dense jungle (see page 88). Sometimes one gazes at a Sella photograph for several moments before apprehending a tiny human figure that jars all sense of proportion and forces the viewer to rethink the magnitude of the landscape at hand. On a few occasions, Vittorio even used darkroom manipulations to achieve this effect, inserting figures from one photograph into another in order to give the great mountains their due (see page 120). Some consider the "pure" landscape as uninhabited and existing apart from man, but Sella often incorporated the human presence—

mortal man versus eternal mountain—to embody the spiritual element so prevalent in the philosophies that shaped his thinking.

According to Flaubert, an artist should be omnipotent and invisible. Sella, by contrast, was not shy about making his presence apparent. His own footprints and those of fellow climbers appear in numerous images, giving concrete evidence of their presence and inviting direct engagement of the viewer (see pages 19, 96). He also includes in his pictures the evidence of the spot in which he has placed his camera (see pages 84, 100, 112, 137). This grounding effect is in direct contrast to the floating, otherworldly sensation of Brad Washburn's aerial mountain photographs. More akin to Washburn's vision, though, are some of Vittorio's telephotos made with a long focal-length lens, or panoramas like his masterful view from the summit of Elbrus. In such pictures, the goal was to encompass all that could be seen from that lofty vantage point, to gather in the physical facts of a great range as well as to portray the visual spectacle.

Like any expert climber, Vittorio was keenly aware that getting to the summit was only part of the experience, and he wrote more than once about the importance of appreciating the journey as keenly as the arrival at the final destination: "He who is really fond of mountaineering is not satisfied with merely reaching a summit and descending again as soon as possible. He wishes to stop, admire, and enjoy."[51] Many of his Alpine photographs (see pages 22, 124) convey a palpable sense of the cold brilliant air of the glaciers and snowfields as well as the pure beauty and adventure of an ascent, and form permanent records of those fleeting moments. In Vittorio's time, and even in our own age of visual overload, such images have had enormous appeal for climbers and nonclimbers alike.

The prodigious list of prizes and honorary diplomas that Vittorio Sella received from international expositions, geographical societies, and alpine clubs around the world is testimony to the high regard given to his pioneering work. After winning a Grand Gold Medal at the 1893 Geographical Congress in Turin, more than four hundred of his prints were sent to Boston where they were shown in an exhibition sponsored by the Appalachian Mountain Club (AMC) and the Boston Art Club. Sella's photographs were extraordinarily well-received, and the collection was subsequently acquired by the AMC where it has been used by generations of climbers to plan their ascents. Charles Fay, a prominent mountaineer and member of the AMC, was instrumental in arranging a nationwide tour of the collection which brought Vittorio Sella to the attention of the American public for the first time in cities from coast to coast. In Bridgeport, Connecticut, alone more than twenty thousand people flocked to see the exhibition. Over the next two decades Sella continued to gain worldwide respect, and photographs by him illustrated the expedition chronicles of Freshfield, the Duke of Abruzzi, and Filippo de Filippi. The National Geographic Society, which named Vittorio an honorary member in 1922, acquired nearly a thousand of his photographs and published a selection of them in issues of its magazine from 1909 onward.

After his last major expedition to the Karakoram at the age of fifty, Vittorio changed course and directed his attention to the family's vineyards in Sardinia.[32] He made few new photographs but continued to print from his negatives in the darkroom at home in San Gerolamo. After his death in 1943, awareness and appreciation of his work dimmed, and Sella's name is found in few of the major histories of photography. Recent exhibitions in Italy, Pakistan, Uganda, and elsewhere have served to rejuvenate his reputation once again, however, and to accord him a stature consonant with his achievement, on a par with photographers like Carleton Watkins, the Bisson brothers, and Ansel Adams.

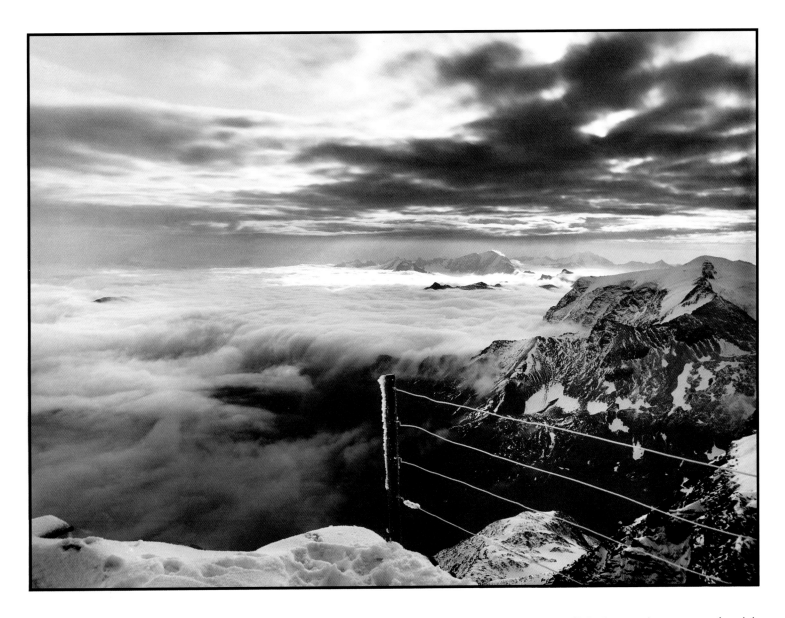

A century has passed since Sella's last major exhibition on this side of the Atlantic. Many of the places he photographed, remote and inaccessible then, continue to be known primarily through photographs or films, rather than through personal experience. Many of them have changed remarkably little in the intervening years—except perhaps to the eyes of those who track the transformation of glaciers and landforms, and to whom Sella's pictures serve as invaluable scientific records. This quiet photographer's images possess a certain timelessness and a pure evocation of natural beauty that appeals once again to a generation faced with global environmental crises and rampant urbanization.

The recent rise of interest in adventure travel and photography in some ways parallels the previous century's spirit of exploration, curiosity about the "exotic," and nostalgia for unspoiled nature. There is a difference, though, that is perceptible in Vittorio Sella's photographs and in the story of their making. While this reserved Italian was by no means impervious to the appeal of risk, he approached his work with a resoluteness of intellect and purity of spirit that is less common in today's world, where personal challenge is often the primary motive. These remarkable images offer a fresh look at the glories of our material world and a glimpse of an era in which the kindred pursuits of travel and mountaineering were allied with the rarer pleasures of discovery and conquest.

NOTES

I am grateful to Lodovico Sella, members of the Sella family, and the staff at the Fondazione Sella and the Istituto di Fotografia Alpina for their extraordinarily generous assistance in the preparation of this essay and the related exhibition. Special thanks are owed to my husband, John Varriano, for his unstinting support and encouragement throughout the research and writing of this essay.

1. Giuseppe Venanzio Sella, *Il Plico del fotografo* (Turin: Tipografia Paravia, 1856; with an expanded Italian edition in 1863 and subsequent editions in other languages).

2. From a letter to the American Alpine Club in 1939, cited in Ronald Clark, *The Splendid Hills. The Life and Photographs of Vittorio Sella 1859–1943* (London: Phoenix House, 1948), 2.

3. Written in the last few months of Sella's life, "Note biografiche personali," appeared in the *Annuario del Club Alpino Italiano*, (1977, 78, 79), Sezione di Biella, 7–11.

4. From "Nel Caucaso Centrale. Note di escursioni colla camera oscura," *Bollettino del Club Alpino Italiano* (Turin: Club Alpino Italiano, 1890), 44. Cited in English in Lodovico Sella's introduction to *Vittorio Sella with the Italian Expedition to Karakorum in 1909* (Biella, 1987), 9.

5. "The Fine Arts: The Wonders of Mountain Scenery as Shown by the Photographs of Mr. Sella," *Boston Evening Transcript*, May 8, 1893, 6.

6. The handwritten notation is found in a copy of the 1890 catalog of Vittorio Sella's Caucasus photographs at the Fondazione Sella, Biella, Italy, and refers to his photograph number 676.

7. Letter from Vittorio Sella to Linda Mosca Sella, inscribed "Portal 24 luglio 1906," written during the Ruwenzori expedition. Cited in English in Mirella Tenderini and Michael Shandrick, *The Duke of Abruzzi: An Explorer's Life* (Seattle: The Mountaineers, 1997), 104.

8. See Peter Henry Emerson, *Naturalistic Photography for Students of the Art* (London: S. Low, Marston, Searle & Rivington, 1889; reprint New York: Arno Press, 1973).

9. Ibid., 112-115.

10. John Ruskin, *Modern Painters*, vol. 4, *Of Mountain Beauty* (Boston: Dana Estes, 1873), 425.

11. Helmut Gernsheim, *The Rise of Photography* (New York: Thames & Hudson, 1988), 176. This daguerreotype image, reproduced as an engraving in Ruskin's *Modern Painters*, was almost surely seen by Vittorio. Ruskin's initial enthusiasm for photography later changed to disillusionment, and he eventually denounced the medium as trivial and mechanistic.

12. Ibid. Von Martens was the first to make single panoramic daguerreotypes of Paris, and he subsequently used a similar format for Alpine landscapes.

13. Arnold Lunn, *A Century of Mountaineering 1857–1957* (London: Allen & Unwin, 1957), 9.

14. For a general discussion of this phenomenon, see Simon Schama, *Landscape and Memory* (New York: A. A. Knopf, 1995).

15. James Howell, *Epistolae* (London: Printed by W. H. for Humphrey Mosely, 1650), quoted in E. S. Bates, *Touring in 1600* (London: Century, 1987), 303.

16. Lunn, op. cit., 18.

17. Mary Shelley and Percy Bysshe Shelley, *History of a Six Weeks' Tour through a Part of France, Switzerland, Germany, and Holland* (London: T. Hookham and C. and J. Ollier, 1817; reprint, Oxford: Woodstock Books, 1989), 151–152.

18. From Vittorio Sella's account of his Matterhorn winter ascent in 1882, published in the *Bollettino del Club Alpino Italiano*, 1882, 40; cited in English in Lunn, 101.

19. Ibid., 18.

20. Petrarca, Francesco, *Letters*, trans. Morris Bishop (Bloomington and London: Indiana University Press, 1966), 45–51.

21. Schama, op. cit., 478.

22. Marjorie Hope Nicholson, *Mountain Gloom, Mountain Glory* (New York: Norton, 1963), 271–273. Sir Douglas Freshfield expressed similar sentiments in *Round Kangchenjunga* (London: E. Arnold, 1903), 1: "throughout the centuries the mountain has stood as a symbol of the existence of something beyond and above the common ken of the dwellers at its feet."

23. See Christopher Hussey, *The Picturesque* (London and New York: Putnam, 1927), 4.

24. Schama, op. cit., 480.

25. Clark, op. cit., 4.

26. Sella, "Note biografiche personali," in *Vittorio Sella. Fotografie e Montagna nell'Ottocento* (Turin: Museo Nazionale della Montagna 'Duca degli Abruzzi, 1983), 19.

27. Before that time, he had often used 24–by–30 cm negatives but found them "aesthetically too square." See Douglas W. Freshfield, *Signor V. Sella's Caucasian Photographs* (London: Royal Geographical Society, February 1890), 4–5.

28. Ibid. For more information about Sella's cameras and techniques, see *Vittorio Sella. Fotografie e Montagna nell'Ottocento.*

29. The letter (cited in Clark, 7) reflects the pride Vittorio took in his work as well as his hard-headed businessman's approach: "My collection of photographs is noted in *The Alpine Journal* of August. . . . My prices are very dear, and to give you an idea, I am sending my catalogue with prices. If you buy many, I will make you a considerable reduction, that is to say, 20 percent."

30. W. F. Donkin, "Photography in the High Alps," *The Alpine Journal* 11 (November 1882), 63–71.

31. "Alpine Art and Appliances at the Winter Exhibition," *The Alpine Journal* 13 (February 1888), 461.

32. See Wendy M. Watson, *Images of Italy: Photography in the Nineteenth Century*, (South Hadley, Massachusetts: Mount Holyoke College Art Museum, 1980).

33. *Boston Evening Transcript*, May 8, 1893, 6.

34. John Pultz, *The Body and the Lens, Photography 1839 to the Present* (New York: Harry N. Abrams, 1995), 9.

35. *Boston Evening Transcript*, May 8, 1893, 6.

36. W. F. Donkin, "Photography in the High Alps," *The Alpine Journal* 11 (November 1882), 71. However, he went on to say that "The wish must have occurred to most climbers to have the power of bringing home with them some record, however imperfect, of the scenery they pass through. To all such who cannot sketch I would say, take up photography."

37. Douglas W. Freshfield, *Alpine Club Exhibition. Catalogue of a Collection of Mountain Paintings and Photographs* (London: Alpine Club, 1894), 10.

38. Captain W. Abney, "Photography in Winter and Summer in the Alps," *The Alpine Journal* 16 (November 1892), 370–371. He did confess in the same essay, however, that Donkin was "not only a scientific man, but he had the feelings of an artist, and the happy combination of science and art gave to the world those inimitable productions."

39. For a general introduction to the subject of anthropological photography, see Elizabeth Edwards (ed.), *Anthropology and Photography 1860–1920* (New Haven: Yale University Press in association with the Royal Anthropological Institute, London, 1992).

40. Vittorio Sella, Caucasus diary, September 20, 1889, Fondazione Sella, Biella.

41. Ibid., entries for October 16, 1889 and July 27, 1889.

42. *Monte Rosa e Gressoney*, an album of prints made from his photographs, was published in an edition of one thousand copies in July of 1890.

43. Clark, op. cit., 13.

44. Clark, op. cit., 14–15. On the optical unconsciousness, see Walter Benjamin, "A Short History of Photography," in Alan Trachtenberg (ed.), *Classic Essays on Photography* (New Haven: Leete's Island Books, 1988), 202–203.

45. One recent exhibition focusing on the panorama was *Expanded Visions: The Panoramic Photograph*, Addison Gallery of American Art, Phillips Academy, Andover, Massachusetts (January 17–April 5, 1998).

46. See John Davis, *The Landscape of Belief, Encountering the Holy Land in Nineteenth-Century American Art and Culture* (Princeton, New Jersey: Princeton University Press, 1996), 53–72.

47. Freshfield, *Signor V. Sella's Caucasian Photographs*, op. cit., 5.

48. As one anonymous *Alpine Journal* writer noted "the effects of snow and ice are reproduced with singular clearness and beauty by photography; and the absence of color, which is the great drawback to all photographic pictures, matters comparatively little where light and shade, and the dark rocks and bright snow form the chief features of the scene." See *The Alpine Journal* 2 (1865–66), 48.

49. For reproductions of some of these works and technical information about Sella's processes, see *Vittorio Sella. Fotografie e Montagna nell'Ottocento*.

50. This episode in the Ruwenzori in 1906 is quoted in Clark, op. cit., 27.

51. Letter of 1893 to Italian Alpine Club about the construction of the Queen Margherita hut, Fondazione Sella.

52. Although Vittorio virtually ceased making pictures after the 1909 expedition to the Karakoram, he continued to work with his darkroom assistant Emilio Botta to produce and distribute his photographs around the world.

53. Freshfield, *Round Kangchengjunga*, op. cit., 3.

SELECT BIBLIOGRAPHY

Adams, Ansel. "Vittorio Sella: An Intensity of Seeing, Majesty and Mood." *Sierra Club Bulletin* 31 (December 1946): 15–17.

Audisio, Aldo, Claudio Fontana, Giuseppe Garimoldi, Luciano Ghigo, Silvana Rivoir, Angelo Schwarz, Lodovico Sella, and Vittorio Sella. *Vittorio Sella. Fotografie e Montagna nell'Ottocento.* Cahier Museomontagna, 20. Turin, 1982

Bizzaro, Leonardo and Wolftraud de Concini. *Karakoram 1909, Vittorio Sella fotografo e cineasta.* Trento, 1995.

Camanni, Enrico, Roberto Mantovani, and Silvana Rivoir. *Le Montagne della fotografia.* Cahier Museomontagna, 83. Turin, 1992.

Cassio, Claudia, Sandro Lombardini, and Cesare Tambussi. *Fotografi del Piemonte 1852–1899.* Turin, 1977.

Ceccopieri, Maria Raffaella Fiory. Alfonso Bernardi. and Piero Racanicchi. *Dal Caucaso al Himalaya, 1889–1909: Vittorio Sella fotografo, alpinista, esploratore.* Milan, 1981.

Clark, Ronald. *The Splendid Hills. The Life and Photographs of Vittorio Sella 1859–1943.* London, 1948.

——— . *The Victorian Mountaineers.* London, 1953.

Crawford, William. *The Keepers of Light: A History and Working Guide to Early Photographic Processes.* Dobbs Ferry, New York, c. 1979.

De Filippi, Filippo and H.R.H. Prince Luigi Amedeo di Savoia, Duke of the Abruzzi. *The Ascent of Mount St. Elias.* Trans. Linda Villari. London, 1900.

De Filippi, Filippo. *Ruwenzori. An Account of the Expedition of H.R.H. Prince Luigi Amedeo di Savoia, Duke of Abruzzi.* New York, 1908.

——— . *Karakoram and Western Himalaya, 1909. An Account of the Expedition of H.R.H. Prince Luigi Amedeo of Savoy, Duke of the Abruzzi, Illustrated by Vittorio Sella.* London, 1912.

Fay, Charles E. "The Sella Exhibition." *Appalachia* 7 (March 1894): 229–238.

Freshfield, Douglas W. *The Exploration of the Caucasus.* 2 vols. London and New York, 1896.

——— . *Round Kangchenjunga. A Narrative of Mountain Travel and Exploration.* London, 1903.

Gallo, Emilio. "Nel Caucaso Centrale colla camera oscura. Terzo viaggio (1896). Impressioni e ricordi di viaggio." *Bollettino del Club Alpino Italiano* 30 (1897): 331–373.

Garimoldi, Giuseppe. "L'avventura fotografica." *Rivista della Montagna* 4 (April 1984): 40–44.

Garimoldi, Giuseppe, Nino G. Gualdoni, and Roberto Mantovani. *Alpinismo Italiano in Karakorum. Italian Mountaineering in the Karakorum.* Cahier Museomontagna, 78. Turin, 1991.

Garimoldi, Giuseppe and Angelo Schwarz. *Fotografia e alpinismo. Storie parallele. La fotografia di montagna dai pionieri all'arrampicata sportiva.* Il tempo delle Alpi, 4. Ivrea, 1995.

Garimoldi, Giuseppe, Roberto Mantovani, and Mirella Tenderini. *Sant'Elia 1897.* Cahier Museomontagna, 112. Turin, 1997.

Gentile, Dino (ed.) *Fotografi Biellesi in Sardegna tra fine Ottocento e primi Novecento.* Biella, 1994.

Gentile, Donato. "L'esplorazione fotografica di Vittorio Sella. Storia e analisi semiologica." Tesi di Laurea, Facoltà di Lettere e Filosofia, Università degli Studi di Torino, 1983.

Gernsheim, Helmut and Alison. *The History of Photography 1865–1914.* New York, 1969.

Gernsheim, Helmut. *The Rise of Photography 1850–1880: The Age of Collodion.* New York, 1988.

Goss, Charles. "Vittorio Sella, Obituary." *The Alpine Journal* 54 (1944): 292.

Guichon, Françoise. *Montagne Photographiés de 1845 à 1914.* Paris, 1984.

Hansen, Peter. "British Mountaineering, 1850–1914." Ph.D. dissertation, Harvard University, 1991.

Holman, Anna E. "In Memoriam, Vittorio Sella." *Appalachia* 25 (December 1944): 235–236.

Lunn, Arnold. *A Century of Mountaineering, 1857–1957.* London, 1957.

Mantovani, Roberto. *The Ruwenzori Discovery. Luigi Amedeo di Savoia Duca degli Abruzzi.* Cahier Museomontagna, 105. Turin, 1996.

Michieli, Alessandro Augusto. "Un maestro della fotografia alpina: Vittorio Sella." *Le vie d'Italia. Rivista mensile del Touring Club Italiano* 8 (August 1947): 722–726.

———— . "Un grande studioso della montagna: Vittorio Sella." *Estratto degli Atti dell'Istituto Veneto di Scienze, Lettere ed Arti.* Venice, 1948.

Milner, Cyril Douglas. "A Century of Alpine Photography." *The Alpine Journal* 62 (November 1957, Alpine Centenary issue): 157–164.

Miraglia, Marina, Daniela Palazzoli, and Italo Zannier. *Fotografia italiana dell' Ottocento, Aspetti e immagini della cultura fotografica in Italia.* Milan, 1979.

Miraglia, Marina. "Note per una storia della fotografia Italiana (1839–1911)." *Storia dell'arte italiana,* pt. 3, v. 2. Turin, 1981, 423–543.

Monkman, Jerry and Marcy. "Vittorio Sella." *Appalachia* 52 (December 15, 1998): 97–112.

Newhall, Beaumont. "Vittorio Sella." *Fotologia* 11 (September 1989): 29.

Pigazzini, Vittorio. "Riscopriamo un grande alpinista-fotografo Sella." *Airone* 79 (November 1987): 64–85.

Pluth, David, *Uganda Rwenzori. A Range of Images, with historical photographs by Vittorio Sella.* Staefa, 1996.

Racanicchi, Piero. "Vittorio Sella." *Popular Photography, Edizione italiana* 47 (May 1961): 41–48.

———— . "Vittorio Sella. Critica e storia della fotografia," *Quaderno* 1, Milan, 1961, 89–96.

———— . *Vittorio Sella in Valtellina 1885–86–87.* Sondrio, 1989.

———— . "Sui monti di Tolomeo," *Prometeo. Rivista trimestrale di Scienze e Storia* 9 (June 1991): 56–69.

Ramella, Carlo. "Vittorio Sella." *Club Alpino Italiano.* Sezione di Biella, 1945, 17–38.

———— . "Vittorio Sella." *Annuario of the Club Alpino Accademico Italiano* 94 (1992): 33–49.

Roberts, David. "Sella's Summit." *American Photographer* 19 (July 1987): 64–71.

Rosenblum, Naomi. *A World History of Photography.* New York, 1984.

Scheller, William. "In the Caucasus in 1889–1890, A Portfolio of Photographs by the Gifted Mountain Photographer Vittorio Sella from the Appalachian Mountain Club Collection." *Oriental Rug Review* 11 (November 1982): 2–3, 18–19, 36.

Scimè, Giuliana. *Vittorio Sella, I Maestri della Fotografia, Dossier.* Supplemento bimestrale a Progresso Fotografico, November 1991.

Sella, Giuseppe Venanzio. *Il Plico del fotografo.* Turin, 1856. Second edition, revised enlarged, Turin, 1863.

Sella, Lodovico. *Vittorio Sella with the Italian expedition to Karakorum in 1909.* Biella, 1987.

Sella, Vittorio. "Nel Caucaso Centrale. Note di escursioni colla camera oscura." *Bollettino del Club Alpino Italiano,* 23 (1889): 243–317.

———— . "Nel Caucaso Centrale. Note di escursioni colla camera oscura, II viaggio." *Bollettino del Club Alpino Italiano* 24 (1890): 262–317.

———— . "Nel Caucaso Centrale. Note di escursioni colla camera oscura, III viaggio: Appunti topografici" *Bollettino del Club Alpino Italiano* 30 (1897): 321–330.

———— . "Note biografiche personali." *Annuario del Club Alpino Italiano,* Sezione di Biella (1977–78–79): 7–11.

Sella, Vittorio and Domenico Vallino. *Monte Rosa e Gressoney.* Biella, 1890.

Tenderini, Mirella and Michael Shandrick. *The Duke of the Abruzzi, An Explorer's Life.* Seattle, 1997.

Tonella, Guido. "Une grande figure: Vittorio Sella." In *Alpes, neige, roc.* Lausanne, 1960, 81–99.

Waterman, Jonathan. *A Most Hostile Mountain.* New York, 1997.

Zannier, Italo. *Storia della fotografia italiana.* Rome, 1986.

Zannier, Italo. *Segni di luce. Alle origini della fotografia in Italia.* 3 vols. Ravenna, 1991–1993.

Those interested in further study of Vittorio Sella's work will find the greatest selection of resources at the Fondazione Sella and the Istituto di Fotografia Alpina Vittorio Sella in Biella, Italy. Additional articles by and on Sella can be found in the publications of the Club Alpino Italiano.

1859 *August 28* Vittorio Sella is born in Biella, Italy, the son of Giuseppe Venanzio Sella and Clementina Mosca Riatel.

1863 His father publishes a revised and expanded edition of the first Italian-language scientific treatise on photography. His uncle, Quintino Sella, founds the Club Alpino Italiano at Turin.

1876 *May 31* His father dies and Quintino Sella takes responsibility for Vittorio's upbringing.

1877 *November* Enters the military for a year of voluntary service in the Foggia Cavalry Regiment at Turin.

1879 Enrolls in the Professional School of Biella, taking courses in chemistry, physics, mathematics, mechanics, and wool technology. Begins to work in the family wool-manufacturing business, the Lanificio Maurizio Sella in Biella. *July* Experiments for several days and nights on the summit of Monte Mars in the mountains above his home town; makes his first alpine panorama using wet-collodion glass-plate negatives.

1880 *March 20* Completes a winter ascent of the Grauhaupt, accompanied by Sebastiano Lynty, mayor of the town of Gressoney, and makes a photographic panorama with dry collodion prepared in his studio on the family estate of San Gerolamo in Biella. *July 17* With his brother Erminio, climbs Mont Blanc and makes photographs with gelatin bromide plates.

1882 *March 17–18* Completes the first winter ascent of the Matterhorn (known in Italy as "Cervino"), with a traverse to Zermatt, accompanied by the guides Luigi, Jean Antoine, and Battista Carrel. *June 5* Marries his cousin, Linda Mosca Riatel. *June 29* Makes a 360-degree panorama from the summit of the Matterhorn. *September* Writes to Spooners in London about selling his photographs there. *December* Contacts Dallmeyer in London to order the construction of a Kinnear camera that accommodates 30-by-40 cm plates; this is the apparatus that he will use in all of his photographic campaigns until the end of 1892.

1883 *May 9* His daughter Clementina is born. *July–September* Climbs in the area around Mont Blanc and in the Pennine Alps.

1884 *January 25–26* Completes the first winter ascent of the highest peak of the Monte Rosa group with J. Joseph and Daniele Maquignaz. *March 14* His uncle, Quintino Sella, dies. *July–September* Climbs in the mountains around Monte Rosa and in the Bernese Oberland.

1885 *March 2* Makes the first winter ascent of the Gran Paradiso accompanied by the English alpinist Samuel Aitken and the guide J. J. Maquignaz. *March 22–23* Again with Maquignaz and with his cousins Alfonso and Corradino Sella, makes the first winter ascent of the Lyskamm. *August* Climbs in the Gran Paradiso, Disgrazia, and Bernese Oberland.

1886 *July–August* Travels and climbs in the Oberland, the region around Monte Rosa, and in the Bernina, making negatives in both the 30-by-40 cm and 46-by-56 cm formats; he abandons the larger format soon after because of its impracticality. *August 23* Establishes a bank, known as Gaudenzio Sella & Co., together with his brothers Carlo, Gaudenzio, and Erminio and his cousins Alessandro, Corradino, and Alfonso Sella. The bank continues to run today under the name Banca Sella within the recently established Banca Sella Group.

1887 *May 19* His daughter Bianca is born. *July–September* Travels and photographs in the Ortler-Cividale area and in the Pennine Alps.

1888 *January 5* Completes the first winter traverse of Mont Blanc from Courmayeur to Chamonix, climbing with guides Giuseppe, Daniele, and Battista Maquignaz, Emilio Rey, his brothers Erminio and Gaudenzio, and his cousin Corradino Sella. *June–August* Travels to Sicily and photographs around Mount Etna; climbs in the areas of Monte Rosa and the Dauphiné. *September 4* His son Giuseppe is born.

1889 *February 17–18* Makes the first winter traverse of Punta Dufour in the Monte Rosa group with guides Daniele and Battista Maquignaz, the porter Giuseppe Gamba, his brothers Gaudenzio and Erminio, and his cousin Corradino Sella. *July–September* Makes his first expedition to the Central Caucasus with his brother Erminio, guides Daniele Maquignaz and Giovanni Gilardi and porters Secondino Bianchetti and Giuseppe Gamba. *December 9* His son Cesare is born.

1890 *July* With Domenico Vallino, he publishes the album *Monte Rosa e Gressoney*, a series of photographs focusing on the environs and people of the Lys Valley in Valle d'Aosta. *June–October* Undertakes the second expedition to the Central Caucasus accompanied by Fabiano Croux, Secondino Bianchetti, and Giuseppe Gamba.

1891 *August–October* Travels and photographs in the Alps, Tyrol, and Dolomites.

1892 Leaves his position at the Lanificio Maurizio Sella. *February–August* Climbs and photographs in the Pennine Alps. *4 December* Visits England

*VITTORIO SELLA AT AGE EIGHTY, ON THE BALCONY
OF HIS SAN GEROLAMO LABORATORY, BIELLA, ITALY, 1939*

and has an accident while on the train from Dover to London. Leaning too far out of the window, Sella strikes his head on the tunnel wall, causing a skull fracture. He recovers fully after remaining in a coma for two weeks.

1893 Acquires new photographic equipment, abandoning his 30-by-40 cm camera and taking up a Ross & Co. camera that uses 24-by-18 cm glass plate negatives and 20-by-25 cm film negatives. He also begins to use two Kodak cameras for "instantaneous" and stereoscopic photographs. *August 18* Accompanies Queen Margherita of Italy to inaugurate a new hut named after her on Punta Gnifetti, in the Monte Rosa group. On this occasion, he makes five photographs, the last ones executed with his 30-by-40 cm camera.

1896 *July–September* The third trip to the Caucasus takes place; Sella is accompanied by Emilio Gallo, his photographic assistant Emilio Botta, and the porter Secondino Bisetta.

1897 *May–August* Takes part in the expedition led by the Duke of Abruzzi to Mount Saint Elias in Alaska.

1899 *September–October* Accompanies Douglas W. Freshfield on the exploratory trip around Kangchenjunga. His brother Erminio accompanies him. *December* With Erminio and his brother-in-law Edgardo Mosca Riatel, he begins an important land reclamation project in the Nurra plain near Alghero in Sardinia to introduce modern methods of viticulture. This wine-making venture became a model project and continues to thrive today under the name of Sella & Mosca. After this time, he no longer initiates any photographic campaigns, although he accompanies the Duke on two additional expeditions. He continues, however, to work in his darkroom and to correspond with alpinists and explorers around the world.

1906 *June–July* The Duke of Abruzzi undertakes a major expedition to the Ruwenzori mountains in Uganda, with Sella as his photographer.

1909 *April–July* Takes part in an expedition to the Karakorum in the western Himalayas, led by the Duke of Abruzzi; makes a film of part of the trip.

1912 The National Geographic Society of Washington, D.C. orders 300 of Sella's prints of the Himalayas, the Caucasus, and the Ruwenzori, including several panoramas. By 1926, nearly one thousand photographs were bought by the Society for its library.

1925 During a trip to Morocco Sella makes his last important series of photographs that are released to the public through an article in *National Geographic.*

1935 At the age of seventy-six, Sella makes his final attempt at the ascent of the Matterhorn; the climb is abandoned because of an accident in which one of the guides is injured.

1942 *November 22* His wife dies.

1943 *August 12* Vittorio Sella dies at his home at San Gerolamo in Biella.

1948 To preserve his photographic legacy, the Istituto di Fotografia Alpina Vittorio Sella is established by his heirs together with the Club Alpino Italiano, and the Consiglio Nazionale delle Ricerche C.N.R. It is based in Vittorio's laboratory at San Gerolamo in Biella, where scholars and visitors continue to consult its resources today.

HONORS

1883 Unione Fotografica Italiana in Turin, honorary member
1886 Cavaliere dell'Ordine della Corona d'Italia
Schweizer Alpenclub, Winterthur, honorary member

1888 The Alpine Club, London, member
1890 Murchison Prize, Royal Geographic Society, London, in recognition of the Caucasus expedition photographs
1892 Imperial Society of Natural Scientists, Anthropologists, and Ethnographers, Moscow, member
Società Fotografica Italiana, Florence, member
1895 Geographical Society of Philadelphia, corresponding member
1897 Appalachian Mountain Club, Boston, honorary member
1898 Club Alpin Français, Paris, honorary member
1901 Cavaliere Ufficiale dell'Ordine della Corona d'Italia
Cross of Saint Anne, conferred by Czar Nicholas II
Caucasus Alpine Club, honorary member
1903 Club Alpino, Italiano, Turin, honorary member
Crimea Alpine Club, Russia, honorary member
1904 Club Alpino Accademico Italiano, Turin, honorary member
1906 Cavalier III Class of the Order of Saint Michael conferred by the King of Bavaria
1922 National Geographic Society, Washington, honorary member
1925 The Alpine Club, London, honorary member
1937 Polskie Towarzystwo Tatranskie, Krakow, honorary member
1938 American Alpine Club, New York, honorary member

SELECTED EXHIBITIONS AND PRIZES

1882 Esposizione Generale dei Prodotti del Circondario, Biella
1884 Esposizione Alpina Italiana, Turin, diploma of honor
1887 Prima Esposizione Italiana di Fotografia, Florence, first-class gold medal
Esposizione Nazionale Alpina, Bologna, diploma of honor
1890 Royal Geographical Society, London, solo exhibition
Appalachian Mountain Club, Boston, solo exhibition
1891 Internationale Ausstellung Kunstlerischer Photographien of the Club Amateur Photographen, Vienna, diploma of merit
Esposizione Nazionale di Dilettanti di Fotografia, Venice, diploma of merit and a gold medal
1892 Geographical Exposition, Moscow, silver medal
Esposizione Generale Nazionale Alpina Italiana, Palermo, gold medal
Esposizione Nazionale Alpina Italiana, Palermo, certificate of merit
Exposition Internationale Alpine du Club Alpin Français, Grenoble, silver medal
1893 Esposizione Fotografica Alpina, Turin, diploma of honor and gold medal
Boston Art Club and Appalachian Mountain Club, Boston, solo exhibition; photographs from the AMC's collection are included in an exhibition which travels to seventy-five cities across the United States.
1894 Circolo Fotografico Lombardo alle Esposizioni Riunite, Milan, first class diploma and gold medal
Photographic Society, London, medal
1895 Photogr. Ausstellung Alpinen Characters, Salzburg, gold medal
1899 Esposizione Fotografica Nazionale ed Internazionale in Florence, diploma of honor
1899 Appalachian Mountain Club, Boston, solo exhibition which travels to thirty-three libraries in New England (through 1900).
1900 Exposition Universelle, Paris, diploma of honor and silver medal
1902 Esposizione Internazionale di Fotografia Artistica, Turin, award of special merit
1910 Società Fotografica Italiana, Rome, silver medal
1911 Esposizione Internazionale delle Industrie e del Lavoro, Turin, two gold medals
1921 VII Congresso Geografico Italiano, Florence, diploma of merit
1923 Esposizione Internazionale di Fotografia, Ottica, Cinematografia, Turin, diploma of high merit
1927 X Congresso Geografico Italiano, Mostra Fotografica del Paesaggio, Milan, diploma of honor
1940 VII Esposizione di Fotografia Alpina, Turin, solo exhibition

ACKNOWLEDGEMENTS

In Memoriam Vittoria Sella, H. Adams Carter

Our foundation and the Istituto di Fotografia Alpina Vittorio Sella has as one of its goals the preservation of precious images and memoirs of men who passionately explored and documented little-known regions of the world in the last decades of the past century. Outstanding among them were Luigi Amedeo di Savoia Duca degli Abruzzi, and Vittorio Sella. Their photographs, with their wealth of geographical and human detail, help us to understand today how to preserve a world that is becoming smaller, without endangering its timeless and delicate balance.

We wish to express our gratitude to Paul Kallmes and to Wendy Watson for having proposed and planned this book and exhibition which will make Americans aware of the important work of our ancestor, Vittorio Sella. Aperture, the world's foremost photographic publisher, and the Mount Holyoke College Art Museum, another distinguished institution, have generously collaborated in this project of bringing Sella's images to the attention of the public in the best possible way.

Our sincerest appreciation goes to Michael Hoffman, director of Aperture, and to his colleagues, and to Marianne Doezema, director of the Mount Holyoke College Art Museum, for supporting our efforts and enabling this magnificent book and related exhibition to become reality. We are also grateful to Antony Decaneas of the Panopticon Gallery in Boston, for his wise counsel about all subjects pertaining to the use of Sella's images. The acknowledgment would not be complete without thanking Vittorio and Franco Sella for permission to use their grandfather's photographs. We remember with great fondness Vittoria Sella who for many years lovingly looked after all the documents, literature, and photography concerning mountains, in her capacity as curator of the institute named after her great-grandfather Vittorio.

LODOVICO SELLA
Chairman, Fondazione Sella

This project was accomplished only through the efforts of many generous people. Primary thanks must go to Lodovico Sella, without whose understanding and patience nothing could have been done. Clotilde Sella and the staff at the Fondazione Sella in Biella, as well as the rest of the Sella family at San Gerolamo, showed me extraordinary kindness and generosity during the months I spent researching these remarkable photographs. Tony Decaneas of Panopticon Lab and Wendy Watson of Mount Holyoke College Art Museum were essential in establishing and maintaining the credibility that carried the book to completion. Michael Hoffman at Aperture agreed without hesitation to publish it, and Phyllis Thompson Reid was invaluable in bringing the project to fruition. Thanks are due to my parents, Otto and Susan Kallmes. In addition, thanks must go to the following people for their assistance, friendship and encouragement at all stages of the project: Jessica Gill, whose off-hand suggestion that I look at a drawer of photographs started it all; the staff at the Fondazione Sella in Biella: Renzo Becchio-Galoppo, Luciano Pivotto, Antonio Canevarolo, Maria Vittoria Bianchino, Gianluca Eandi, and Teresio Gamaccio; Brad and Barbara Washburn, Jeff Bowman, J.T. and Lindé Ravizé, David and Anne Brower, David Cole, Elizabeth Coletti, Greg Child, Kate Kallmes and Carlos Alvarez, Robert Ketchum, Anne Labe, Bradley Lechman, Tracey Levy, Gerry Lewis, Rick Silverman, Ace Kvale, Kit Katzenbach, Diana Nielsen, Alison Palmer, Pat and Baiba Morrow, John Hake, Leah Ribak, Maria Sella Moriondo, Alfonso Sella, John Varriano, Anita Woodruff, Scott Darsney, Richard Doege, and Joanie Norris; finally, the remarkable Julia Thompson ensured that the book assumed a form that I would be proud of ten years down the road.

PAUL KALLMES

I first saw Vittorio Sella's photographs in 1995, in a thin, decades-old volume handed to me by the museum's curator, Wendy Watson. Even poorly reproduced, the images were stunning. The idea of organizing an exhibition that would reintroduce this extraordinary work to American audiences after a hiatus of a century developed rapidly. The current book and the exhibition result from a four-year collaboration between Ms. Watson and Paul Kallmes, mountaineer, engineer, impresario, and Vittorio Sella's most dedicated and tireless ambassador. We owe a great debt to Lodovico Sella, the photographer's descendant and the director of the Fondazione Sella in Italy, for his full and gracious cooperation with every phase of this endeavor. It was very much in the collaborative spirit of enterprise that Lodovico's entire family became involved, including Clotilde Sella (Mount Holyoke Class of 1999). We are grateful also to the trustees of the Fondazione Sella and the Istituto di Fotografia Alpina Vittorio Sella who agreed to lend the photographs that are the project's core. To the dedicated staff members there, we extend heartfelt thanks for their invaluable assistance with all aspects of the research as well as the logistics of the exhibition. Finally, the museum is indebted to Arthur and Joanne Hall and the Fairweather Foundation, and to the Institute of Mountain Photography for a generous grant which provided essential support for the exhibition in the final stages of its organization.

Forming an association with Aperture was a crucial development for the project and made possible the present publication in which Sella's photographs are seen, for the first time in America, in all their vibrancy and splendor. Michael Hoffman, immediately recognizing the importance of Vittorio Sella's work, was the driving force behind the publication and, together with editors Maureen Clarke and Phyllis Thompson Reid, has made this handsome book a reality.

MARIANNE DOEZEMA
Director, Mount Holyoke College Art Museum

EXHIBITION SCHEDULE

Mount Holyoke College Art Museum, South Hadley, Massachusetts: January 25–March 10, 2000

Gallery of the New York School of Interior Design, New York, New York: April 12–May 27, 2000

Whyte Museum of the Canadian Rockies, Banff, Alberta, Canada: September 14–November 26, 2000

The publisher wishes to acknowledge the support of the Institute of Mountain Photography, a non-profit corporation dedicated to increasing awareness of the vital importance of pristine mountain ranges and the preservation of historically important works of mountain photography, film, and literature. For more information, call (775) 586-8280, email IMP@aframeofmind.com, or write to: Institute of Mountain Photography, P.O. Box 10331, Zephyr Cove, NV 89448.

Editor's note: The fifth and sixth sentences of Ansel Adams's essay (see page 7), which appeared in the December 1946 issue of the *Sierra Club Bulletin,* have been altered to correct factual errors. Adams's original passage reads as follows: *Sella was born in 1859 in Biella, in northern Italy, and died in Rome in 1943. Apart from his photographic accomplishments in the Alps, he was photographer on many important expeditions—to the Caucasus in 1889, 1890, and 1896, to the Saint Elias range in 1897, to the Karakoram and Western Himalaya in 1899 and 1909, and to Ruwenzori, in Africa, in 1906.*

Design by Peter Bradford and Michelle M. Dunn

Printed and bound by L.E.G.O., Vicenza, Italy

Duotone separations by Martin Senn

The Staff at Aperture for *Summit* is: Michael E. Hoffman, *Executive Director;* Phyllis Thompson Reid, Maureen Clarke, *Editors;* Stevan A. Baron, *Production Director;* Lesley A. Martin, *Managing Editor;* Eileen Max, *Associate Production Director;* Rebecca A. Kandel, *Editorial Work-Scholar*

Aperture Foundation publishes a periodical, books, and portfolios of fine photography to communicate with serious photographers and creative people everywhere. A complete catalog is available upon request. Address: 20 East 23rd Street, New York, New York 10010. Phone: (518) 789-7000, ext 007. Fax: (518) 789-3394. Toll-free: (800) 929-2323.

Visit the Aperture website at: http://www.aperture.org

Aperture Foundation books are distributed internationally through: CANADA: General/Irwin Publishing Co., Ltd., 325 Humber College Blvd., Etobicoke, Ontario, M9W 7C3. Fax: (416) 213 1917. UNITED KINGDOM, SCANDINAVIA, AND CONTINENTAL EUROPE: Robert Hale, Ltd., Clerkenwell House, 45-47 Clerkenwell Green, London EC1R OHT. Fax: 44-171-490-4958. NETHERLANDS, BELGIUM, AND LUXEMBURG: Nilsson & Lamm, BV, Pampuslaan 212-214, P.O. Box 195, 1382 JS Weesp. Fax: 31-294-415054. AUSTRALIA: Tower Books Pty. Ltd. Unit 9/19 Rodborough Road Frenchs Forest, New South Wales Fax: 61 2 99755599. NEW ZEALAND: Southern Publishers Group, 22 Burleigh Street, Grafton, Auckland. Fax: 64-9-309-6170. INDIA: TBI Publishers, 46, Housing Project, South Extension Part I, New Delhi 110049. Fax: (91) 11-461-0576.

For international magazine subscription orders for the periodical *Aperture,* contact Aperture International Subscription Service, P.O. Box 14, Harold Hill, Romford, RM3 8EQ. England. One year: £30.00. Price subject to change.

To subscribe to the periodical *Aperture* in the U.S. write Aperture, P.O. Box 3000, Denville, New Jersey 07834. Toll free: (800) 783-4903. One year: $40.00; two years: $66.00.

First edition

10 9 8 7 6 5 4 3 2 1

(NEXT) CLIMBERS ON THE LYSKAMM, ALPS, 1893

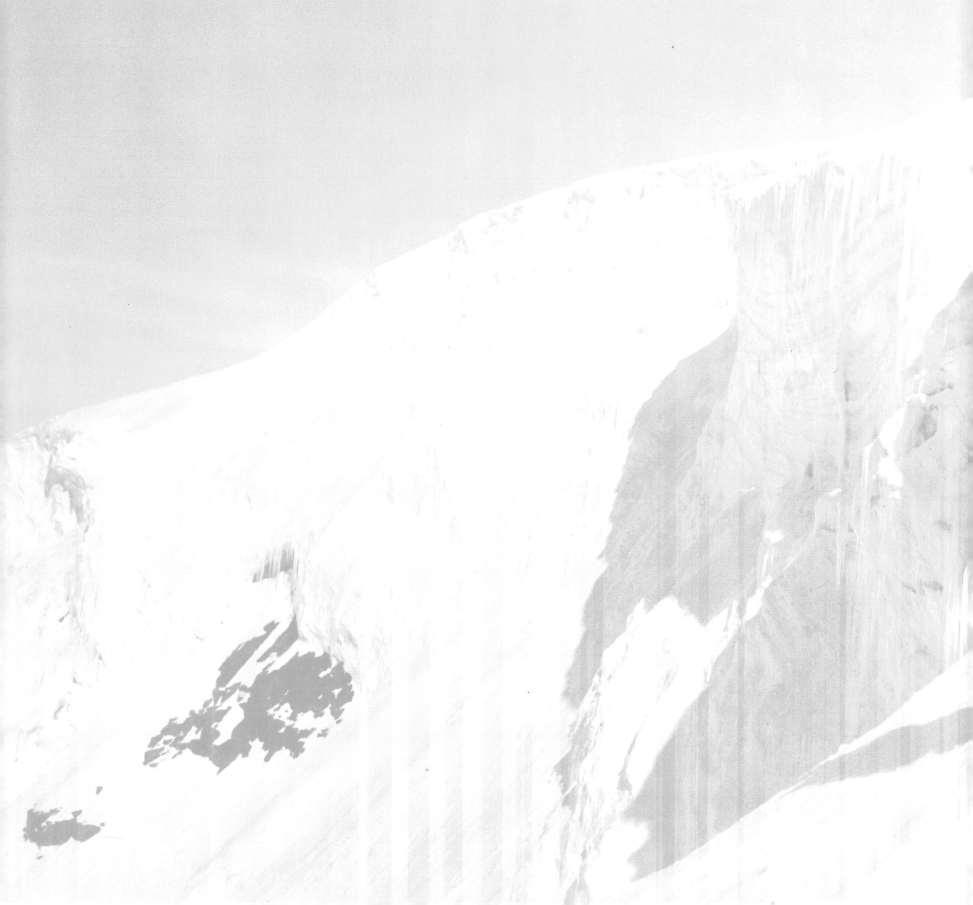